THE ILLUSTRATED

STAR VARS

UNIVERSE

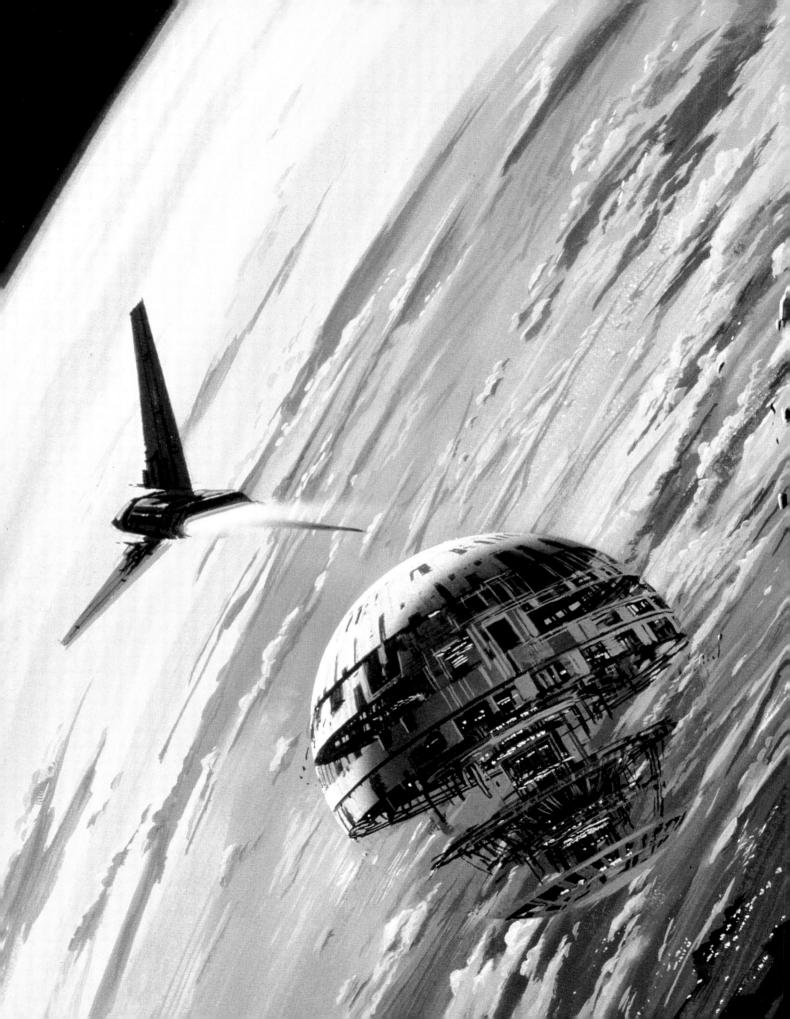

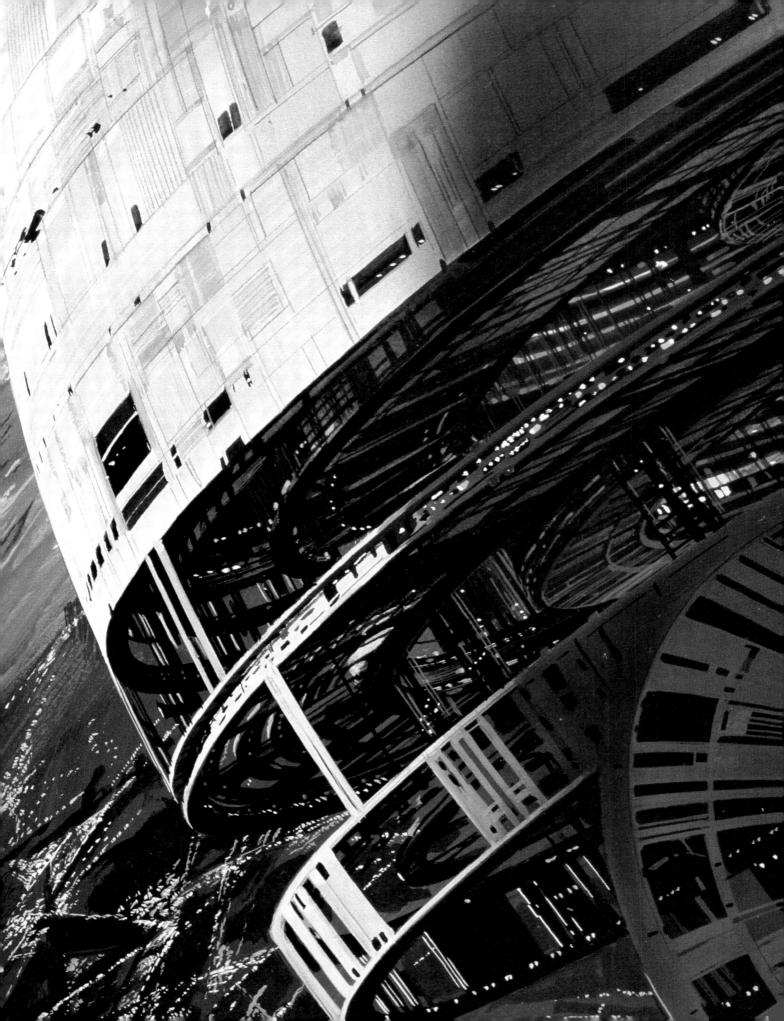

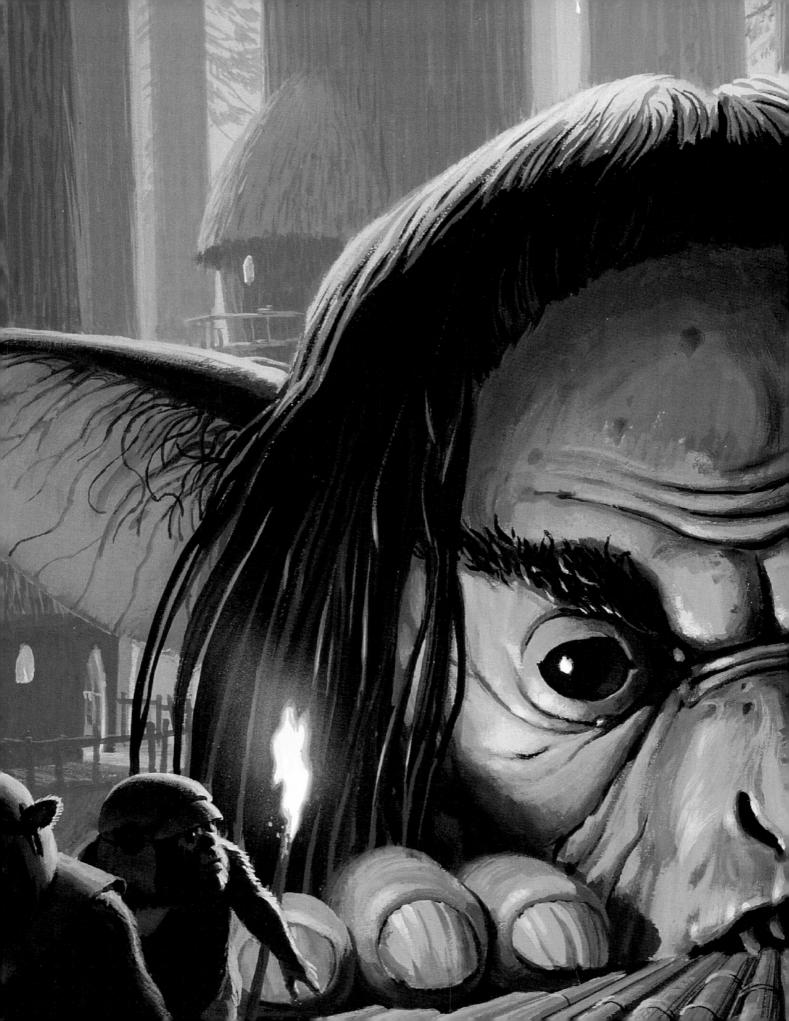

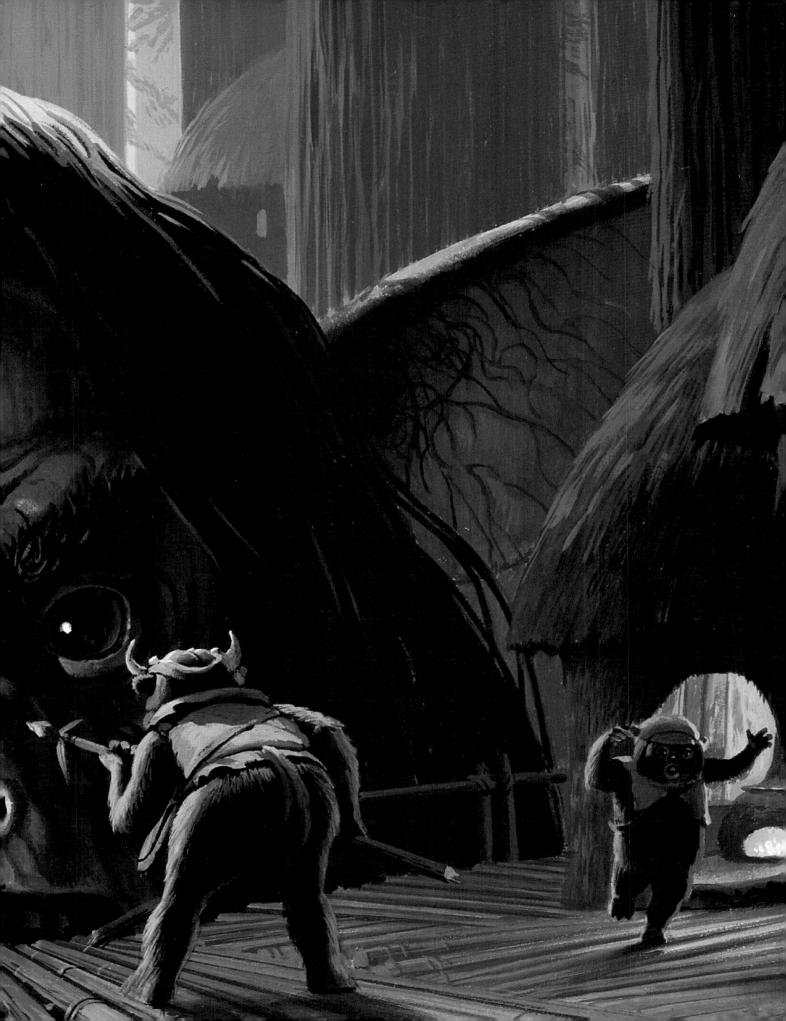

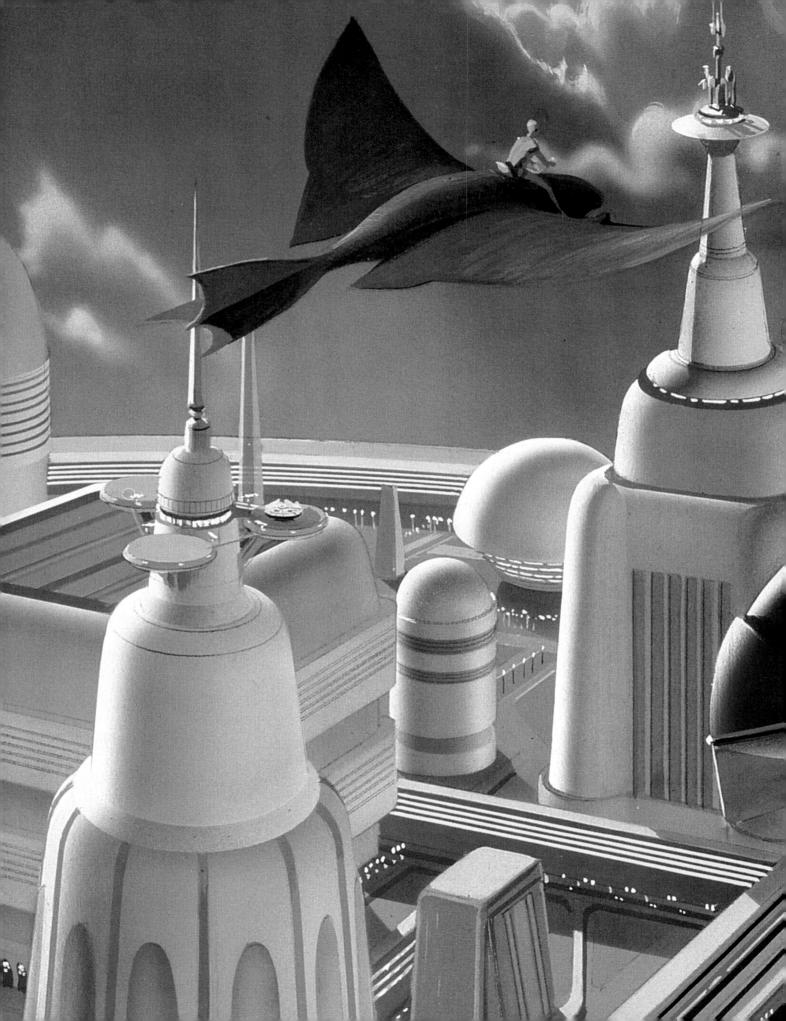

ART BY RALPH McQUARRIE TEXT BY KEVIN J. ANDERSON

ADDITIONAL ART: MICHAEL BUTKUS · HARRISON ELLENSHAW · CHRIS EVANS NILO RODIS-JAMERO · JOE JOHNSTON · MICHAEL PANGRAZIO · NORMAN REYNOLDS

THE ILLUSTRATED

THE ILLUSTRATED STAR WARS A Bantam Spectra Book

PUBLISHING HISTORY

Bantam Spectra hardcover edition published in December 1995 Bantam Spectra trade paperback edition / October 1997

DEDICATION

To my grandfather, JENS T. ANDERSON, who was never much of a reader, but always kept my books proudly displayed along with all his other mementos from his grandchildren. He taught me many things, including the small measure of common sense I might once have had.

I think he would have liked this book. *Kevin J. Anderson*

ACKNOWLEDGMENTS

Thanks to George Lucas, Lucy Wilson, Sue Rostoni, Allan Kausch,
Halina Krukowski, and Janet Silk at Lucasfilm;
STAR WARS authors Dave Wolverton, Timothy Zahn, and Tom Veitch;
Bill Smith and West End Games; Scott Usher, Peter Landa and Megan
Rickards Youngquist at the Greenwich Workshop for their design skills;
Betsy Mitchell; and last but not least—Tom Dupree for imagination
and editorial assistance.

®, ™, © 1995 by Lucasfilm Ltd. All rights reserved. Used under authorization. Book design by Megan Rickards Youngquist and Peter Landa of the Greenwich Workshop Press

Cover art by Ralph McQuarrie

Library of Congress Catalog Card Number: 95-14854

No part of this book may be reproduced or transmitted in any form or by any means, electronic or mechanical, including photocopying, recording, or by any information storage and retrieval system, without permission in writing from the publisher.

For information address: Bantam Books.

ISBN: 0-553-37484-2

Published simultaneously in the United States and Canada

Bantam Books are published by Bantam Books, a division of Bantam Doubleday Dell Publishing Group, Inc. Its trademark, consisting of the words "Bantam Books" and the portrayal of a rooster, is Registered in U.S. Patent and Trademark Office and in other countries. Marca Registrada. Bantam Books, 1540 Broadway, New York, New York 10036.

PRINTED IN THE UNITED STATES OF AMERICA

KPP 10 9 8 7 6 5 4 3 2

CONTENTS

TATOOINE

12

IMPERIAL CENTER

CORUSCANT

46

DAGOBAH

76

HOTH

90

ENDOR.

112

BESPIN

138

YAVIN4

166

ALDERAAN

186

TATOOINE

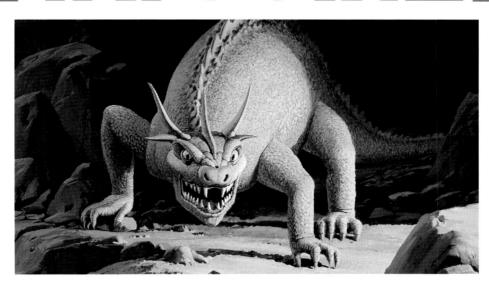

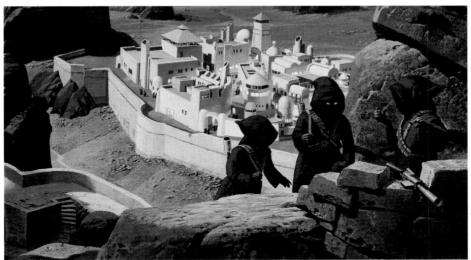

ABOUT THE AUTHOR:

(Indeterminate) Hoole—Senior
Anthropologist Hoole has taken great
advantage of his species' astonishing
shape-changing and mind-fogging
abilities, vastly enriching our
knowledge of the galaxy's varied
worlds through his unique powers
of investigation. His skill at imitating
and infiltrating alien cultures—not to
mention interpreting them for our
readers—has earned him many honors. Unfortunately, there are few like
him; his race, the Shi'ido, is rare.

In this report, written before
Tatooine was thrown into prominence
as the homeworld of Luke Skywalker,
(Indeterminate) Hoole describes his
fascinating and sometimes harrowing
experiences on the remote and littleknown desert planet.

TATOOINE

wo suns burn down on the planet Tatooine, rising and setting over the harsh desert landscape. The system contains the binary stars Tatoo I and Tatoo II, similar yellow G1 and G2 stars that would have made for a pleasant climate...if the planet had not orbited on the hot inner edge of the life zone.

One can find this information in any star gazetteer. But I wanted to know more, not just a list of statistics and astronomical quantities. I wanted to know the real Tatooine, this place of mystery. And because of my unique biology, I could discover knowledge hidden from even the best anthropologists and survey teams. I could observe like the proverbial mace fly on the wall.

ther members of my shape-changing race have given my entire species a disreputable air. My people are most commonly thought of as spies and assassins, able to disguise themselves and blend in with any group of sentients. We can fog the minds of those around us, erasing suspicions and distracting people from asking embarrassing questions. Naturally, we are greatly sought after by powerful crime lords as well as the Empire itself for espionage and covert operations.

I have chosen, however, to turn my skills to the advancement of knowledge. As an "invisible" anthropologist, I am able to blend in with any culture and observe it from the inside, discovering valuable details hidden from blundering, intrusive teams with their electronic imagers and keypads and blunt questions.

No, I work alone. I slip in and play my role. I watch, and learn.

I reached Tatooine by impersonating a crew member on a long-distance cargo hauler. With my abilities of distraction, I made sure no one particularly noticed me or realized that I seemed to have no defined duties. I wasn't there to deceive anyone. I just wanted passage to the planet, where I could begin my studies.

During the brief passage, I reviewed what other

databases already contained about the arid desert planet. Much of the information was dry and uninspired, as if the original survey teams had not been much interested in the place, and no one had bothered to expand the write-ups.

Tatooine has the fortune—or *mis*fortune, some might say after learning of the planet's tortured history—of being located in the remote Outer Rim, yet near a prime nexus of hyperspace routes. This makes the planet easy to get to…but nobody particularly wants to go there. Given the world's low profile and strategic location, a significant amount of smuggler traffic has always passed through the Tatooine system—even before the recent Imperial crackdown on commercial spice freighting.

Tatooine has been settled by outside colonists for only a few hundred years; but in that time the desert world has been the site of countless battles between rival gangsters and smuggling lords.

According to anecdotal reports, the uncharted landscape is scattered with the debris from burning ships, crashed fighters, and the broken hulks of mercenary battle cruisers. Scavenger races in the desert arm themselves with all manner of weaponry, from archaic bombs and projectile weapons to contraband double-blasters dumped by gunrunners fleeing the Empire.

s we approached the silent, orange-tan sphere of Tatooine, I stood on the observation deck, completely unnoticed, while the other crew members bustled about in their preparatory work for landing. The planet looked stained and desolate, practically featureless, blazing in the reflected light from its double suns.

The geography of Tatooine has never been precisely mapped, probably because no one really cares. The planet is sparsely inhabited with well-defined settlements and holds few resources of galactic interest. Titanic sandstorms roar across the face of Tatooine every year, altering the landscape and erasing landmarks.

From my vantage at the observation windows, I watched one of Tatooine's few prominent features orbit beneath our ship—the wide expanse of the

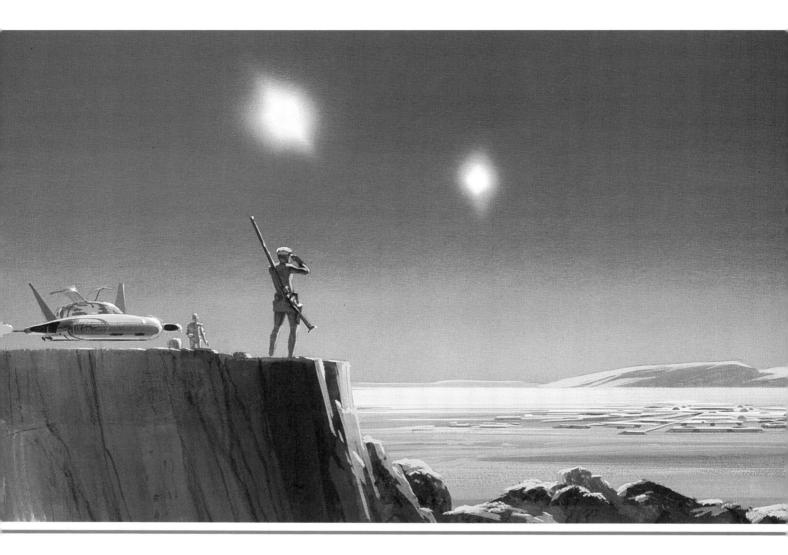

Dune Sea, a harsh basin left from the drying of an ancient ocean. I had seen grainy images showing how the alkaline sands glitter under the binary sunlight, without so much as a rock outcropping to break the monotony for kilometers.

ordering the Dune Sea lay the badlands of the Jundland Wastes, rocky canyons and mesas in which roam the Sand People, or Tusken Raiders, a violent and secretive race who inspire fear among the local settlers. The caves and crannies in the Jundland Wastes supposedly house an unknown number of fugitives, hermits, and marauders. I had also read overblown, boastful reports of local flyers who spent their free time practicing aerial combat and gunnery skills in the steep and winding gorges, such as Beggar's Canyon.

I couldn't wait to get to work down there. I was ready for anything.

We landed in the seedy spaceport of Mos Eisley—Tatooine's only "big city"—which seemed

identical to a thousand other spaceports on a thousand other backwater worlds. I overheard one of the crew members muttering that the place was a "wretched hive of scum and villainy," but that didn't seem to bother him in the least.

After the long-distance cargo hauler had landed in one of the docking bays, I slipped off the ship. No one noticed me, and no one would ever remember me. With my slim electronic notepad in hand, I entered the city, eager to jot down my impressions.

Mos Eisley is a haphazard array of low, gray steelcrete structures and semidomes at the bottom of a wide, windy basin surrounded by bluffs.

Large, shabby spaceship hangars line the actual spaceport district near the Spaceport Traffic Control Tower, the beacon that guides shuttles and small cruisers down to land. Because of the small amount of "official" traffic, the traffic control tower rarely does anything beyond negotiating landing fees at the various docking bays. Unofficial traffic usually consists of smugglers hauling glitterstim or ryll

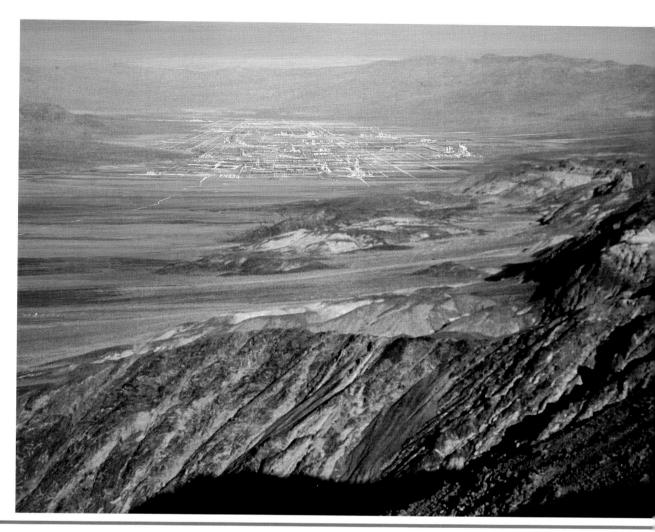

spice or other contraband through the black-market centers on Tatooine.

In the town center I found the large wreck of a crashed spacecraft, the *Dowager Queen*, a mess of tangled girders and falling-apart hull plates that had been picked over by generations of scavengers. From what I could tell, the wreck provided a home for all manner of strange creatures, vagrants, and scavengers lurking inside the cool shadows.

ear the center of the dusty town, I saw the corroded hulk of a large space freighter half-buried in the sands, much more intact than the *Dowager Queen*. From the visitors' information I had taken from the docking bay, I recognized this as the *Lucky Despot*, a ship no longer spaceworthy that had been converted into a hotel and casino, now run by the long-faced, tusked Whiphid female, the Lady Valarian, reputed to be one of the powerful crime lords on Tatooine.

Officially, Imperial law is enforced on Tatooine

Tatooine offers vistas as sweeping as any in the galaxy. From a distance it may seem that nothing could live in such a hot, dry place—but the spaceport at Mos Eisley thrives with activity (both legal and illegal).

through a small contingent of stormtroopers; however, it is obvious the Empire does not consider the place worth a major effort. The man in charge, Prefect Talmont, seems to spend most of his time trying to get himself reassigned, ignoring the blatant crime in the streets of Mos Eisley.

It took little time for me to pick up details of how this city works. Much of the business—legal or otherwise—is conducted in the seedy cantinas near the docking bays. Like all spaceports, Mos Eisley is a melting pot of sentient creatures, from honest traders to fugitives to bounty hunters. Many of the inhabitants have taken up spying as a profession, keeping careful tabs on every being who comes and goes, hoping to find someone else willing to pay for

the information they've gathered.

An efficient network of brokers connecting buyers and sellers has fallen into place. If you need to hire a starship or a guide, you can find the right person by asking a few discreet questions. If you need to sell illegal imported weaponry or buy a personal supply of glitterstim, someone will take care of you.

ost of the businessmen in Mos Eisley have become accustomed to bribing Prefect Talmont or other city officials to avoid being harassed about permits or code compliance. Though many of the people there have no love for the Empire, the stormtrooper outpost is considered a necessary evil. With the influx of regular water tankers and supply ships to stock the garrison, the standard of living in Mos Eisley is now higher than it has ever been.

I spent only a day in this city, since Mos Eisley interested me little. I wanted to go out and see the real Tatooine.

As a stepping-stone to the great barren wilderness, I traveled to one of the smaller settlements, Anchorhead, which serves as a central trading point for moisture farmers and others eking out a living on the edge of the Dune Sea. It was once the site of a deep, reliable well frequented by pilgrims crossing the wasteland, but the well has long since dried up.

Many support services survive in Anchorhead, but the economy is tied directly to the vagaries of the desert air. When the wind blows hotter and dryer than usual, decreasing the water harvest, the crops wane, credit accounts get thinner, and everyone suffers.

With the automation of vaporators and reclamation systems, the younger generation often has little to do except

dream about the lives they could have had elsewhere in the galaxy. I infiltrated a group of teenagers near the popular hangout of Tosche Station, a power and water distribution complex, and listened to their rebellious dreams of running away from home, making their way to Mos Eisley, and finding a ride that would take them to the Imperial Academy. Their impossible but heartfelt talk disturbed me, though, and I made my way out of Anchorhead toward one of the outlying moisture farmer settlements.

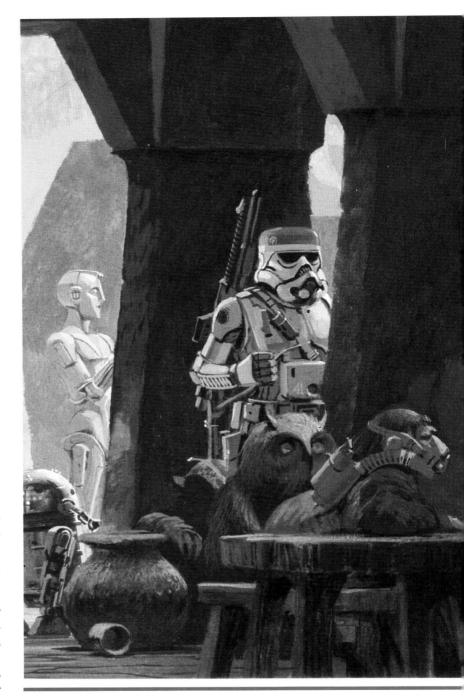

Unless the blaster fire is particularly loud or a brawl gets out of hand, in seedy establishments such as this cantina most customers barely notice a disturbance.

On a desert planet such as Tatooine, the most precious commodity is water. The people who have adapted to the arid conditions have developed drastic measures to acquire and conserve water. Living in underground dwellings, moisture farmers deploy

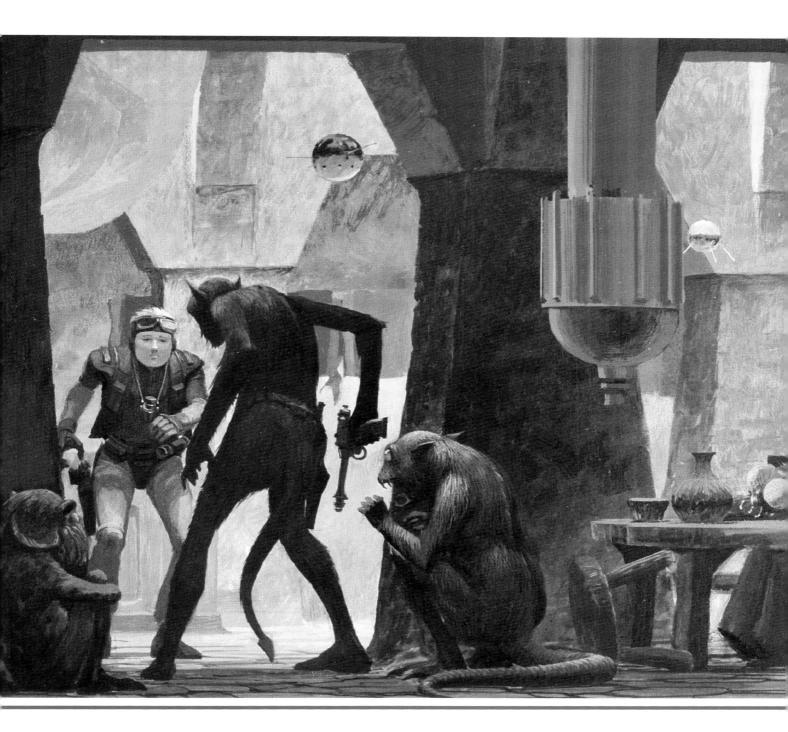

water collection devices of all kinds along the broad perimeters of their stake, harvesting the scant droplets and hoarding them in armored underground holding tanks.

Posing as a hired hand who had lived with them for the past season, I stayed with one such family for a week. I observed their daily routine and how the moisture farmer's very existence is tied to barely functional technology, the best equipment they can scrounge on such an out-of-the-way planet.

he most common water collection device is the vaporator: three meters tall and made of multiple refrigerated cylinders. The hot wind of Tatooine blows through the open tubes, and the vital moisture condenses out upon striking the chilled metal surface. All day long, drop by drop, the distilled water fills small catchbasins buried in the base unit beneath each vaporator.

Some sophisticated-model vaporators can adapt to wind speeds, external temperature, and moisture

content in the air, regulating the refrigeration unit to require the minimum power necessary to extract the maximum moisture. The programming of most vaporators, however, is done in an archaic binary language that is no longer understood by many repair droids.

art of a moisture farmer's daily work is to travel the perimeter of his property to harvest the vaporator network. Occasionally, desperate Sand People will break into deployed vaporators and steal the collected water, but the Tusken aversion to technology usually proves as effective a

barrier as the farmers' perimeter shields.

Moisture farmers sell some of their hard-won water in small containers for personal use in the towns of Anchorhead and Bestine. Most of the moisture harvest, however, is piped to extended subterranean agricultural complexes. In small artificial caverns, botanical engineers grow extended crops in intensive cultivation, using carefully regulated drip systems to add just enough precious water and concentrated nutrients directly to the root masses.

The invigorating light from the two suns of Tatooine is piped underground through prisms and mirrors, keeping the plants well nourished. This type of agriculture does not allow for much profit, but it provides enough food for the population of Anchorhead and the outlying moisture farmers.

ome of Tatooine's water, I learned, is also obtained by roving, solitary prospectors who search the uncharted desert for their wet treasure. After I had lived with the moisture farmers for a week, one of these water prospectors came to the dwelling, asking for a meal and some supplies before he journeyed out into the Jundland Wastes again. Seeing an opportunity to explore the deep desert, I changed my appearance and fogged the memories of those around me.

The following day, disguised as the water prospector's longtime partner, I journeyed out into the baking desert, riding in the passenger compartment of a battered old XP-30 speeder.

Water prospectors roam the wastes in search of undiscovered catchtraps

that have formed reservoirs near enough to the surface to be reached by laser drills. Though my companion was human, I learned that water prospectors are frequently aliens with a high tolerance for Tatooine's heat and baking dryness.

I inferred from my nameless companion's sketchy conversation that prospectors rarely find more than

Whether in the stillness of the afternoon's peak heat or in the chill of a deep desert night, the backstreets of Mos Eisley are the site of any number of underhanded dealings.

a mere trickle, which is pumped at great effort from beneath the ground. A persistent legend, though, tells of a great underground river that can be heard rushing under the rocks of certain winding, windcarved canyons far to the north. To me it sounded typical of the "lost treasure" myths frequently told by desperate people.

Many hermits live by hidden springs deep in caves or fissures in the labyrinthine badlands, such as Beggar's Canyon, which is aptly named for the beseeching sound made by the wind as it whistles through the crevices.

e told me that the Sand People also know where water sources can be found, and these are jealously guarded; any hapless stranger who ventures too close to a secret Tusken oasis is sure to be killed.

Day after day we cruised over the landscape, studying delicate moisture sensors or just following his instincts. If we did happen to strike an underground spring, my partner carried three repulsorlift cargo platforms in the cargo bay of his vehicle. When deployed, these platforms could carry tough bladders filled with the valuable water.

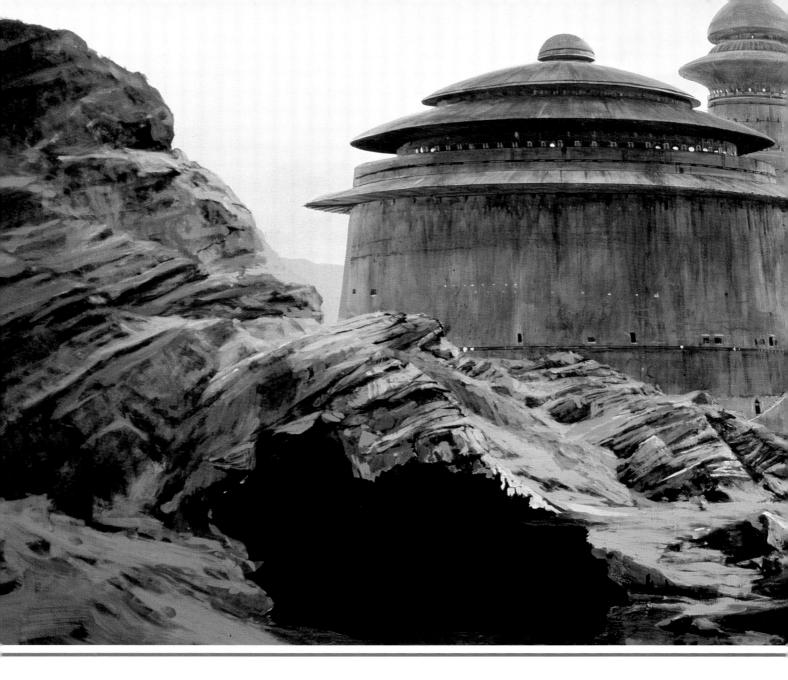

However, during all the time I spent with him, we found nothing; and so I left him to set off on my own. I blurred the memory of the water prospector so that he remembered being alone all the

time. Then, confident and fascinated, I strode into the sprawling desert.

At first glance, Tatooine may seem like a desolate and unforgiving place—but the persistence of life throughout the galaxy has left a rich and varied ecosystem even in the most hellish places.

Cliffborer worms, found among arid rocks.

I saw many astonishing adaptations during my time alone in the hot, rocky sands, but I managed to sketch only a few.

Tatooine's razor moss chews into shadowed rock and uses corrosive root tendrils to break down crystals and chemically extract water molecules hydrated into certain minerals. Tiny arthropods known as sandjiggers feed on the razor moss, as do long, armored cliffborer worms.

Another interesting species, the funnel flower, sports a brilliant cone of flapping petals on each end of a long strawlike stem; the hollow stem dips through a shadowed crevice in a cliff wall, then bends back upward. Hot air sucked in through one end of the funnel flower plunges through the cool crevice, where the faint moisture condenses out in

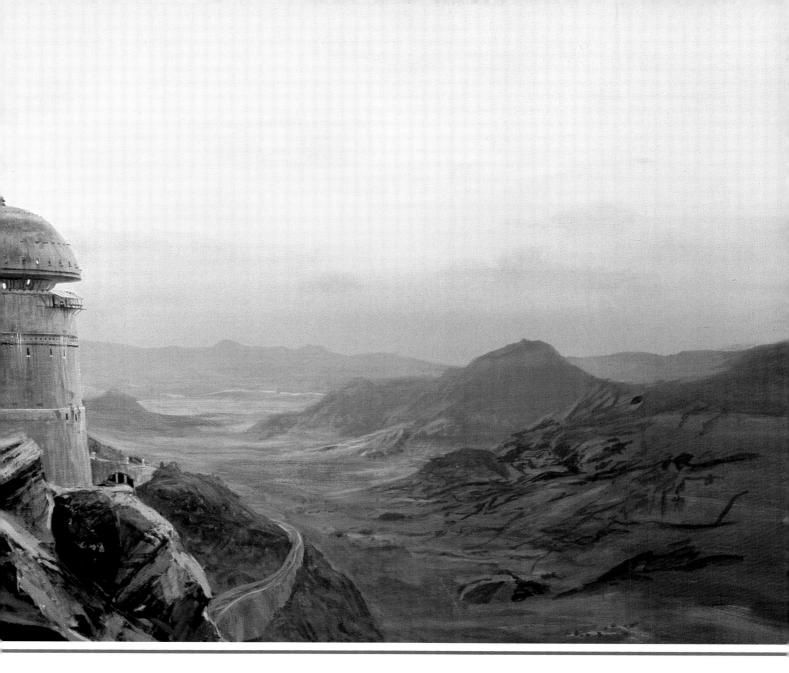

The palace of Jabba the Hutt, originally constructed by the reclusive and mysterious B'omarr monks, is an unmistakable citadel at the edge of the Dune Sea. In its shadowy interior (right) many creatures have taken refuge... or vanished.

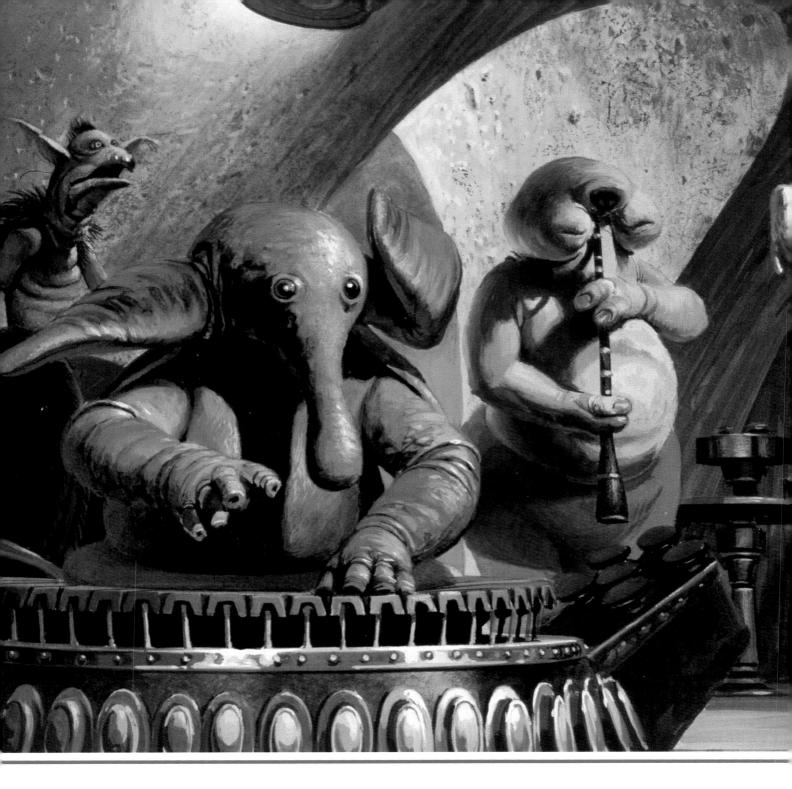

the temperature differential, collecting in the crook of the stem. Root systems spread out from the moisture-laden elbow, seeking nutrients in the rock. Deep in a crevice, this water is not directly accessible to desert people. Later I found out that Jawas have become masters at inserting long, thin hoses down the stem to siphon off the reservoir.

The hubba gourd, a tough-skinned melon studded with small reflective crystals to deflect the Inside Jabba's throne room, various entertainers—such as Max Rebo, Droopy McCool, and Sy Snootles, shown above—play to amuse their Hutt master...or else.

harsh sunlight, is a difficult-to-digest fruit, but it is a primary food of the Jawas and Tusken Raiders. In the Jawa language, hubba means "the staff of life."

I also came upon larger animals, such as a family

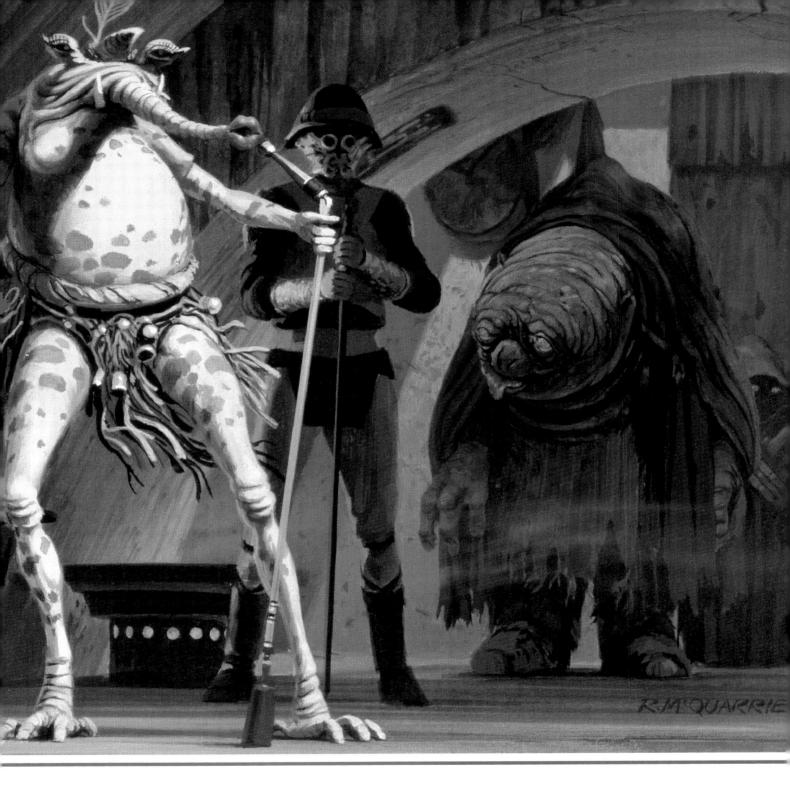

of scuttling womp rats, camouflaged as gray-brown boulders while they foraged along canyon bottoms. From my initial eavesdropping in Mos Eisley, I knew that though they are slow movers, the womp rats' relative invisibility has made them favorite practice targets for flyers and stormtroopers, and these creatures are becoming increasingly scarce.

Herbivorous reptilian dewbacks are used by moisture farmers as beasts of burden and by desert storm-

troopers as patrol animals. Though sluggish in the cool of the night, dewbacks can be urged to bursts of great loping speed in the daytime heat. At full run, they have been able to pace landspeeders for a

(pages 26-27) In the undesirable levels of Jabba's palace—rooms that are clean and brightly lit—the wives and children of Gamorrean guards make the best of their airy but miserable quarters.

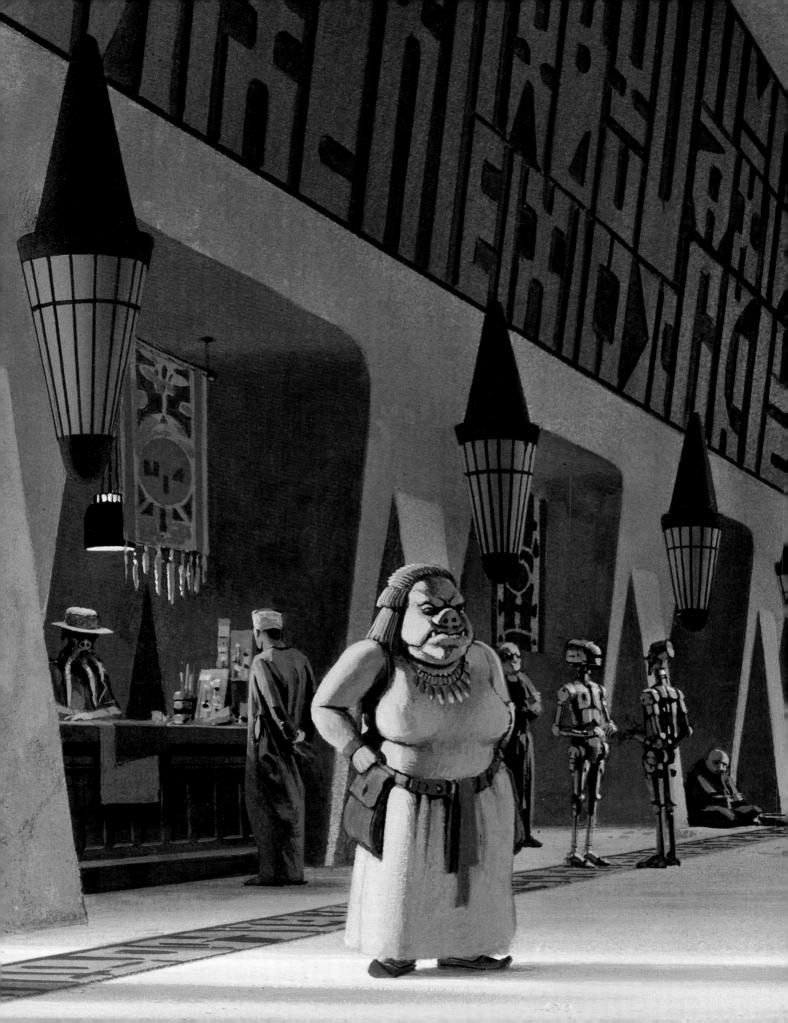

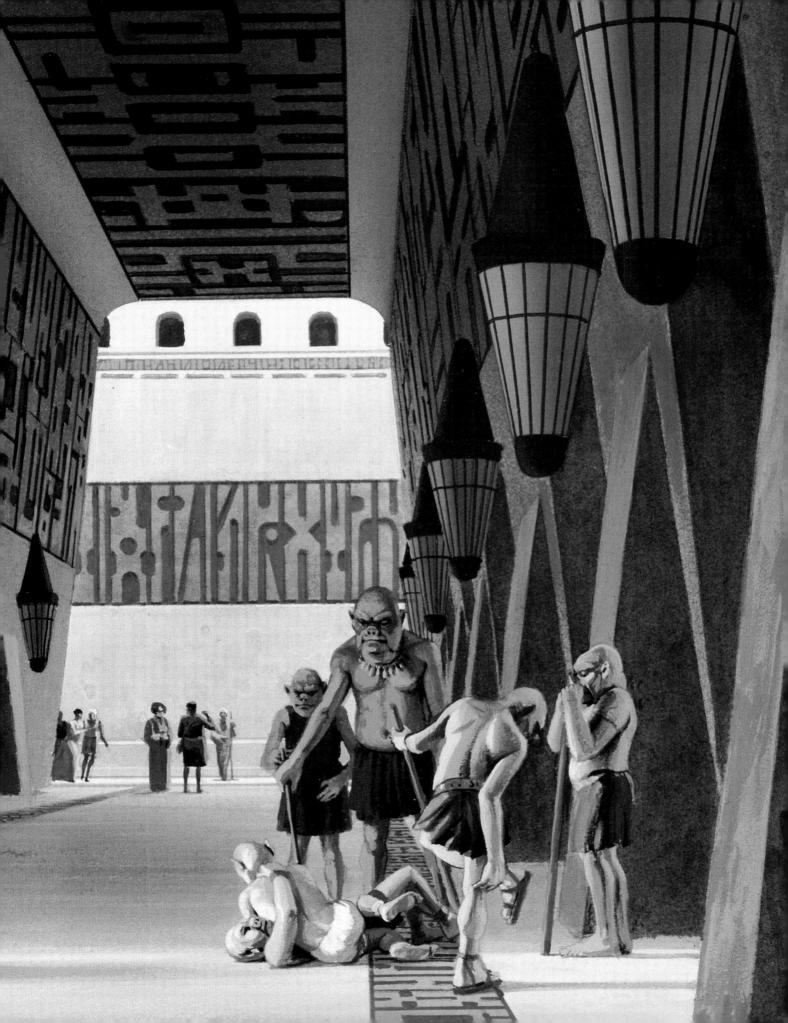

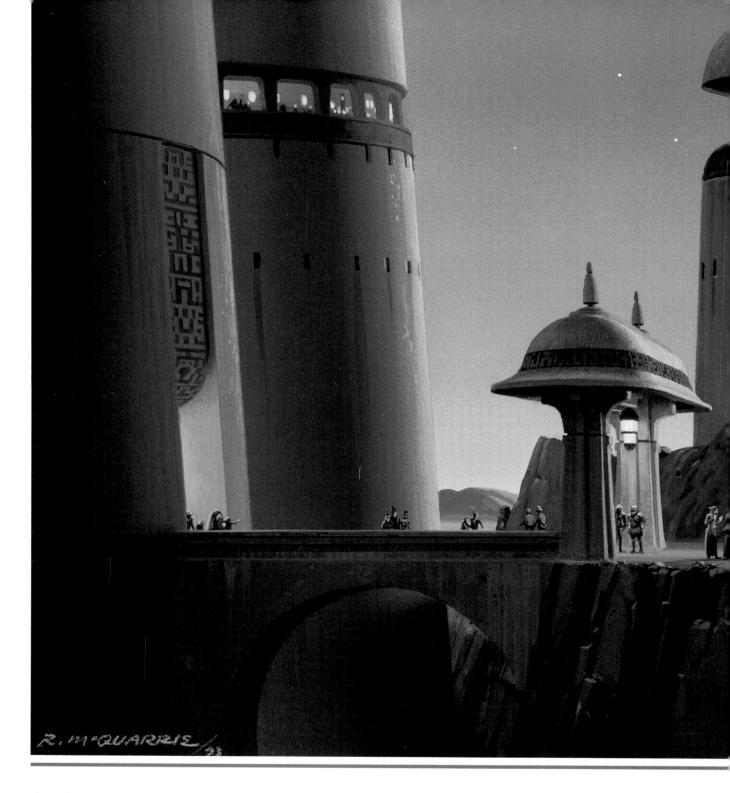

short distance—and (I heard one stormtrooper say), unlike mechanical vehicles, dewbacks do not break down in sandstorms.

Herds of furry, shuttle-sized banthas run wild in the badlands of Tatooine.

While passing through Anchorhead nearly two weeks earlier, I had heard the tale of one trader who had attempted to sell captured Tusken banthas as beasts of burden; but the banthas became listless and

could not be trained to perform even simple duties, though the animals are thought to be quite intelligent. Not until I saw how the Sand People domesticate wild banthas in a strange familial relationship did I understand why the trader had encountered so many difficulties.

After some time surviving alone in the desert, wishing again for the companionship of other sentient beings (as well as the amenities civilization

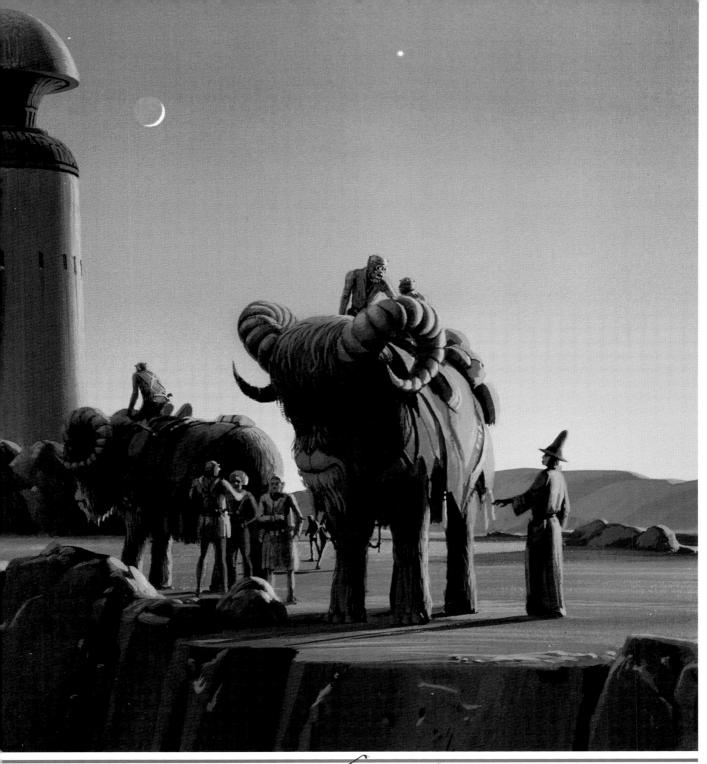

Tusken Raiders (above) are occasionally visitors to Jabba's palace, secretly trading with the B'omarr monks or others in the fortress. Their huge bantha mounts are skittish and rarely allow the curious to approach. Inside the palace, many strange creatures (right) can be found, some of which have not yet been classified by galactic xenobiologists.

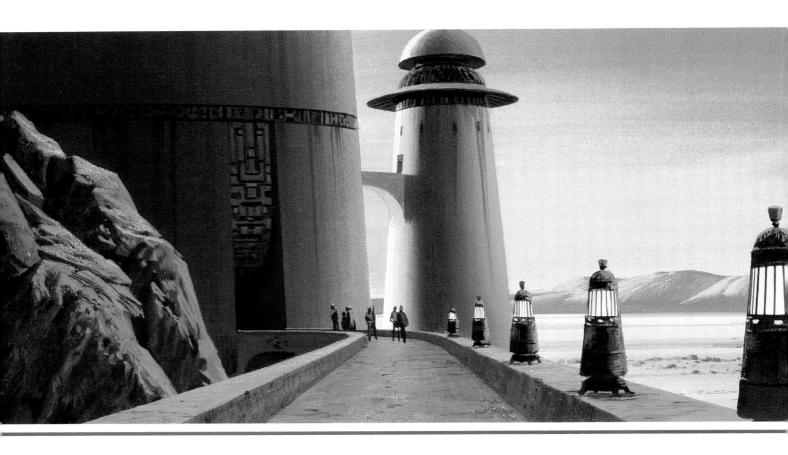

offers), I came upon a towering citadel at the far edge of the Dune Sea. I had not come here consciously, but I counted myself very fortunate to come upon the imposing palace currently owned by the gangster and smuggling kingpin Jabba the Hutt.

Currently an odd assortment of creatures, clingers, "business associates," sycophants, and slaves live in Jabba's palace, along with their families. Gamorrean guards are totally loyal—if a bit unimaginative—defenders of the palace, while their wives spend their days lording over their households in other parts of the palace. Among Jabba's strange companions are never-before-seen species, bounty hunters, and assassins found only on wanted posters throughout the galaxy.

I was forced to use my abilities of disguise and deception to the utmost just to divert attention from myself. The inhabitants of Jabba's palace are accustomed to suspecting everyone and everything because they are embroiled in so many plots. Reading their thoughts and learning their intended plots made me literally dizzy as I went about

studying the palace itself and its history—which I found far more interesting than the petty underworld squabbles.

The enormous citadel has actually been on Tatooine for centuries, as was obvious from the generational structure of the outside, with modifications and additions constructed over the years.

Centuries before a few hardy colonists arrived to scrape out a living in the desert, the mysterious religious order of the B'omarr monks moved their followers to Tatooine. Out in the harshest wastelands, the monks sought a place of suitable isolation among the crags;

there, over the generations, the monks carved for themselves a labyrinthine palace of grim solitude.

A legend dimmed by time claims that the monks built their fortress in this area of Tatooine with some assistance from roving bands of Tusken Raiders, though I encountered no one who understood the connection between the Sand People and the B'omarr order.

Occasionally, though, the grim and mysterious Tusken Raiders will

A Gamorrean guard in full work regalia.

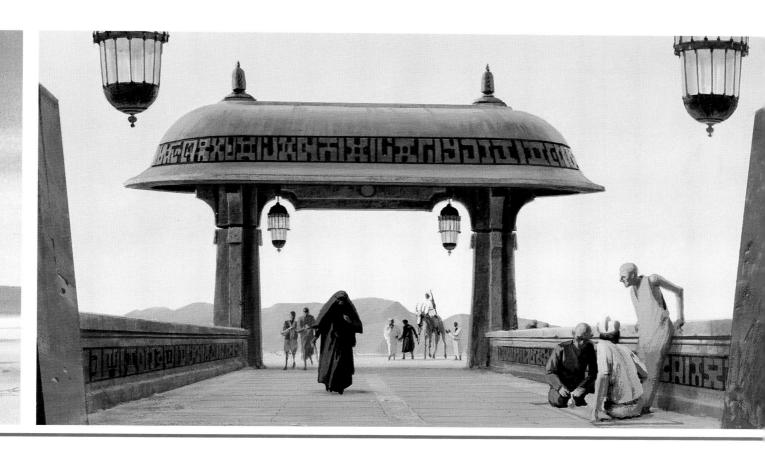

Walkways and observation towers allow a full view of the desert surrounding Jabba's palace. For a few hours during the long, hot day, some people willingly go outside for some fresh air.

ride their banthas to the gate of the palace and just stare, making no attempt to communicate, and then they depart as silently as they have come.

It frightened me to discover that the B'omarr monks saw through my deception with ease and observed my real nature. I could keep no secrets from them—but they did not seem to care. They accepted my presence as part of the natural order of things.

The belief system of the B'omarr monks is centered on physical denial; by cutting themselves off from all sensation, they can focus and enhance the power of the mind, embarking on journeys made possible through inner space. Thus the rugged, unwelcoming climate of Tatooine seemed a perfect exile to them.

Once built, the citadel remained silent and mysterious, mostly hidden within the rock face, showing only battlements and great doors from the outside. Seeing the huge gates, travelers across the desert often wondered what might be hidden inside. The dark silhouetted forms occasionally seen on the

ramparts never spoke, never gestured in greeting.

Over the years the B'omarr monks had no contact whatsoever with the local moisture farmers or representatives from other religious orders, such as the bantha-worshiping Dim-U monks in Mos Eisley.

The inner citadel of the monastery was so vast and empty, and the place so isolated, that renegades and smugglers soon broke in and became squatters in abandoned alcoves and corridors.

The first usurper to occupy the B'omarr monastery was the great bandit Alkhara, who once allied himself with the Sand People to wipe out a small police garrison near the former capital of Tatooine, and then butchered the Sand People who had helped him—thereby beginning the centuries-long blood feud the Tusken Raiders have toward humans.

Alkhara and his band fled into the desert from military retribution and stormed the citadel, intending to take it as a place against siege. He was surprised to find the gates unlocked, and the monks were unimpressed by his arrival. One of the monks apparently told Alkhara to make himself at home and stay as long as he liked. The monks themselves had other concerns.

B'omarr acolytes rarely speak to each other, pondering their own philosophies, except during times when they all sit in tea-rooms and sip their only nourishment, a potent tea made from herbs stored in caches somewhere in the citadel. During this time, the monks talk in snatches of conversation, entire lectures boiled down to an obscure word or phrase that they somehow seem to understand. I listened in on one of these abbreviated, esoteric conversations and walked away shaking my head, unable to fathom just how the palace's monks could be communicating.

The higher up the monks went in their studies, the fewer words they used and the less they moved... the less they needed their own bodies. Even with all the shocking things I have seen in my varied anthropological investigations, I was still shocked to discover the monastery's horrible secret.

When a B'omarr monk reaches the stage of final enlightenment, he has no further use for his body, his eyes, his ears, his senses. Nothing at all. The monk has achieved a stage of pure mental power, at one with the cosmos. When this occurs, the other, "lesser" monks help the enlightened one to shed his body, surgically. The enlightened brain is removed and placed in a nutrientfilled jar, forever freed from the distractions of the flesh and able to spend the years in perpetual thought. The monks showed me their wall cases filled with brain jars as they proudly explained their technique.

ven these enlightened brains still occasionally have business to attend to along the monastery corridors. Mechanical, spiderlike walking legs are available if ever an enlightened one feels the need to "go for a walk." Telepath-

ically, the brain in a jar summons the walking legs, which approach the storage alcoves, pick up the appropriate brain jar, and attach it under the walking legs. When such a mechanical walker comes clicking along the corridors, the other B'omarr monks give it a wide, reverent berth, as did I.

Recently it has been said that Jabba the Hutt captured one of his rivals and, as punishment, demanded that the monks surgically "shed" his body and place his brain in a jar among their own. For his own amusement, Jabba wanted to see whether the hapless enemy would survive. Unfortunately for

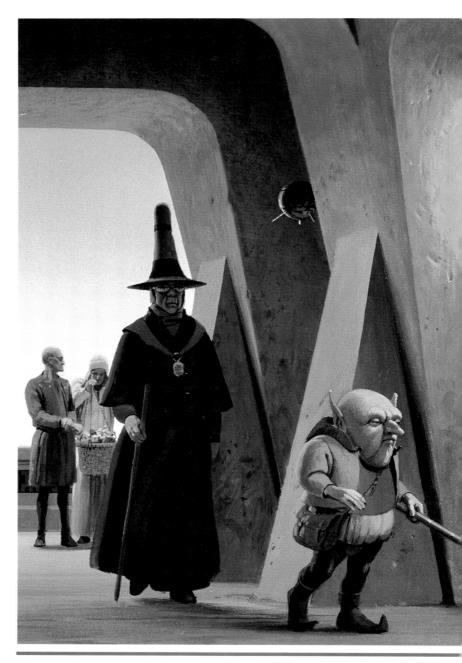

the victim, he did. Now, blind, confused, and unable to communicate, this brain has commandeered a set of the spider legs and wanders the palace, lost and without purpose.

hen the monks graciously offered to help me on the way to my own enlightenment, I declined—perhaps a bit too vehemently—and decided I would be safer in the upper levels of Jabba the Hutt's palace, among the cutthroats, bounty hunters, and assassins.

The bandit Alkhara used the citadel as his head-

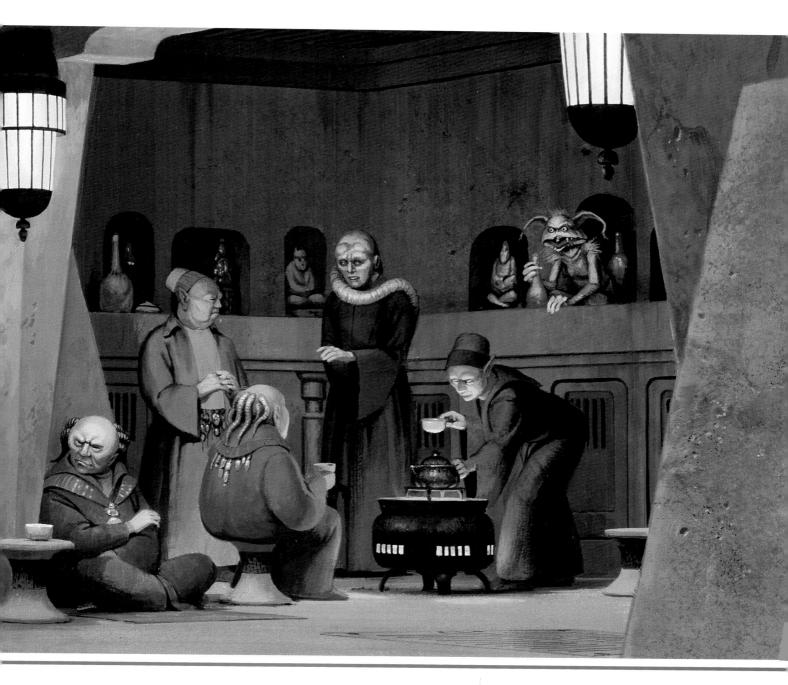

The B'omarr monks ignore all their unwanted visitors, preferring instead to discuss esoteric subjects (top). The most enlightened monks—merely disembodied brains in jars—move about on robotic legs (right).

quarters for thirty-four years, improving many of the rugged corridors and great halls. His followers fixed many of the living quarters and added a deep network of dungeons and underground chambers, which the monks adored. So vast was the citadel and so few were the monks that they rarely noticed

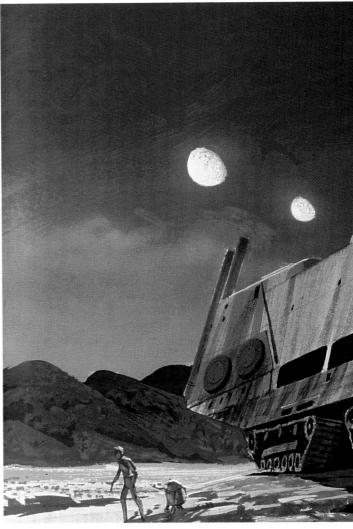

Many vehicles are used to cross the desert, such as these sand-sailing skiffs (above) or the immense and corroded sandcrawlers used by the scavenger Jawas (right).

their unwanted visitors were even there.

Over the years other bandits, revolutionaries, and crime lords took over the B'omarr monastery, occupying it under the same terms. In payment for this lodging and protection, the visitors each built another portion onto the sprawling complex: perhaps a cistern in the bluffs beneath the palace, an observation tower, or more extensive dungeons.

abba the Hutt has been the most recent and extravagant follower of this tradition, converting the rugged facades into a towering but elegant palace built out of sandrock reinforced by ditanium plating and reflective shielding.

Jabba constructed a vast hangar wing and garage to house his sail barge along with the sandskimmers and other vehicles. The Hutt and his retinue frequently go out across the sands on pleasure rides—usually to watch hapless victims die in various ways out in the desert.

One of his favorite styles of execution is to toss his prisoners into the gullet of a strange and fearsome creature, the Sarlacc, which makes its nesting place at the bottom of a slippery-sided basin called the Great Pit of Carkoon. The only portion of the sand dwelling creature visible aboveground is its pink, mucus-lined mouth opening, more than two meters in diameter.

Tentacular appendages can whip out and snare spectators from the rim of the pit, and inward-pointing spearlike teeth make escape impossible. Though the Sarlacc does not get frequent prey, its extremely long digestive cycle sustains it through

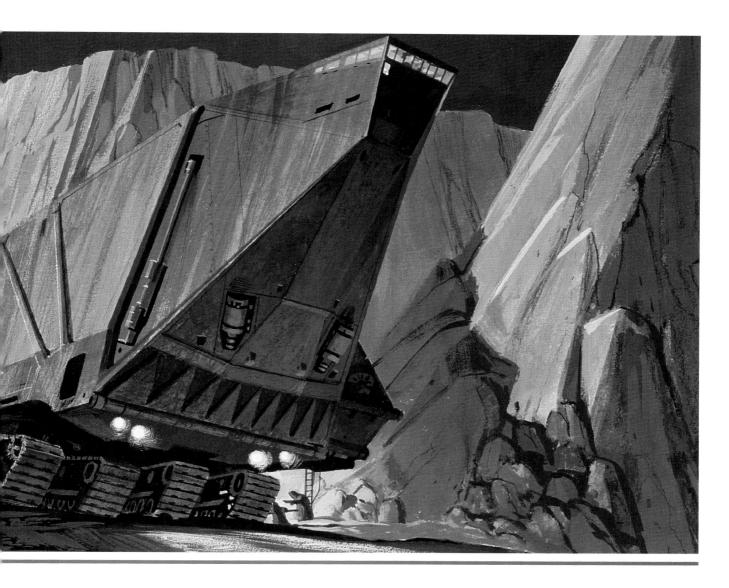

lean times. Legend has it that the Sarlacc may bear a rudimentary intelligence, and that it intentionally keeps its victims alive for a hideous sort of companionship even as it feeds on them.

uch as he enjoys feeding the Sarlacc, though, Jabba seems prouder still of his pet monster, the rancor, which he keeps in a slimy, dank pit beneath his throne room. The rancor is one of the most hideous beasts I have ever encountered, best described as a walking collection of fangs and claws, with no thought other than to kill and eat. Jabba frequently delights in plunging random cronies or unwanted guests through a trapdoor just to watch their death struggles.

After some time surrounded by the Hutt's weakminded cronies with their poisoned thoughts, I found myself being looked at with more and more suspicion. Everyone, it seemed, had plans in motion to kill Jabba, and the Hutt himself seemed able to resist some of my mind-muddling attempts.

When a passing group of chittering, hooded Jawas took their leave of Jabba's palace to continue their endless scavenging journey across the sands, I joined them in their sandcrawler. I was glad to get out of there, before Jabba fed me to his rancor just to see what color my blood really is.

After spending days in the fearsome cesspit of Jabba's palace, I found the company of the Jawas quite refreshing. The Jawas are a small-statured, rodentlike people, hardworking but eager to take advantage of any opportunity they spot. They have earned their place as Tatooine's master scavengers, salvagers, and tinkerers.

Our sandcrawler ground its way across the Dune Sea, leaving broad tracks across the sand. A team of hooded spotters stared out the narrow window high up on the pilot's observation bridge. With their

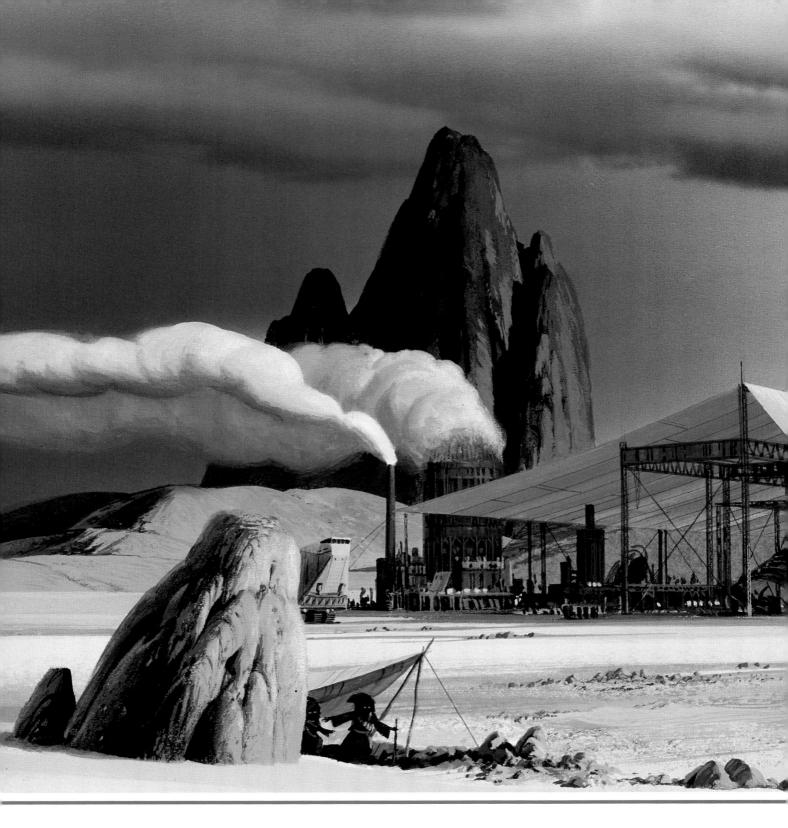

glowing yellow eyes, they searched for any usable garbage exposed by time and weather. After I had quickly assimilated their language, I heard some of the clan members speak of foolhardy Jawa family units that actually venture out during sandwhirl season, tracking the paths of the great storms to see what the winds and scouring dust uncover.

The Dune Sea is studded with the crashed hulks of spacecraft from centuries of warfare. Escape pods, shuttlecraft, attack cruisers, even luxury passenger liners have been buried under the desert. The Jawas find them.

One of their legends tells of a huge Old Republic water tanker that soft-landed out in the desert, its

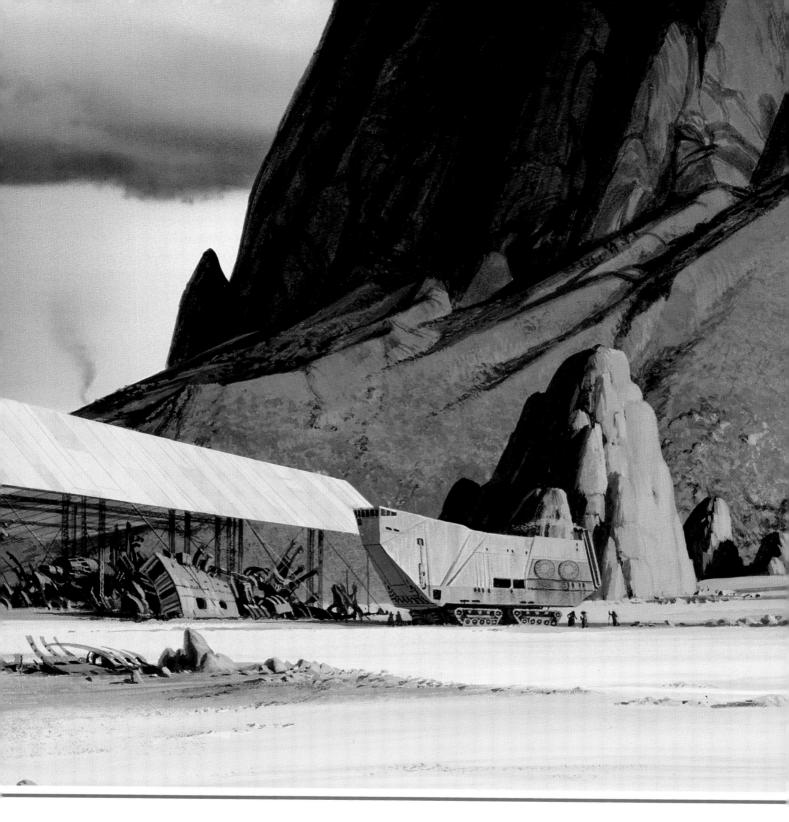

crew killed by a poison gas leaking from a cracked hyperdrive chamber. Any Jawa expedition that finds this wrecked tanker with its cargo holds unbreached would be wealthier than even Jabba the Hutt.

Jawa resourcefulness can be seen in their abilty to survive by picking over wreckage and debris long since discarded by other races. These little people The Jawas set up portable smelters to break down salvage they pick up on their travels. Such smelters can be dismantled in a hurry in the face of an impending sandwhirl storm.

can make workable devices from the most corroded components, the most battered engines.

Decades ago the Jawas took their sandcrawlers from a fleet of abandoned ore-hauler vehicles, left behind as junk from a failed mining expedition in the days before Tatooine was colonized. Each sandcrawler started out looking identical, but more than a century of repairs, embellishments, and quick fixes cobbled together from the engines and hull plates of other excavated wrecks has given them an individualistic appearance. The mechanical drives are steam-powered nuclear fusion engines, sufficient to propel the giant vehicles across the desert for centuries to come.

s an anthropologist, I found the Jawa social structure fascinating. About half of each clan spends time out in the sandcrawlers scavenging, while the remainder of the family unit lives in thickwalled fortresses erected for protection against attacks by Tusken Raiders or ferocious predators such as kravt dragons. The walls of these fortresses are made from large chunks of wrecked spacecraft, pitted and corroded by the desert winds.

Posing as a member of the Nkik clan, I made the journey from Jabba's palace in our sandcrawler. Over the course of the previous year, the vehicle had made a great circular sweep across the desert landscape, crisscrossing swaths across the empty wastelands, searching for any useful item. About half the volume of a sandcrawler is used for cargo space, storage areas to hold the junk the Jawas have managed to collect during their journey. The rest of the sandcrawler contains workshops where Jawas tinker with and repair their prizes.

Only a small amount of space is wasted on amenities for the crew and the pilot's compartment. The Jawas are expected to sleep six in a cabin the size of a closet. When not working, they strap themselves upright into coffinlike cubicles for peace and solitude—of which they need little because their family units are accustomed to being close.

Jawa sandcrawlers roam the edges of civilization on Tatooine. Emissaries from the family unit seek to barter with moisture farmers, trying to sell reconditioned droids, asking to buy malfunctioning

then fix and sell again,

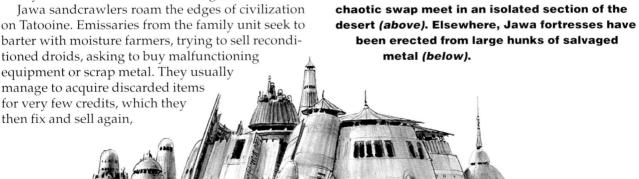

Each year, all the Jawa clans gather for a

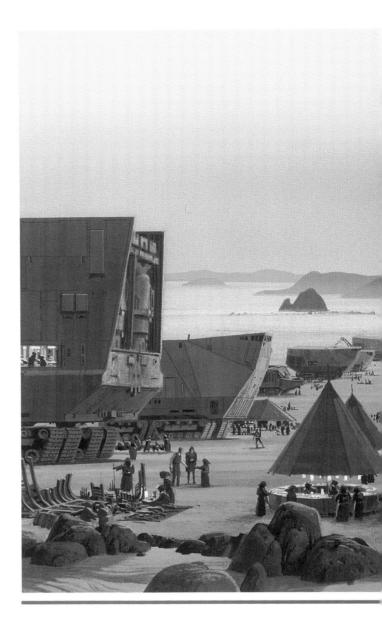

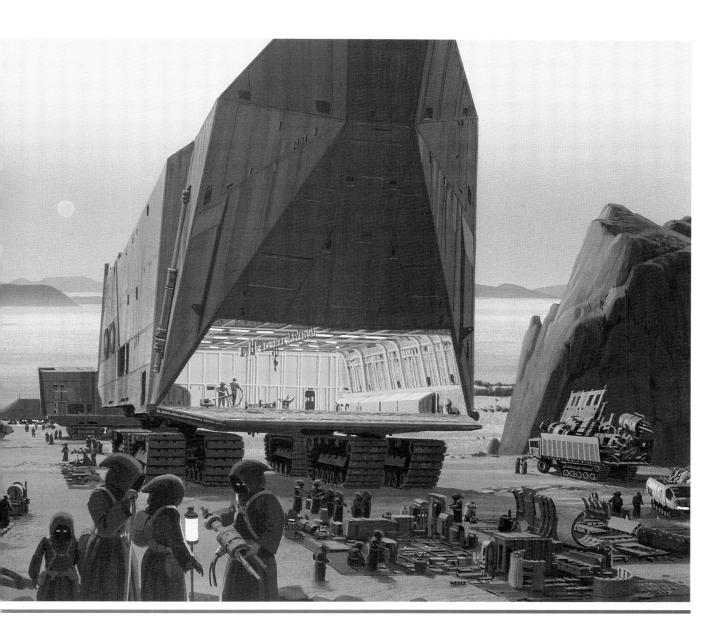

although I understand that humans do not like to deal with Jawas because of their offensive smell. Master tinkerers, Jawas know how to make their wares work *just enough* that they can sell them, knowing they will be long gone before an item breaks down again.

The Nkik clan seemed relieved to be leaving Jabba's palace, though, because of a grim incident that befell another group of Jawas. The Rkok clan foolishly unloaded a cargo of questionable merchandise on Jabba the Hutt, who was neither pleased nor forgiving. The Nkik clan later found the smoking hulk of their brothers' sandcrawler utterly destroyed out in the Dune Sea, with no Jawas to be found, only a few torn brown Jawa cloaks blowing

around the lip of the Great Pit of Carkoon. The stench of Jawa terror clung to the golden sands, and the hideous Sarlacc appeared to have feasted....

We spent days out on the desert, driving and searching, driving and searching, until finally we entered more rugged territory and suddenly came upon the family fortress. The sandcrawler spent days unloading treasures behind the safety of the thick fortress walls, where the rest of the family members sorted and assessed the wealth. I even deigned to help a little bit as I continued my observations.

While many of the sandcrawler crew members were proficient at repairing equipment, I realized that most of the true experts remained inside the fortress, working at the items the crew members could not fix. For truly unsalvageable debris, the

Jawas have highly efficient solar smelters to melt down the junk and process the raw metal into ingots.

Jawa society is tightly knit, with large family units spreading out along tangled family trees. In their chittering language, the Jawas have forty-three different terms to describe relations and lineage, such as *father's-sister's-son's-son-by-second-wife*, and so on. Bloodlines are carefully recorded, though, and Jawa families are not interbred; each family unit mingles its marriage line with other Jawa groups.

As I lived invisibly among them, I learned of an impending celebration, the greatest event in the Jawa calendar: the great swap meet. Once each year, just before the storm season, Jawas from across the continent make a pilgrimage to the great basin of the Dune Sea for a huge, secret rendezvous, "the greatest swap meet in the galaxy." Here Jawas exchange salvaged items, haggling and trying to outsmart each other. Jawas can find missing components to otherwise repaired items, tell stories, and even exchange sons and daughters as "marriage merchandise" with much dickering over bloodlines and how the family unit will be strengthened by the union.

Though I eagerly looked forward to this exciting opportunity to see Jawa culture in its purest form, my time among them was destined to be cut short by an exciting turn of events.

The Jawas are a skittish people, downtrodden and preyed upon by their enemies for as long as they can remember. Even in their heavily defended fortresses they post regular guards to watch for impending attacks—but unfortunately, even with the diligence of the Jawas, it turned out that the Sand People were stealthier warriors.

Appearing out of nowhere, it seemed, a Tusken war party attacked in the long shadows of first dawn, leading a thunderous group of banthas that rammed the crumbling walls until the armored plates fell away. The Sand People charged into the breach, wielding their long, sharp pikes called gaffi sticks. The banthas trampled the carefully sorted Jawa salvage material, and the Sand People howled as the panicked Jawas squealed and fled, making no attempt whatsoever to fight back.

The Sand People showed no interest in grabbing booty for themselves; they seemed intent merely on causing damage and maintaining the impression of fear usually associated with any mention of their vicious race.

I believed I had already learned much from the Nkik clan, and I doubted if I would ever again get the chance to spend time with the elusive Sand People. And so I became one, and followed the Tusken Raiders off to their secret encampments.

Because of the threat of attacks from Tusken Raiders (right), Jawas maintain tight security at their mountian fortresses. Sentries keep regular patrols at all hours of the day and night.

From speaking with the inhabitants of Mos Eisley and Anchorhead and the moisture farmer family, my impression was that the Tusken Raiders were called Sand People in a derogatory fashion, yet always the speakers' voices carried a hidden fear. The Sand People are violent, nomadic, and extremely mysterious. Roving in skilled hunting bands, they eke out a harsh life on the fringes of civ-

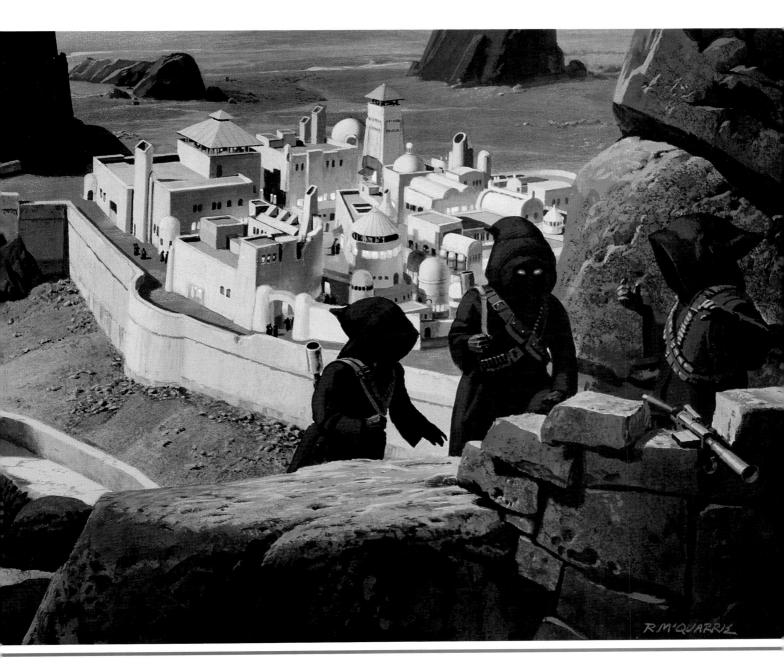

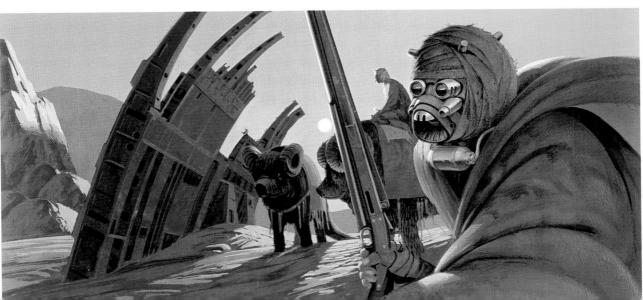

ilized areas, taking from the desert in good times, taking from other people in bad times.

Even as I departed the Jawa fortress with the victory cries echoing in my ears, I got the distinct impression that the Raiders sensed something amiss, though they could not pinpoint the source of their uneasiness. It took all my skill to divert their thoughts, and I knew then that this could be my greatest challenge—but ah, to be the first anthropologist in the galaxy ever to describe the Tusken Raiders from firsthand knowledge! It was a risk I was willing to take.

Tusken clans roam the deserts of Tatooine. The Sand People keep only meager possessions, which are considered a liability when they are moving across the burning sands, especially during flight from an enemy. The Tusken Raiders have built no permanent shelters, al-

though I followed them to a traditional encampment among the rocky badlands in the Jundland Wastes, in an area called the Needles. These caves and fissures in the hot rock are sheltering places for Tusken clans during the sandstorm season.

and People have no compunctions about killing anything in battle, hand to hand, with primitive weapons, because that is the bravest way to fight. Tusken Raiders prefer, however, merely to subdue a captive and take him as a prisoner back to the encampment. There they will use the captive as part of their vicious "sport" and to hone their skills at inflicting pain on an enemy.

Tusken Raiders ride in single file to hide their numbers, and even though the deserts of Tatooine are flat and featureless, somehow they manage to sneak up on their prey—no simple thing while riding a huge bantha or other large desert creature! They demonstrated this skill amply with their attack on the Jawa fortress.

Though they are nomadic and have no permanent settlement, the Sand People allow no change in their lives. This perhaps explains their resistance against adopting high technology and against adapting to the new weapons they have been able to take from the stormtroopers and the outlying moisture farmers. They

rely instead on their wits and their "traditional" weapons: their gaderffii, or gaffi sticks—double-edged spear-axes made from scavenged metal—and an occasional blaster rifle.

The more time I spent observing these strange people, the more I grew to admire them, in an analytical sort of way, of course. Their cultural heritage is rich and rigid, unchanged after many difficult centuries on Tatooine.

I learned how important "coming of age" is to the Sand People. Children are guarded by the adult

Tuskens, but youngsters are not considered truly "people" until they have endured the ceremonies that make them valuable adults. Many babies die because of difficult desert conditions, and the Sand People take great pride in knowing that only the strongest reach adult-hood—and fewer still sur-

vive the rigorous rites of passage.

To earn a place among the Tusken adults, a candidate must perform some great feat of skill or prowess, the magnitude of which determines his or her station among the clans. A common adventure involves ambushing stormtrooper squadrons and taking home their armor as trophies.

Tusken lore has it that four youths once banded together and single-handedly slew a krayt dragon without bantha assistance. Many other Tusken youths have attempted the same feat, with predictably gruesome results. Judging from the size of a single krayt dragon skeleton I saw atop a dune during my solitary journeys, these monsters must be formidable indeed.

The krayt dragons, usually found in mountainous areas, are the largest and most feared of all creatures on Tatooine. Krayt dragons continue to grow throughout their lifetimes, and they do not become weaker with age. At high summer each year, the mountains ring with the bellowed challenges of krayt

dragons. Upon hearing a nearby dragon mating cry, all wise people flee—because a dragon in such a frenzy kills everything within reach.

Tusken Raiders ride any serviceable desert beasts, such as the rangy creatures shown at left, to reach remote and uncharted encampments (above).

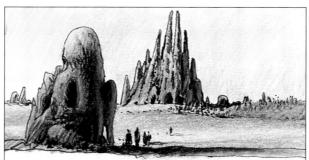

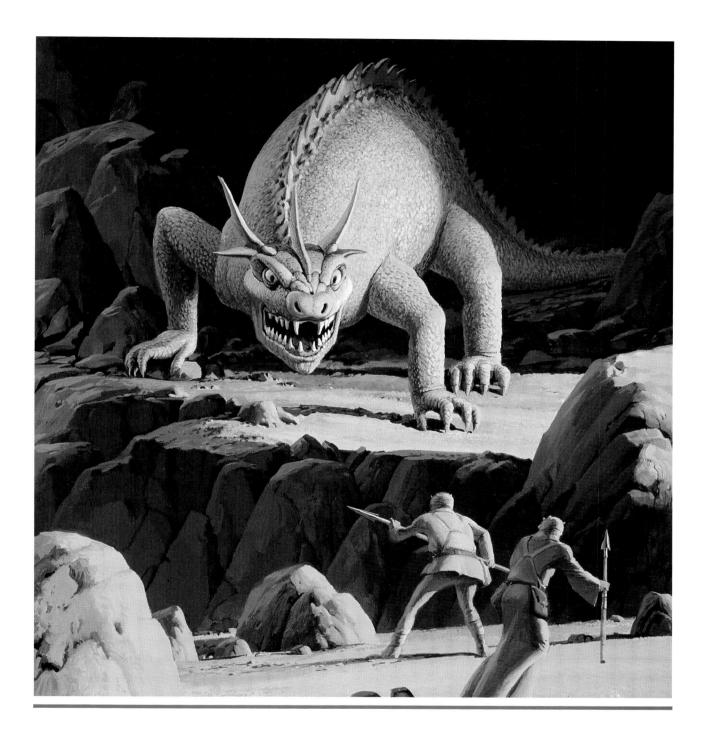

To prove their bravery, young Tusken Raiders try to hunt the krayt dragon, the most ferocious beast on Tatooine—perhaps in the entire Outer Rim.

From early childhood, the Sand People wrap themselves in ritual rags and protective gear. They wear loose and flowing robes, letting no part of themselves show. They see through eye filters protruding from their bandaged faces; across their mouths they wear breath masks to filter sand particles.

Tuskens make no distinction between males and females, and only the clan elders keep records of the sexes, so that they can arrange marriages. (As one can imagine, some rather embarrassing mistakes have been made, unfortunately.)

Once each year, all newly recognized adults are assigned mates. In a bonding ceremony that involves mixing the blood of husband and wife, and of their respective bantha mounts, they become joined for life. Sheltered in the privacy of their tent, the new

husband and wife are allowed to unwrap the bindings from their faces and view their true selves. Then, for the rest of their lives, only a Tusken's mate is allowed to know his or her true appearance. Matters of personal hygiene are attended to in the utmost privacy; one Tusken seeing another's face, even accidentally, is cause for a blood duel. I took great care to keep my distance.

uch to my amazement, I learned that the Sand People have developed a tight symbiosis with the huge, hairy banthas, an emotional bond stronger than any I have previously seen between master and beast.

Banthas may be intelligent, although in captivity they have never shown any signs of communication or behavior beyond that of a domesticated beast of burden. Wild banthas also show no initiative other than a kind of feral violence toward their captors. However, I was amazed to see that among the Sand People banthas act much differently.

Tusken children tend young banthas, but upon reaching adulthood, one Tusken and one bantha team up in a kind of deep emotional bonding, as strong as a marriage. It is as if bantha and rider become extensions of the same person. When a Tusken is killed, the suddenly "widowed" bantha will fly into a vicious suicidal frenzy; the same is true if a bantha mount is killed, leaving the rider alive.

If a bantha is left without its Tusken companion, the Sand People turn the bantha out into the desert to survive alone. Likewise, when a bantha is killed, the bereaved Tusken wanders off into the desert on a vision quest. There the Tusken must come to terms with the spirit of his bantha partner—if the bantha partner wishes to drag his companion into the afterlife, then the Tusken will die out on the sands. If, however, the bantha spirit guide is generous, he will lead the Tusken to another wild bantha, a riderless bantha, whom the Tusken will take back to the tribe as a new companion. When such a Tusken returns "reborn," he is much esteemed by the other Sand People.

Tusken Raiders have no written language, relying instead on long and complex chants to keep track of their lineage and of their legends. Handing their chants down from generation to generation, they remember the great and devastating space battles that laid waste much of Tatooine and strewed the desert with wrecked battleships.

The most revered person in the camp is the storyteller, whose duty is to retell the old tales, allowing no word to be changed. It is the storyteller who chronicles the coming-of-age stories of each mem-

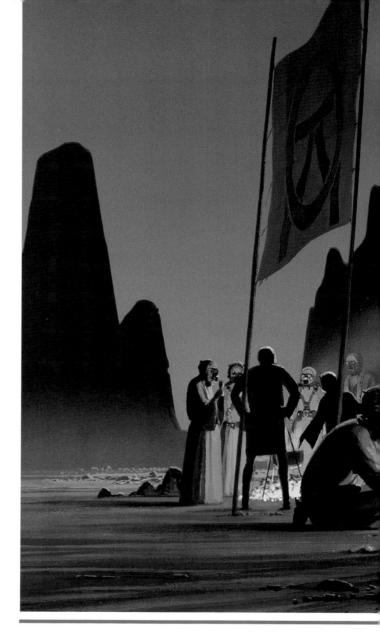

The most revered member of any Tusken clan is the storyteller, who speaks the old legends by firelight, never daring to alter a single word.

ber of the clan; once he tells the tale the first time, not one word is allowed to deviate—not ever. This practice, which may sound harsh, makes an anthropologist want to jump for joy because the records are preserved intact from generation to generation, without the distortion that comes from sloppy mistakes.

The storyteller takes an apprentice and begins hammering in the vast amount of verbal knowledge. The apprentice is not allowed to recite any of this, or to practice out loud—since the words may never be spoken incorrectly, even during the learning process. When the apprentice feels he is ready to become the master, he is called upon to recite what he has learned. If the apprentice makes so much as

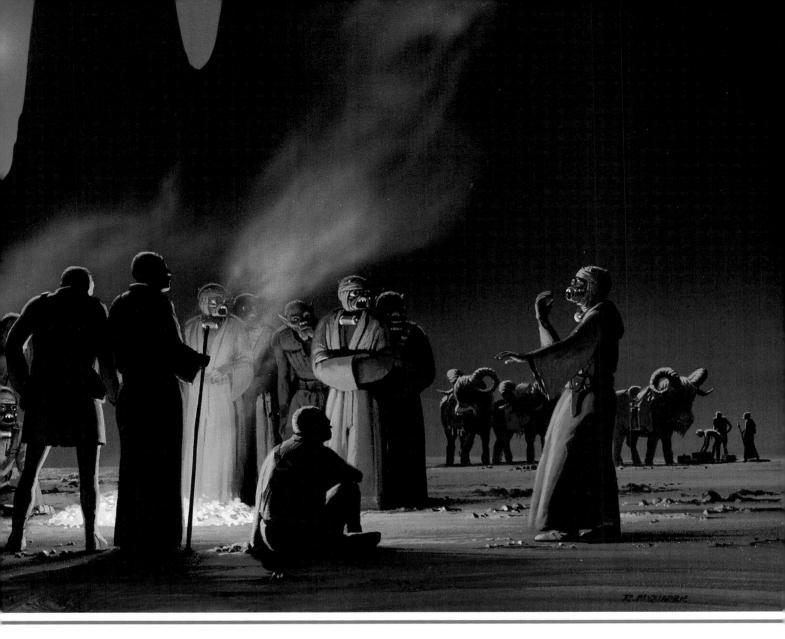

one mistake, he is killed outright—it is blasphemy to speak the wrong words. If, however, the apprentice has learned every word, every tale, every lineage, then he becomes the tribe's next storyteller—and the old storyteller, no longer needed, wanders off alone into the desert to die.

This rigid and violent people, however, proved more volatile than even I had anticipated. Perhaps I erred, or I asked too many questions, or my smell wasn't quite right, or the Tuskens just decided to kill someone that day—but I found myself fleeing across the desert with my disguise in tatters as Sand People charged after me on their banthas, waving their wicked gaffi sticks at me.

I had little hope of surviving, but I continued to run in dismay, greatly disappointed that all my newly uncovered knowledge would not now be published and available to my colleagues. Nevertheless, I fled to the best of my ability.

By sheer luck I stumbled upon a deep desert stormtrooper patrol and, as a desperate ploy, made them think I was a lost comrade. They fought against the Tuskens and rescued me, at the cost of three of their own party.

They brought me back to Mos Eisley, where I now sit in a cantina writing this account, waiting for passage out of the system and back to where I can begin the lecture circuit, describing my adventures on this harsh world.

There are plenty of ships at the docking bays, but I want to find one with a reasonably good chance of not falling apart as soon as it enters hyperspace. As time goes by, though, I am growing less selective, anxious to be away from here.

I have had enough of Tatooine!

IMPERIAL CENTER

CORUSCANT

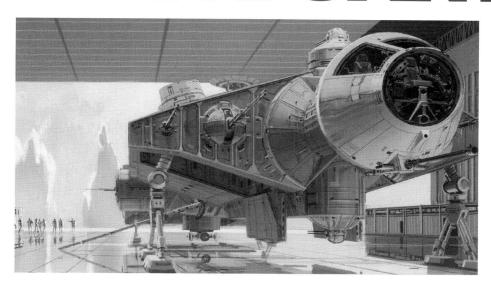

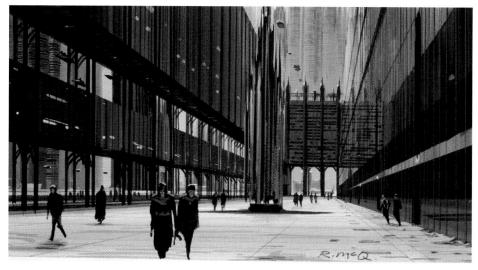

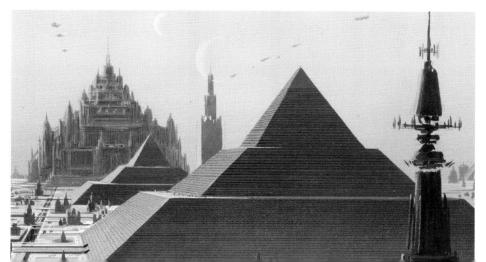

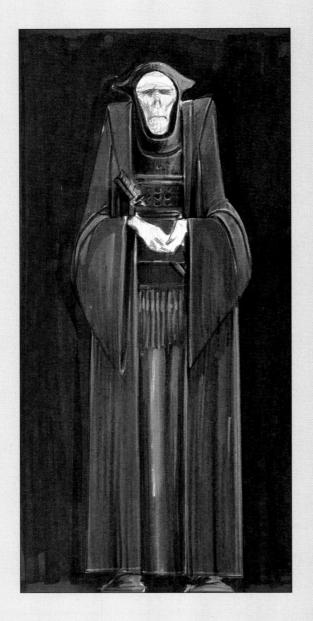

ABOUT THE AUTHOR:

Pollux Hax served for several years as chief of the Emperor's propaganda dissemination section.

We are honored to present this report exactly as Emperor

Palpatine wishes it published.

Being an enlightened man, the Emperor has read many articles on the cultures, life-forms, and land forms of other planets, the better to understand them so that his benevolent rule could be more attentive to the needs of his subjects. He commissioned Pollux Hax to write a similar article about the wonders of Imperial Center, which was called Coruscant in the days of the Old Republic.

We are pleased to present this report verbatim. Not one word has been changed from the original text.

CORUSCANT

he illustrious planet Coruscant, now renamed Imperial Center to reflect the progress of the times, has been the hub of the galaxy's government for millennia. Naturally, since Emperor Palpatine wishes to minimize displacement of his subjects, the planet continues to serve in this capacity, as it did during the days of the Old Republic and perhaps even before. The recorded history of Coruscant stretches back so far that it becomes indistinguishable from legend, and we in the Imperial administration are proud to be part of this continuing legacy.

Galactic governments have changed over the ages, but Coruscant has always been the center of power. Though poor in resources, the planet thrives on the changing tides of politics, providing a stable anchor through damaging rebellions, the long-overdue fall of the corrupt Old Republic, and the sweeping introduction of the Emperor's resplendent New Order.

fter many thousands of years of constant construction and expansion, Coruscant's entire planetary surface has been covered with layer upon layer of buildings, like crystalline growths on a rock. Por-

tions of the unending city have been rebuilt, demolished, and rebuilt again over the centuries. As part of the Emperor's new efficiency programs, not a square meter of space is wasted, and the people are happier than before.

The rooftop of virtually any building offers a truly breathtaking view unparalleled on any other world. Towering skyscrapers, built of transparisteel and smoked duracrete, stretch to the horizon like a great forest of structures built by hundreds of different architects, both human and alien. The city dazzles the imagination, and has rightfully been the subject of much poetry and music commissioned by the Emperor himself.

Many of the huge buildings are identical—nondescript and functional, population centers where people live, work, and sleep. Other gigantic constructions are wildly exotic, designed by alien minds accustomed to worlds with less gravity or other resources. At the tops of the skyscrapers lighted shuttle landing pads welcome visitors. Everything gleams, everything is clean. Never before in all of history has a city such as this existed.

Our planet is a interminable metropolis that twinkles with power systems, city lights, traffic landing beacons. Seen from

orbit, Imperial Center is a blaze of light and sparkling colors, reminding some spacers of gemlike corusca stones, after which this planet was named long ago.

Because of its importance in galactic politics, offworlders view an assignment to Imperial City as a marvelous opportunity to promote bureaucratic careers back on their home worlds. It is a challenging but rapid career path, with the rewards of a satisfying

career in civil service. The greatest minds are tempered by the stress, turned into valuable gems in the Imperial administration.

Other workers, unfortunately, succumb to "government fever,"

which catches them up

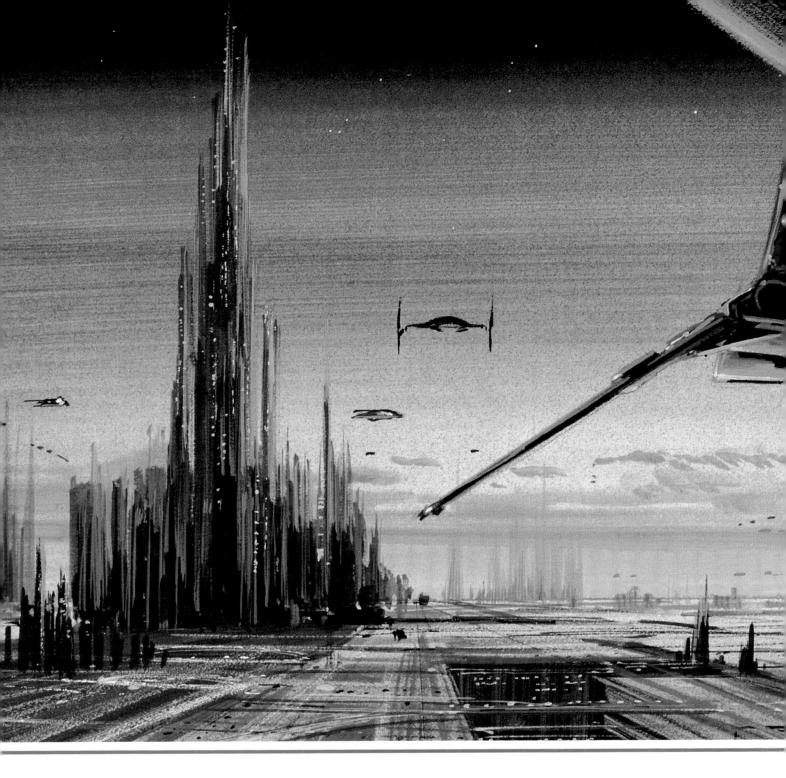

the demands of their profession . . . much to the Emperor's dismay, of course.

The buildings of Imperial Center are densely packed, with major thoroughfares slicing like deep canyons through the metropolis. Hawk-bats ride thermals flowing up from the bowels of the city, swooping down to prey upon granite slugs and other creatures that have adapted to survive on the vertical surfaces of the tall buildings. It is a magnificent sight to see these efficient and successful predators

attacking these destructive parasites on our city.

The complex terrain of towering metal and transparisteel pinnacles makes our weather difficult to predict, even with the best Imperial climate modeling routines. Occasionally, unexpected storms coalesce out of water evaporating from millions of rooftop exhaust vents, condensing and rising from the skyscraper forests, creating squalls that dump rain upon the hard surfaces of the buildings.

Each section of our vast, unending city has high-

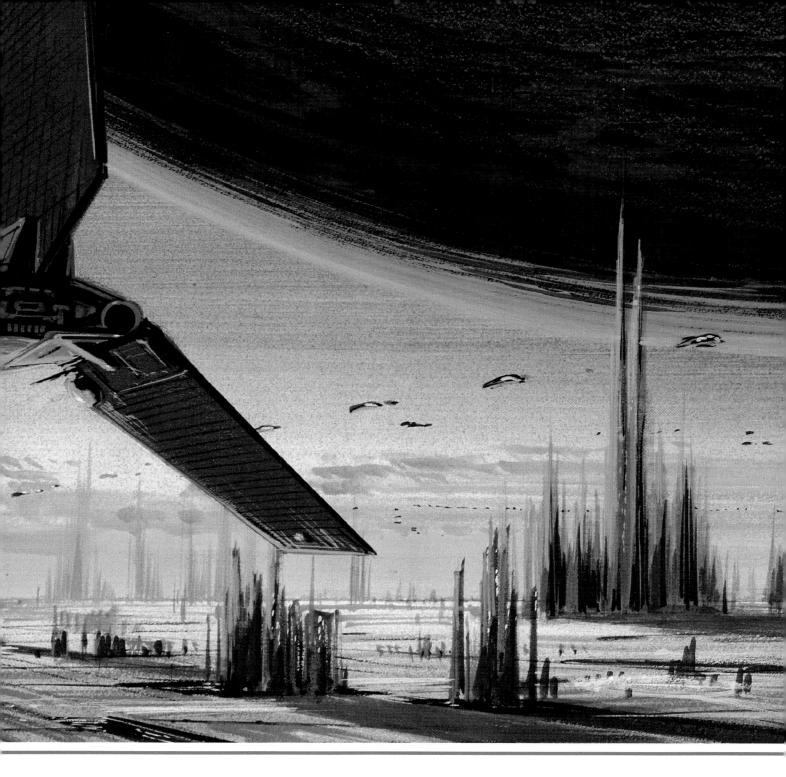

Cruising over Imperial City for the first time is a breathtaking sight, sure to cause awe and wonder in even the most inferior species.

(left) Imperial City rooftops provide convenient walkways and open-air meeting places for small assemblages with appropriate permits. Even taller skyscrapers rise like landmarks in the distance.

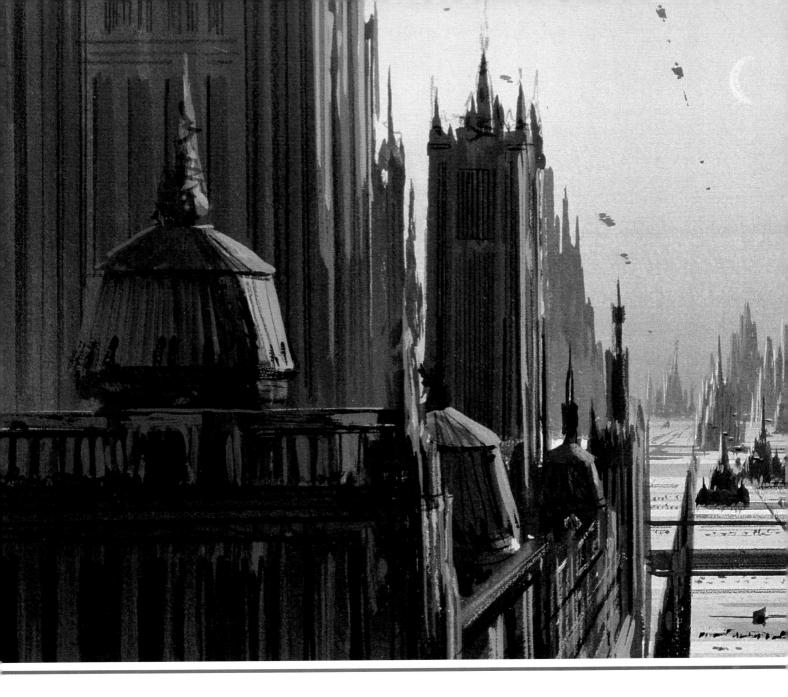

lights and attractions for visiting dignitaries and off-planet sightseers. The marvels of Imperial City are sung from planet to planet. Automated tourist stations provide information on cultural activities that cater to different interests. The numerous entertainment centers are clusters of bright lights and exotic pleasures ranging from the hedonistic to the enlightening and educational. No one has ever been disappointed with the spectrum of enjoyment available on Imperial Center.

or example, the Skydome Botanical Gardens rest on the level roof of an isolated skyscraper. Constructed by an Old Republic philanthropist who had grown rich by establishing the Galactic News

The greatest city in the galaxy extends from horizon to horizon. The rooftops are glorious (top), and the vertical levels seem to go to the core of the world itself (right).

Service (one of the more prominent news services that help disseminate all the information appropriate for the Emperor's subjects), this giant terrarium is a carefully tended place with compartmentalized environments to display exotic and otherwise extinct flora from those worlds that have sworn fealty to the Empire.

Tour droids, fluent in most known forms of communication, are available for hire, although special guide/guards are required for entry into our

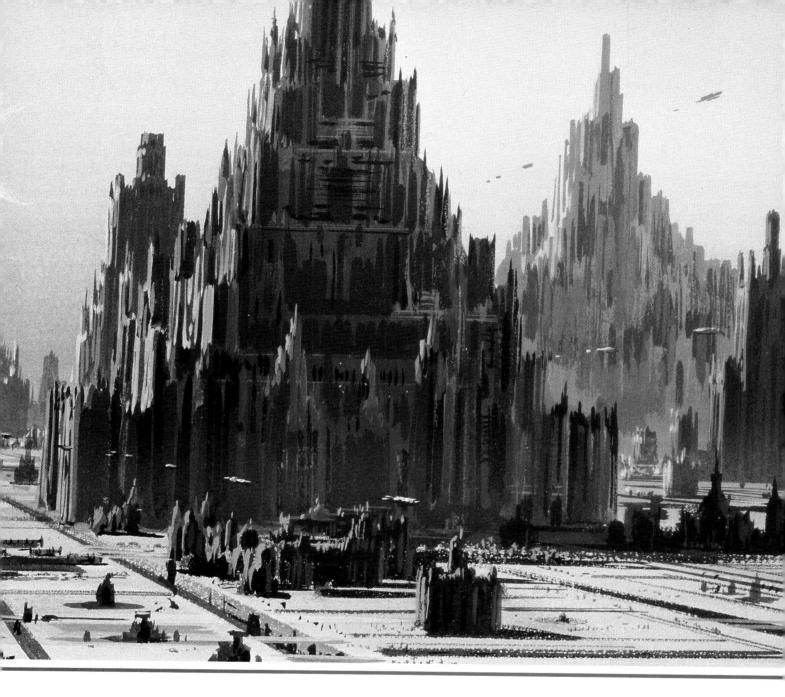

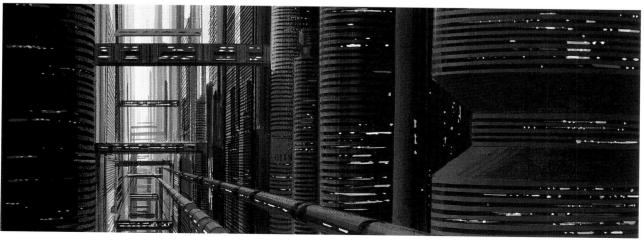

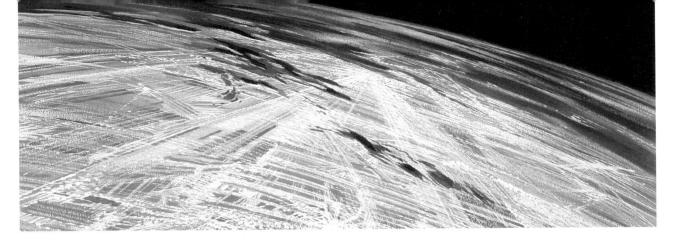

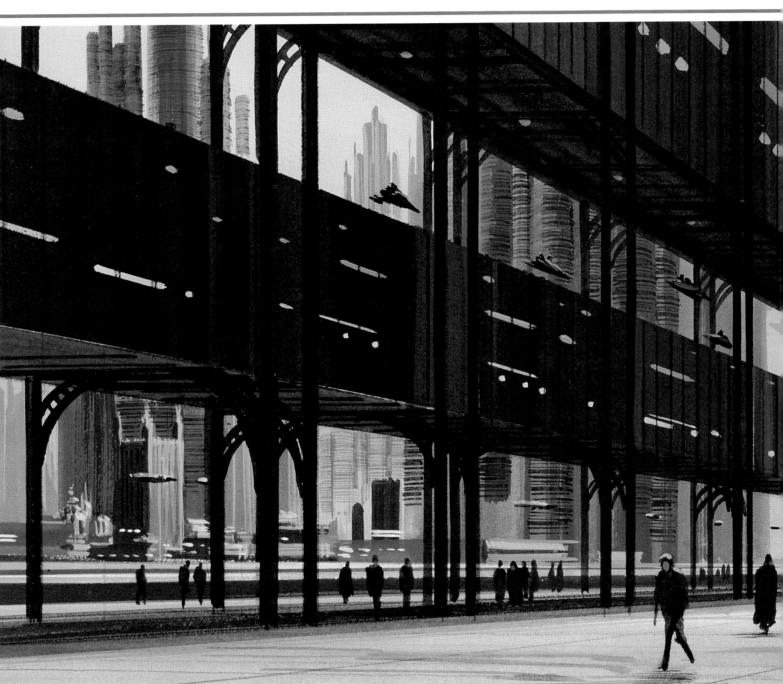

renowned Carnivorous Plants section. Because the Skydome Botanical Gardens are such a popular attraction, and because they are so near the Imperial Palace, the facility is often used for receptions thrown to honor important arriving diplomats.

Learned scholars from all corners of the galaxy come to study at the spacious Galactic Museum, which houses records dating back thousands of years, through the stages of the Old Republic, preserving artifacts from lost civilizations. Popular displays in-

clude relics from the Sith culture and tokens of the old order of Jedi Knights. Though the Emperor has been forced to eliminate funding for the museum, due to costs incurred in snuffing out the damaging

Seen from space, the planet Coruscant gleems like a brilliant corusca gem, from which it draws its name (left). In the street levels (below) open-air mezzanines offer Imperial-approved cultural opportunities.

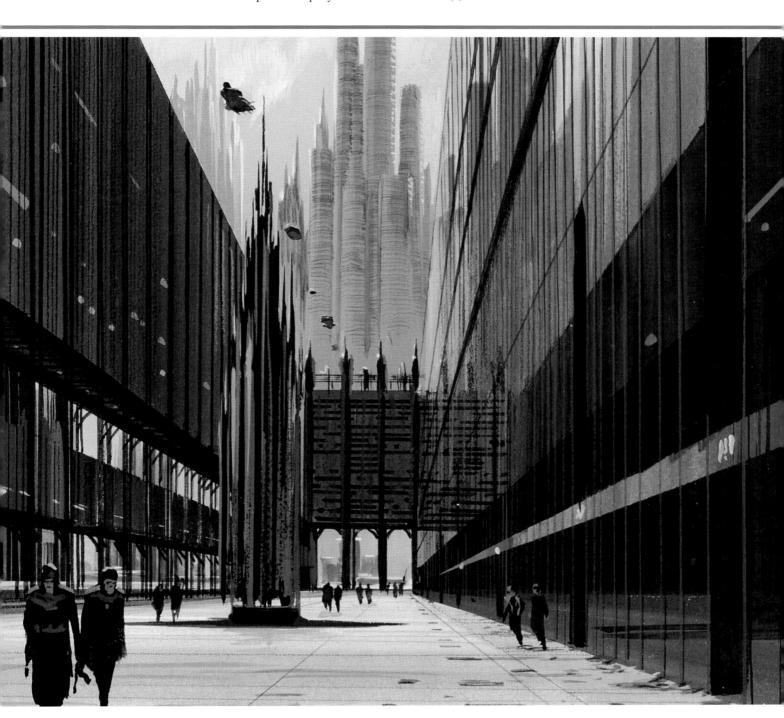

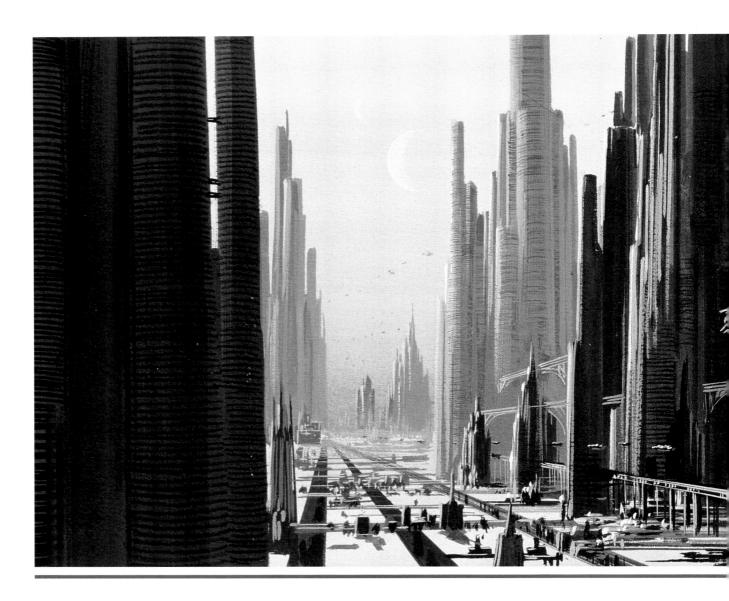

rebellion against his rule, he has given his verbal support for the museum to continue to preserve the heritage of his subjects.

Another of Coruscant's popular attractions—built during the days of the Old Republic so that now it appears rather dated and rough at the edges—is the Holographic Zoo for Extinct Animals. Inside a labyrinth of small chambers, dramatic three-dimensional dioramas are projected, showing spectacular (perhaps even fanciful) life-forms from other planets, such as the mammoth krabbex, the manticore, and the singing fig trees of Pil-Diller.

A recreational area frequented by the civil servants and other planet-bound inhabitants of Imperial Center is Monument Park—a protected mall built around what was once a tall peak in the Menarai Mountains visible from the Imperial Pal-

Skylanes and transit systems provide for rapid travel and efficient courier traffic on important Imperial business.

ace. Since practically every square meter of land on the planet has been built over, Monument Park gives the people a chance to touch the naked ground.

Layers and layers of construction have erased most topographical features from view, but the single jagged outcropping of this one mountain peak still protrudes from the surrounding buildings, to the amazement and delight of all. Emperor Palpatine himself often goes to this place for his own solitude and communion with nature.

A small group of meditative religious followers has made a shrine of the rock outcropping, however, protecting it from souvenir gatherers who might chip off a flake of stone as a memento to take

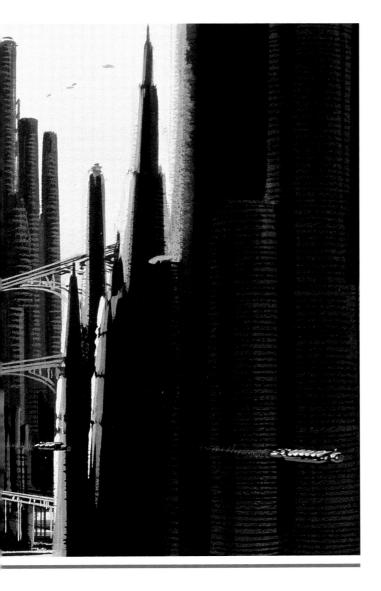

back to their crowded cities. The meditative followers stand vigil around the mountaintop, touching the living rock and communing with the sleeping core of Coruscant. From the bare stone they attempt to draw a reminder of the peace and serenity the world experienced before the sprawling cities. The Emperor, naturally, tolerates all such forms of religious expression.

Some libelous and illegal reports have claimed that the Emperor has a clear prejudice against nonhuman species, but this is demonstrably not true. Sentient beings from the Empire's arctic worlds make their homes in the planet's colder latitudes, while aliens from hotter tropical worlds live closer to the equator. Species accustomed to subterranean settings inhabit the lower, shadowy levels of the Imperial Center's huge buildings.

To understand the depth of the Emperor's tolerance, one needs only to observe the cultural areas he has allowed to exist in segregated parts of the city. In carefully bordered sectors designated for particular cultures and life-forms, these honored non-human visitors can live their lives as they would on

The architecture of Imperial City is as varied as the species serving the Empire, from open-air stadiums for every citizen to hear important speeches (below left) to information exchange and confidential intelligence centers (below).

(pages 58-59) The night life in Imperial City is renowned throughout the galaxy. Regular security patrols ensure that everyone has a good time.

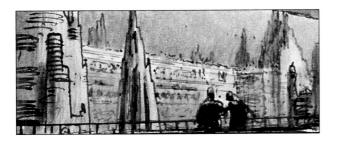

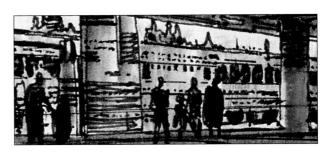

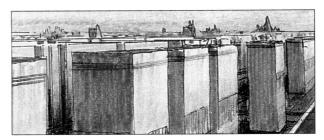

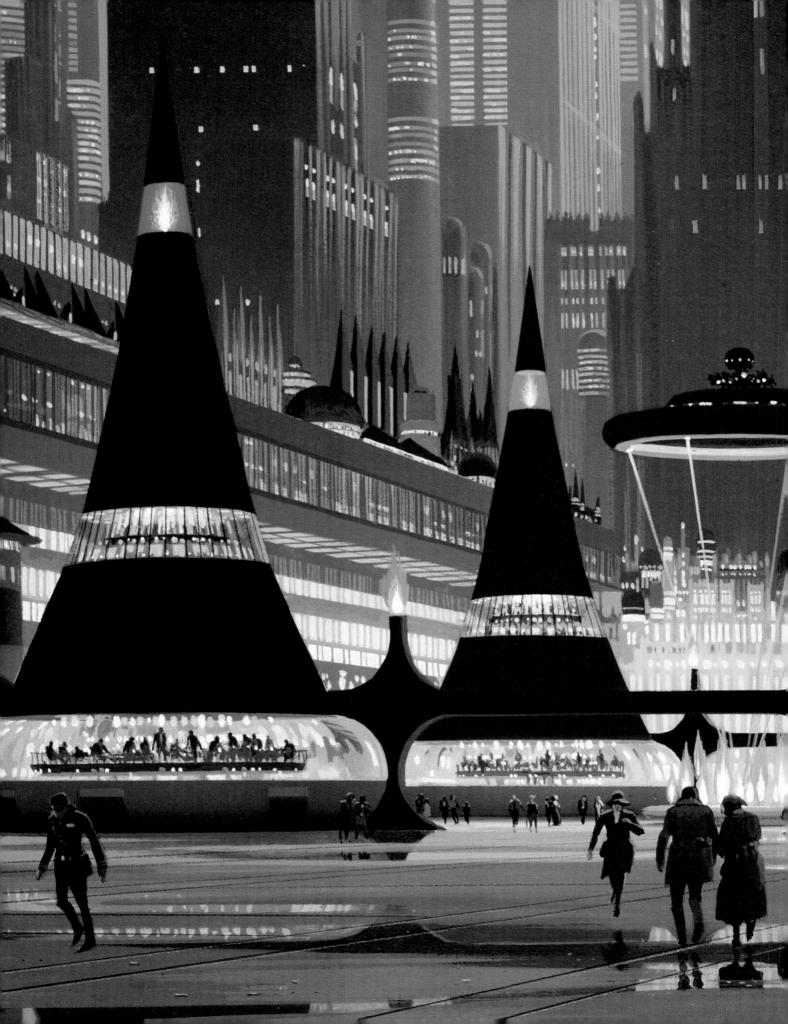

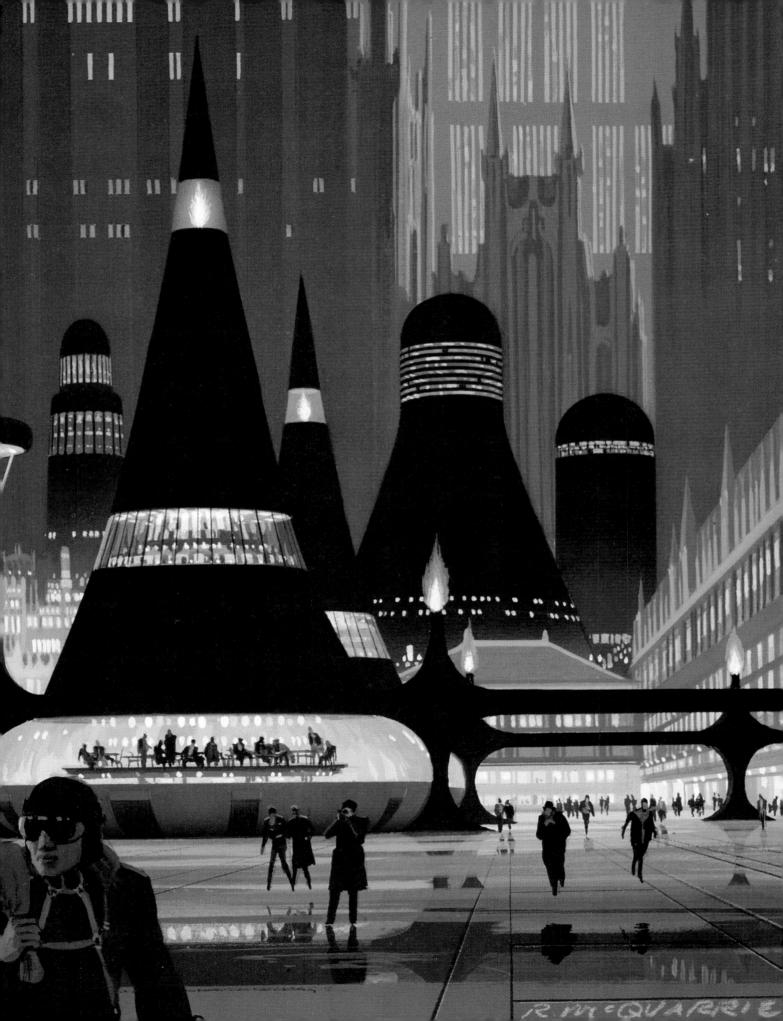

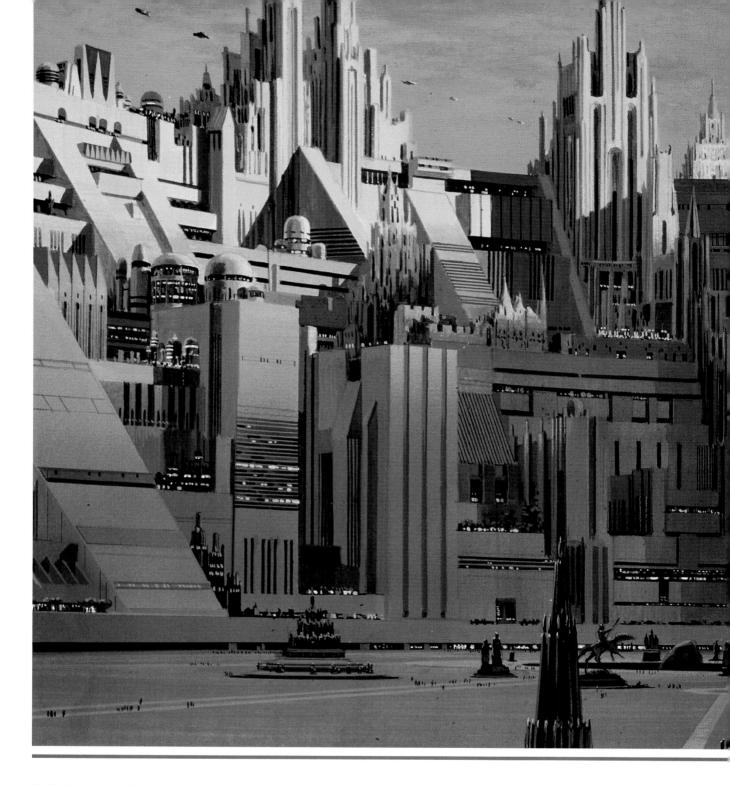

their homeworlds. There they are protected from the hazards of genuine prejudice by guardian contingents of stormtroopers who patrol the borders of the alien sections.

rchitecture varies to reflect the different cultures and their social preferences in colorful pockets of "ethnic neighborhoods" like charming islands in the midst of Imperial City.

Often these alien neighborhoods are dominated by tall statues erected to honor offworld heroes and planetary legends from other parts of the galaxy. Humans are frequently confused to see towering monuments of bizarre multilegged heroes riding equally bizarre mounts in these permanent reenactments of unforgotten glory.

Unfortunately, due to the extended diplomatic families and retainers from alien planets who do not

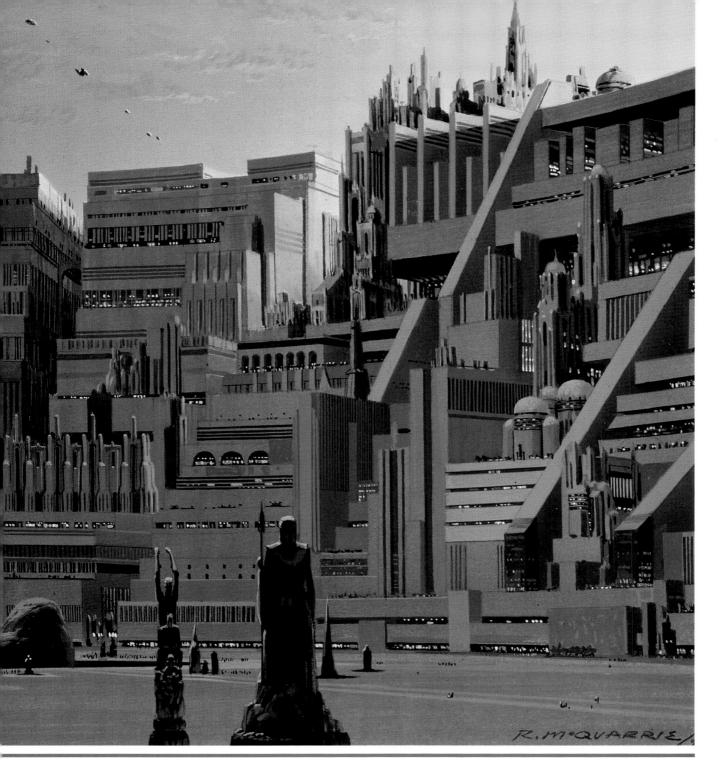

Monument Plaza—one of the gems of Imperial City, where visitors can actually touch bare rock, which was once on a mountaintop.

The approach to Monument Plaza is a cavalcade of quaint ethnic banners and memorials erected by stubborn races who still attempt to retain their individual identities.

understand Imperial customs and rules, many personal squabbles erupt. The Emperor has brought in crack squadrons of stormtroopers to quash any such short-lived disturbances.

As part of his New Order, the Emperor has abolished the outdated Old Republic concept of diplomatic immunity. All troublemakers are responsible for the problems they cause, and disobedience is dealt with sternly. We are proud to note that there are very few repeat offenders. Thanks to the protective stormtrooper presence, Imperial City is one of the safest places in the galaxy.

ecause the surface of Coruscant has been completely built over, resources and food are a precious commodity, and our people work together to make the whole system function efficiently. Transportation and delivery systems have been perfected,

out of necessity. Giant thoroughfares carry shipments continuously and at high speed, distributing needed items throughout the planetwide city. These shipments are generally shuttled through the lower levels of the metropolis, where they will not disturb the more important government officials.

New raw materials are brought down from asteroids on the fringes of the Coruscant system, as needed. Heavy lifters drop the massive rocks down through the atmosphere—but this is an extremely expensive way to get new supplies of metals for underground processing stations.

Instead, the people of Imperial City have developed closed-loop ecosystems inside their giant buildings. Major recycling efforts have resulted in an efficient operation monitored by multiarmed droids, sorting through the garbage of Imperial Center to select out even tiny scraps of useful material.

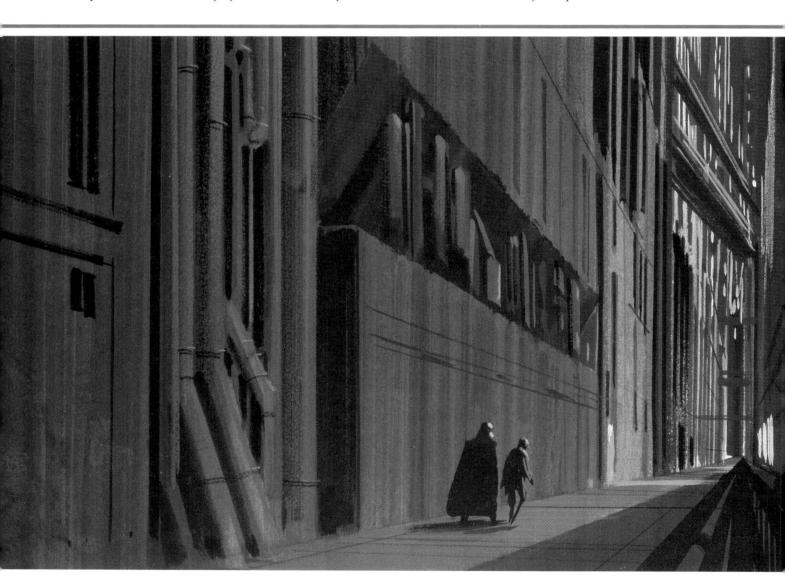

A metropolis as large and as old as Imperial City is in a constant state of urban renewal. Central planners in the Imperial Palace monitor the decay of old buildings and sections of the city. One entire central computer is devoted to updating and maintaining a master plan of the world-city. With our constant vigilance and preplanning, we have made Imperial Center the envy of all urban areas in the Empire.

n Coruscant, enormous walking factories—construction droids—wade through older sections of the city designated for renewal. These construction droids are fully as tall as the skyscrapers themselves, moving at a ponderous pace. Both the front and the back ends of these machines are a blur of moving mechanical arms, conveyor belts, demolition equipment, and sensors.

A construction droid tears down a condemned

building in front, shoveling the debris into its vast furnaces and material sorters, where useful items are extracted, recycled, and smelted. The corresponding factory on the opposite half of the droid extrudes new girders and transparisteel sheets. The rear side of the droid assembles a brand-new building from a preprogrammed blueprint while the front side tears down the ruined hulk. As these independent construction droids march through old sections of the city, they leave in their wake a gleaming swath of polished new skyscrapers.

Only rarely has it happened that the directional

Only rarely has it happened that the directional sensors of these droids have malfunctioned, causing them to rip the wrong buildings apart, much to the dismay of the unfortunate inhabitants.

Dedicated Imperial functionaries are given the task of delivering the proper eviction notices to those still living within condemned structures; re-

> ports that these notices are often misdelivered, or not delivered at all, are grossly exaggerated. While it is true that occasionally people have had to flee as their building began to topple into wreckage around them, there are no casualties on record resulting from this inconvenience.

> urrounded by immense buildings, the deep lower levels of the city entrap air and create a sheltered microclimate. Moisture rises partway into the air up the sheer sides of the skyscrapers, condensing into small clouds, then drizzling a mist of lukewarm rain back down into the murk. Convective wind whistles through the narrow, buildinglined canyons.

Deep in the lower, forgotten levels, in the oldest subbasements of ancient buildings, an entire shadowy culture has developed. Coruscant's underworld is dank and oppressive, never seeing the sun or the night sky because of the looming shadows of kilometer-high buildings. Low-flying shuttles traveling near ground level must fly with all their running lights on and weapons powered up. Otherwise, the underworld is never traveled alone.

The shadowy streets of Imperial City's underworld were once a dangerous haven for criminals and fugitives, but the Emperor has stepped up efforts to clean up the lower levels.

ome have said that down here the Emperor keeps private detention centers where black IT-0 interrogation droids extract every scrap of valuable information from a victim. It is time to put these rumors to rest once and for all. The Emperor has no need of such barbaric practices, and he has no need to keep secrets.

Because all space traffic to and from Imperial Center is tightly controlled, many criminals flee to the lower levels to escape the Emperor's justice: bureaucrats who have made a fatal mistake in their paperwork, ambassadors from a planet reprimanded by the Emperor, even clumsy personal servants from the Imperial Palace...all vanish into the lower levels, where, amazingly, they think they must hide for the rest of their lives.

Judging from signs found by stormtrooper commando teams, these clever fugitives have established a tolerable lifestyle by revamping some of the abandoned underbasement rooms, tapping into elec-

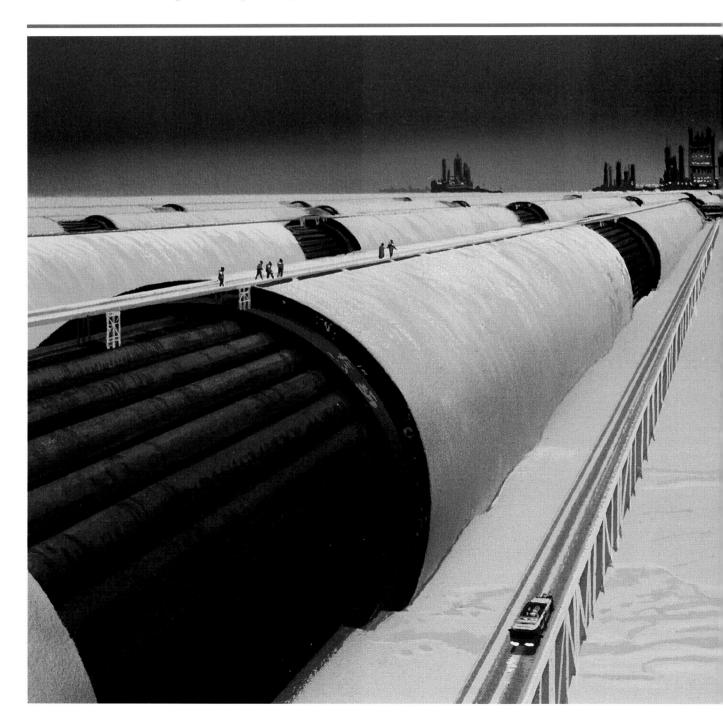

trical conduits, and stealing energy from the Imperial Center power grid. They have formed their own pathetic civilization from scraps of the shining world that has been forever forbidden to them.

We believe there may even be descendants of exiles from the Old Republic who do not know that the political order has changed for the better, that the Emperor's New Order has replaced the corruption and unpleasantness. Emperor Palpatine would welcome these refugees with open arms if only they would return and ask his pardon.

These poor people know no other life, not even in their imagination. Living like troglodytes, sleeping in abandoned alcoves, these shaggy semihumans have never seen the sun. Clothed in tatters, they walk

Coruscant's water needs are met by huge pipelines carrying melted ice from the polar caps of the planet.

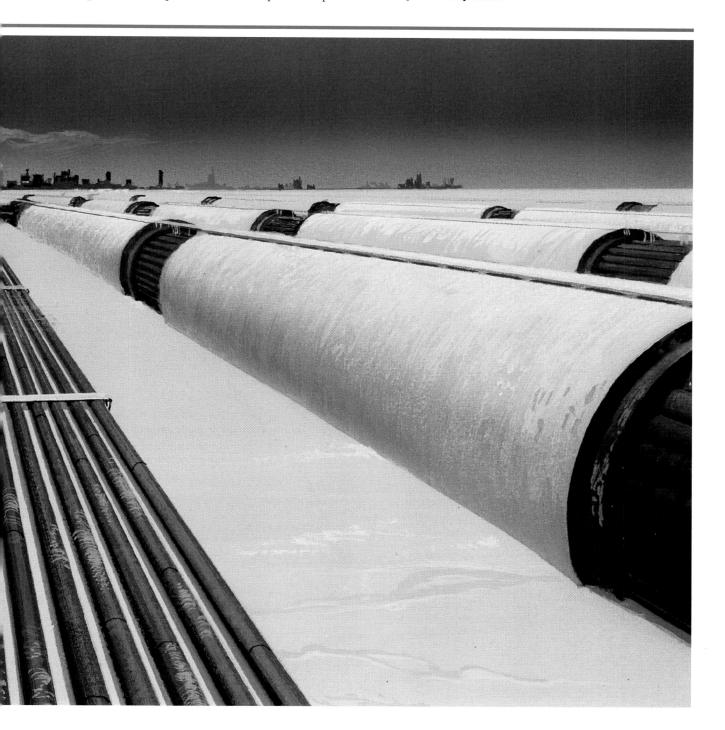

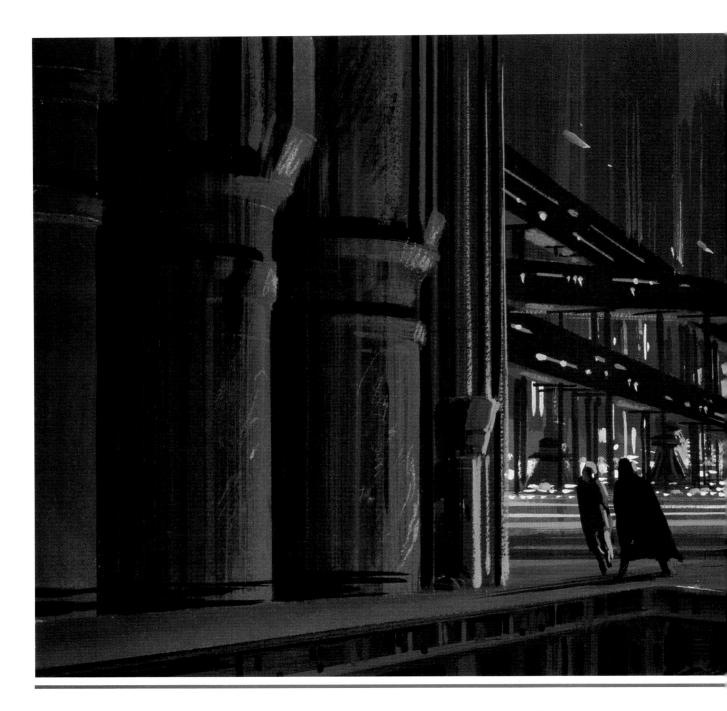

hunched from bone diseases and nutritional deficiencies; their skin is clammy and corpse-white. The Emperor's benevolence would extend even to such unproductive members of society, but the troglodyte specimens flee and somehow manage to elude all attempts to capture and reeducate them. Several troglodytes—unfortunately killed during capture—have been preserved and are now on display in the Galactic Museum.

The inhabitants of the underworld must live on scraps, or harvest the fungus that grows in the sod-

den shadows. Duracrete worms, shadow-barnacles, and granite slugs also inhabit the protected corners of the underworld.

arger creatures, too, have made their homes in the forgotten tunnels, including gigantic mutated rodents that will attack and eat anything they can find—whether it fights back or not. The troglodytes must occasionally hunt these rat-things, then eat the flesh raw or sizzled on a burst-open power coupling. Before any of the automatic mainte-

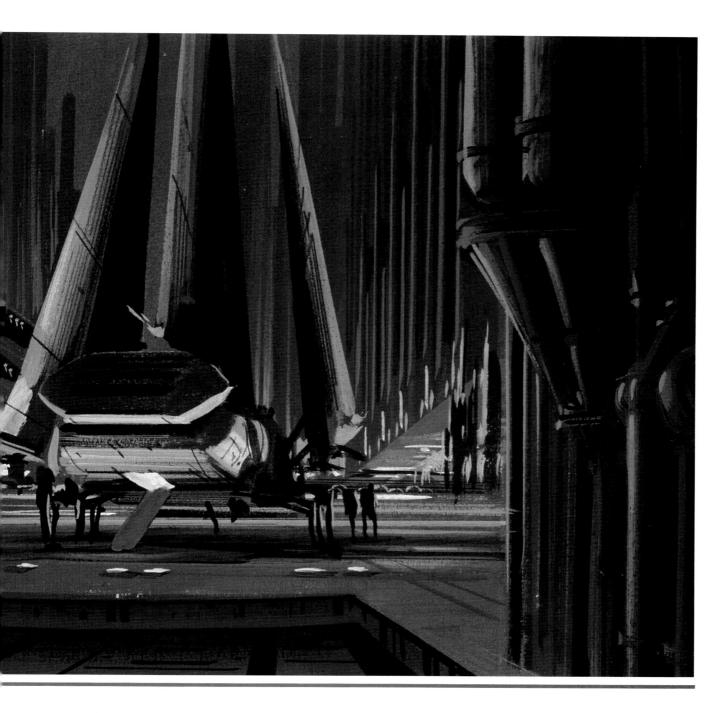

nance/repair droids can come to fix the ruptured power coupling, though, the troglodytes vanish into their hiding places.

Our failure to bring these poor people back into the fold of society remains the Empire's great shame.

The Imperial planet is too far from its small white sun to have a climate truly comfortable to humans, which leaves even the temperate zones of Coruscant rather cold and bleak.

However, because of our technological advances,

The bustling shuttle ports in all parts of the city are busy day and night, transporting valuable diplomatic personnel.

the vast, self-contained metropolis is mostly immune to the climate outside. The attitude of most inhabitants is that Coruscant exists for the business of government, not for vacations and sunbathing and sightseeing...although many facilities have sprung up by necessity, simply because of the sheer numbers of people assigned to Imperial Center.

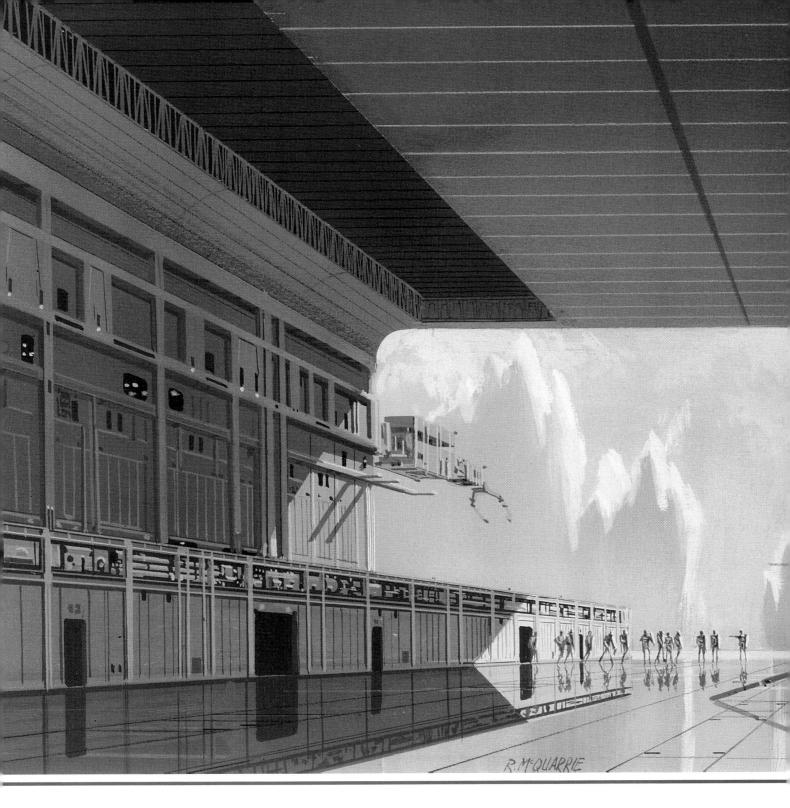

The most spectacular show in the night sky is the flaming veils of aurorae in shimmering gray-green and red curtains. The enormous amount of space traffic to and from Imperial Center continuously dumps residual field discharges and broken debris into orbit around the planet, energizing the aurorae even when Coruscant's sun is not in one of its active phases.

The densest population centers are clustered around the temperate zones, as are the main business areas, political centers, and commercial hubs. Unsightly manufacturing and industrial facilities have been relegated to the less habitable zones, or beneath the planet's surface.

The extreme northern and southern areas are great plains of crystal and metal buildings covered

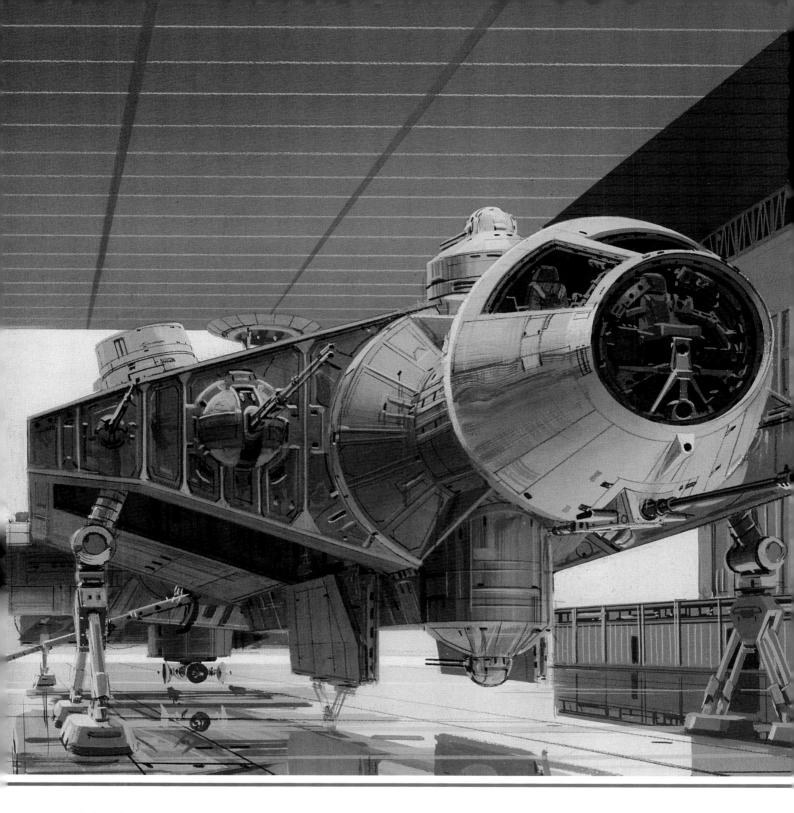

with hoarfrost. Plumes of steam curl upward from heating and ventilation systems. Transportation conduits from the northern to the southern areas of the planetwide city are so efficient that people can live near the arctic circle and attend weekly meetings at the Imperial Palace.

The polar caps are the planet's only water reservoir. All inland seas and oceans have been drained

Rooftop landing pads in the tallest skyscrapers of Imperial City receive shipments of matériel and duly acquired items of tribute to the Emperor.

and consumed over the thousands of years of overpopulation, leaving no other water than what is locked inside the ice. Large stations have been established on the rim of the ice shelves, with huge

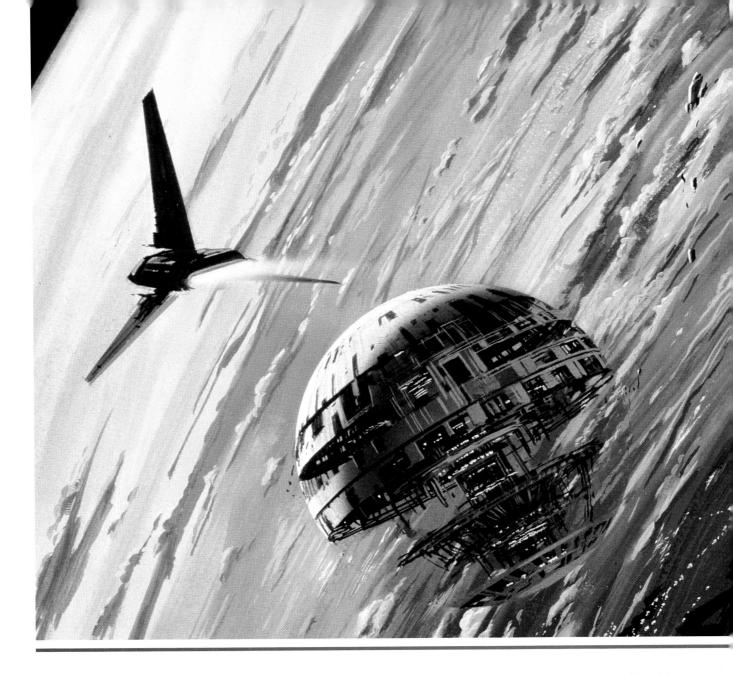

mechanical borers to mine the ice, self-contained furnaces to melt it, and an intricate network of pipelines to distribute the recovered water. Our amazing recirculating systems and purification facilities connected to the plumbing labyrinths allow for recycling of the vast majority of water used, so that the polar ice caps are only slowly becoming depleted. The Emperor has appointed a powerful commission and workgroup to study this problem.

on the other end of the spectrum, at the planet's equator most of the upper levels of the metropolis are glassed-over greenhouses devoted to agriculture. Fully automated, the agricultural roof-land-scapes glint with brilliant reflections visible even from orbit. Our planet is by no means self-sufficient, but the Emperor does what he can to minimize the

amount of food and water required from offworld, so that his subjects can keep the fruits of their labor for their own enjoyment and the strengthening of their planetary economies.

The orbital activity around Imperial Center is a constant blur of shuttles arriving and departing, weather and communications satellites, starship construction yards, and military staging areas. The space navigation systems used by every ship in the galaxy are based on the coordinates of Coruscant, defined as zero-zero-zero on all recorded maps.

Pumped up on stimulants and mind-focusing drugs to improve their personal efficiency and to minimize human error, space-traffic controllers crowd around giant holoprojections. These teams monitor the location of each vessel or large piece of debris, tracking its path in a complex intercon-

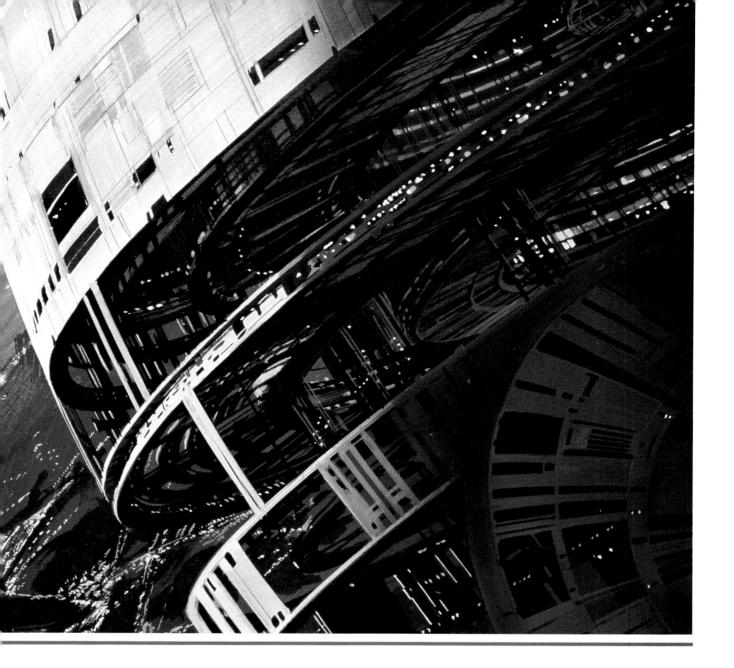

nected dance that brilliantly keeps the traffic flowing smoothly while avoiding collisions.

Orbiting climate-control mirrors focus sunlight on the extreme northern and southern latitudes of the planet, warming the environment by a few degrees to make more of the land area hospitable. These mirrors are usually monitored and piloted by low-ranking Imperial Navy troopers sworn to do even this grueling duty. Among troopers, "riding the mirrors" is considered the loneliest, most tedious assignment on Coruscant, but all are happy to serve the Empire in whatever capacity they are needed.

Spidery docking and starship repair yards ride high above the planet, providing reconditioning facilities for the largest of spaceliners. Spherical selfcontained colony vessels, Imperial Star Destroyers, and huge luxury yachts are built in the space-dock Coruscant's space construction platforms are remarkable examples of Imperial industriousness. Here giant-size habitation spheres are designed and assembled strictly for peacetime purposes.

centers. The Emperor has commandeered other, more sophisticated space construction centers in other systems, notably the Kuat Drive Yards and the Rendili and Loronar space construction facilities, for assembling his largest battleships and special weapons platforms.

The most prominent building on the face of Coruscant, indeed the centerpiece of the entire gleaming city, is the Imperial Palace.

The Palace stands like a hybrid cathedral and pyramid, rising higher than any other structure on

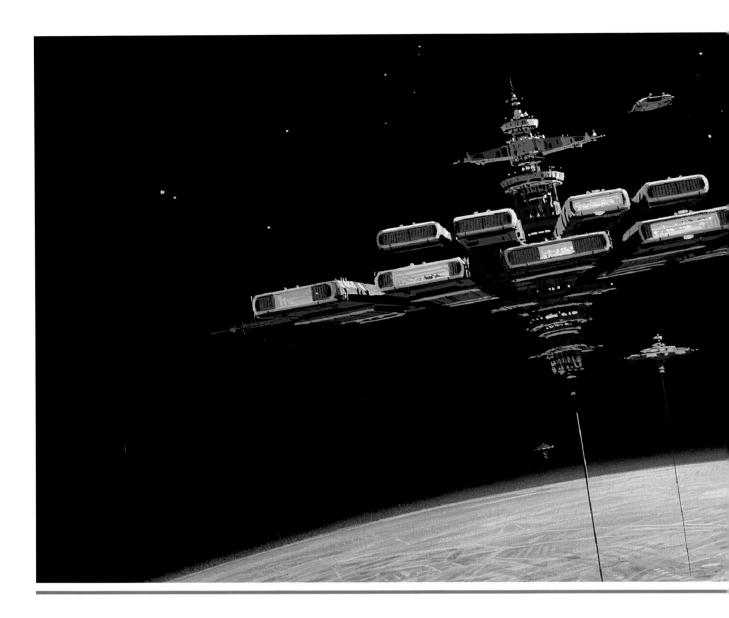

the planet. Its tallest spires reach up into the rarefied atmosphere, occasionally sparking discharges from the hovering aurorae in the sky. Made of polished gray-green rock and mirrored crystals, the home of Emperor Palpatine sparkles in the hazy sunlight, a fitting example of the glory of our leader.

ven in the deepest hour of night, the Imperial Palace never grows dark. Blazing illumination from phosphorescent panels, glowspheres, and electroluminance strips keeps the Palace in a shower of shifting light up and down all the corridors.

After Senator Palpatine took on the cowl of Emperor in the crumbling days of the Old Republic, he decided to show clearly the enormous difference between his New Order and the stagnant, thousand-generations-old Republic. The Emperor programmed

Communications and surveillance stations keep an ever-vigilant eye on the populace below, making every citizen feel safe and cared for.

construction droids to tear down portions of the ancient Presidential Palace and ordered it reconstructed and "enhanced" as a new facility. His Imperial Palace was erected in record time.

The Palace is enormous, with some of its open areas large enough to house a *Victory*-class Star Destroyer. The Palace looms high over the old Senate Hall in an adjacent sector of the city—and the Senate Hall itself towers over everything else on Coruscant.

Within the cyclopean palace, the Grand Corridor is like an enclosed canyon, populated by thousands of bureaucratic functionaries, diplomatic runners,

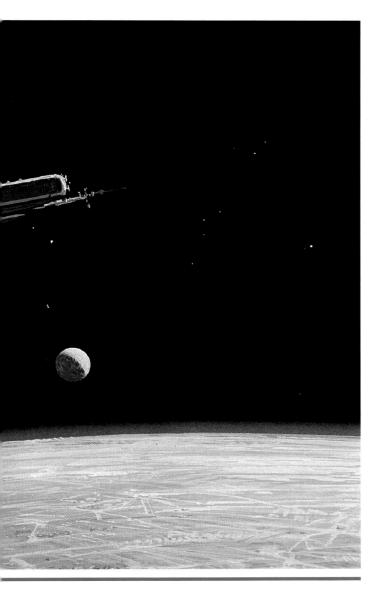

staffers, and ambassadors of all races and species, as well as specialized droids of many fantastic configurations. Insectile maintenance droids ride hoverlifts over the crowds, polishing and cleaning the intricate carvings or richly colored transparisteel insets.

The corridor is lined with exotic purple-and-green ch'hala trees, the transparent bark of which is sensitive to vibrations in the air, responding to each noise with a turmoil of color. The Emperor himself expressed a personal fondness for these trees, claiming that watching their changing hues reminded him of changing patterns in the universe. No one knows the name of the planet from which the ch'hala trees were originally transplanted, or if they were genetically manipulated in the Emperor's finest laboratories.

bove the Grand Corridor, much business is carried out on promenade balconies, where sentient beings sit in high cafés to stare down at the flowing bustle of traffic below. Lift platforms requiring special key access prevent unauthorized creatures from reaching secluded areas. Stormtroopers patrol the corridors, enforcing security and tranquility in the halls of government.

Important visiting dignitaries are housed on the President's Guest Floor, a vestige of the old capitol building that has been engulfed by the much larger Palace structure. These shielded inner rooms are well protected and nearly impregnable from outside attack, should violent criminals from the Rebel Alliance attempt terrorist acts or sabotage.

Deep inside the structure of the Palace, in the most protected rooms at the core of the building, are several "artificial penthouse" suites, with window walls made of projection screens, displaying realistic images from cameras mounted at the top of the

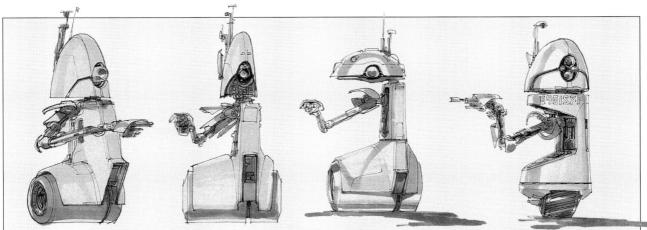

Many new model droids, from cleaning models to fast courier droids, assist in the efficient running of Imperial City.

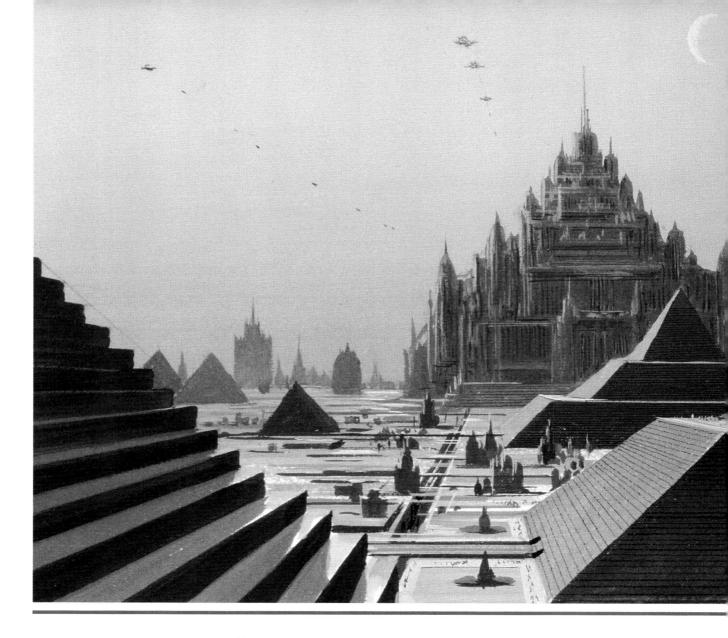

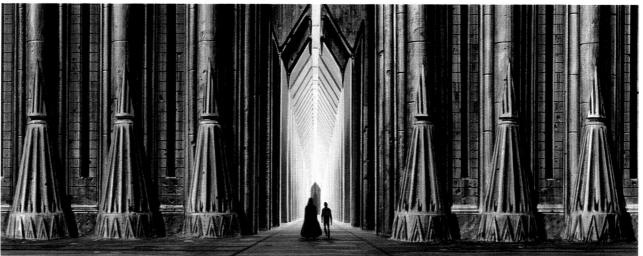

The Imperial Palace (top) is the largest structure on Coruscant, perhaps on any planet. Its interior (above) is a breathtaking monument to the grandeur of human capabilities.

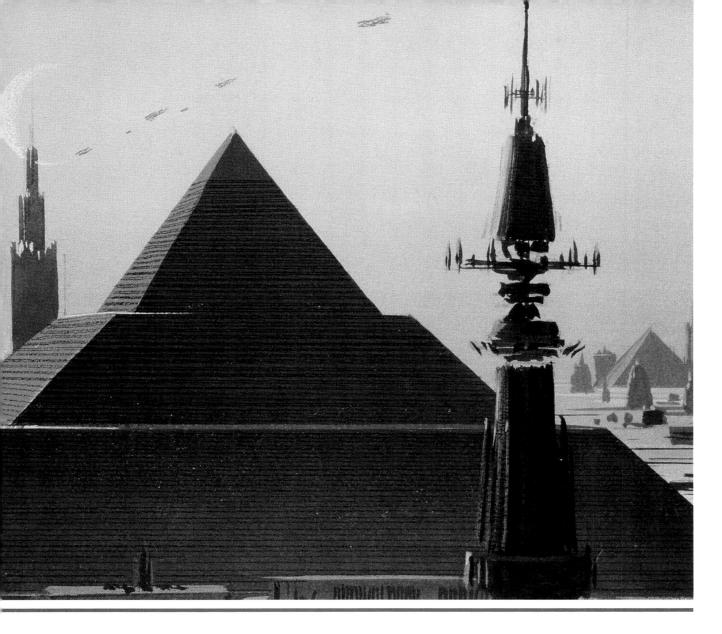

Imperial Palace. In this way the Emperor can hold meetings in total security and privacy, yet still enjoy a sweeping view of his planet.

Numerous architectural styles and design motifs can be found throughout the Palace. In some sections the structure is open and airy, with much illumination and transparisteel; other sections are dark and brooding, with carved friezes along the ceiling. Some rooms have old-fashioned hinge doors, made from exotic wood carved with intricate figures.

The Emperor's throne room is a sunken auditorium like a great crater dug into the bedrock. In the audience decks, flat stone benches are arranged in long arcs, where visitors can come to hear Imperial pronouncements directly from the Emperor himself. Acoustics are perfect, allowing the audience to hear the barest whisper from the Emperor; the reverse is also true, and the Emperor is able to hear any question spoken to him from the highest row of benches,

even whispered comments from one audience member to another.

At the pinnacle of the throne room is an angled, prismatic skylight, which pours rainbows of light onto the Emperor as he lounges back in his levitating chair, bathing him in glorious colors as he speaks....

The Empire's business never slows down, and some say the Emperor himself never sleeps. Palpatine has many private rooms, studies, audience chambers, libraries, and retiring alcoves hidden throughout the labyrinth of the Palace.

One of his well-known personal haunts is a transparisteel-enclosed observation deck on the tallest spire, where he can recline in a comfortable chair and stare out at the glittering chaos of the world he holds in his benevolent grasp, merely one planet at the heart of a great web of planets that comprises his glorious Empire.

DAGOBAH

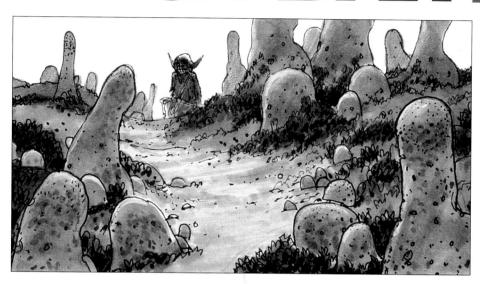

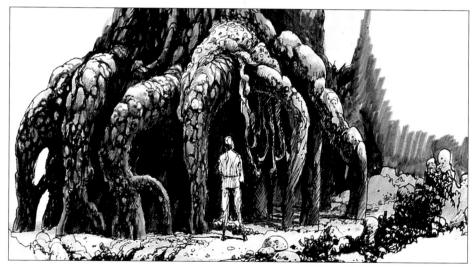

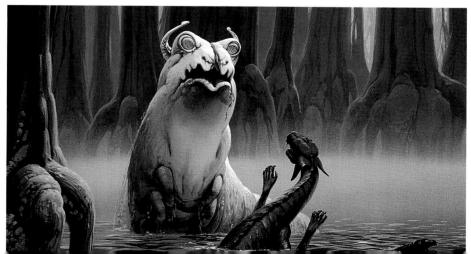

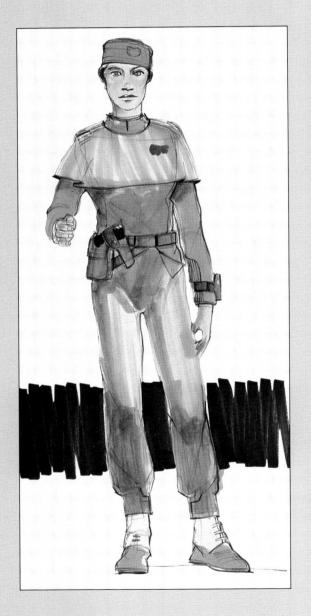

ABOUT THE AUTHOR:

Halka Four-Den kept these detailed journals of her experiences in command of a forgotten Republic research team stationed on the swampy world of Dagobah. Her previous record of service is exemplary, and she was placed in the role of supervisor of this team as her first command assignment. Unfortunately, the supposedly simple scientific survey of Dagobah was not to be a routine mission.

Halka Four-Den's account gives a vivid view of the exotic flora and fauna her team studied during their overlong assignment, as well as the hazards associated with performing straightforward scientific research during a time of great political upheaval.

DAGOBAH

[Ed. Note—Even as its government structure began to crumble, the Old Republic continued to send ambitious exploratory expeditions to study and catalog little-known worlds, such as Dagobah. We can now see it as an effort made through momentum and established bureaucracy, with no real scientific drive; after all, the Republic had sent out missions like this for centuries, then dutifully cataloged and forgot all the survey reports. We are only now beginning to mine the treasures of information buried deep within the databases on the Imperial capital world of Coruscant.

The commander of the Dagobah research team, Halka Four-Den, kept an account of the expedition, as she was required to do; but unfortunately all her records were misplaced during the upheaval of the Emperor's New Order. Now, though, after many years, Halka Four-Den's fragmented log entries have been located and are being published here for the first time.]

FIRST WEEK SUMMARY

he planet Dagobah—who named it, and why, is told in no existing record. Dagobah itself seems to avoid mention, as if some invisible power deflects all inquiries. As a result, the swampy planet is cloaked in mystery.

We—my team and I—were chosen to shed light on the enigma of Dagobah. It is an honor to add our discoveries to the greater knowledge of all sentient beings. The task ahead of us seems great, but we are enthusiastic and dedicated.

Dagobah is the only inhabitable world in a system of the same name in the Sluis sector. Shrouded in thick clouds over a dense gray-green blanket of foliage, Dagobah looks grim from space.

Two of my team members expressed uneasiness as we approached and entered orbit, somewhat concerned to be stranded here alone and self-sufficient for our allotted standard year in the field, but I tolerated none of that talk. Perhaps I was too harsh, but I could not allow a drop in morale before we even landed at our objective!

The cargo pods detached first from the main

freighter, burning down through the atmosphere and carrying transportainers of supplies and armored self-erecting shelters and laboratory enclosures.

Then the eight of us suited up and took our meager personal possessions. We said our good-byes to the other passengers, who would continue to a distant star system, climbed aboard the robotic dropship, and strapped in. I gave the order to launch, and we fell toward Dagobah, which would be our home for the next standard year.

t ground level, the smell of rot permeates the air. The buzzing, chirping, crunching sounds of billions of living things make a constant, pounding hum of white noise.

The swamp looked the same and endless for kilometers. One site seemed as good as any other, so we used heavy laser burners and plasma fusers to clear a camp, where we established our permanent base. Working together, we set up our prefabricated shelters, sealed our supplies in airtight armored containers, and took inventory.

My seven companions comprise a small botanical and zoological research team, dedicated to compiling all possible information about the world. In its ancient days of expansion, the Republic had established a venerable tradition of mapping and cataloging all known planets—but in such a vast galaxy with hundreds of millions of star systems, this was no simple task, and many had slipped through the cracks. Dagobah was one such planet, and we would be the ones to rectify that mistake.

n this swampy, inaccessible world, we were supposed to summarize and comment on the characteristics of the primary indigenous species—plant, animal, insect, and...other. Our survey team was woefully understaffed for the job, eight researchers to catalog and understand a world, using only old and questionable equipment...but it was the best the Republic could spare for us. We were enthusiastic xenobotanists and naturalists, so we attempted the task, regardless.

As commander of the expedition, I gathered the team in the main shelter and slipped the data chip

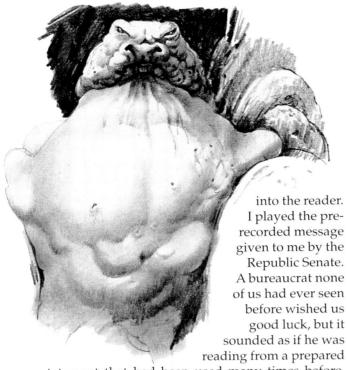

statement that had been used many times before. I did not point this out to my companions. The message ended, and we set to work.

Initial Impressions: Dagobah is absolutely covered with life, swarming with creatures and plants large and small. Within the tiers of the ecological system can be found every conceivable form of stalking technique, defense mechanism, and camouflage. We learned quickly that if you don't watch where you sit, you may well find the rock or log to be alive and scuttling away under you!

s near as we can tell, all creatures we have seen so far are nonsentient. The planet's ecosystem must have spent its energy on quantity and diversity, filling every possible natural niche, rather than developing intelligence.

Sometimes, though, as I stand alone in the noisy but weirdly silent swamp, I wonder if the world itself resents our presence, wanting to keep the mystery that shrouds it. Perhaps Dagobah is gathering its malevolent forces to resist our work at unraveling its secrets.

I shouldn't be thinking like this.

SECOND WEEK SUMMARY

Our two entomologists began to collect specimens. As part of the plan established in our expedition protocol, we all assisted them in rigging up bright

lights around the clearing of our settlement, along with nets connected to very weak stunner fields. In the dim underworld of the Dagobah swamps, we assumed that the bright lights would attract various nocturnal insects, but we weren't prepared for the magnitude of the response.

The brilliant lamps stabbed through the thick mist, burning like a target. The entomologists sat waiting, electronic logpads in hand, ready to record what they saw; the rest of us joined them, prepared to offer our assistance.

fter only a few moments, the spotlights brought swarms of creatures from every direction, whining and buzzing, smothering the lamps, dropping dead in their frenzy to batter themselves against the glow. The stunner nets clogged in moments. The entomologists could barely restrain their delight.

More insects came, and more, followed by leathery flying things that feasted on the swarms. The noises of the swamp grew deafening, an incredible crescendo. Then the disoriented creatures began to swoop down and attack us. My team members and I frantically tried to keep ourselves safe under the protective cover of the nets.

Out among the wall of shadowy trees, we heard larger predators stomping through the undergrowth, attracted by the light and sound, coming closer. In the shadows they roared and snarled hungrily.

Before everyone could panic and run inside our flimsy shelters, I ordered the lights switched off. We ran inside our dwellings,

barricaded the doors, and pressed our faces against the armored ports, staring out into the tepid darkness, but by the time our eyes had adjusted to the sudden shadows, the swamp creatures had forgotten about the disturbance, and we saw nothing unusual for the rest of that long, sleepless night.

The following morning, I insisted that the spotlights be dismantled and stowed away. We never used them again. The murky fog, frequent torrential downpours, boggy ground, and dense undergrowth make lengthy expeditions from our modular base extremely difficult. Though four members of the team wanted to range far from our site, I advised them to cut back their expectations for the time being, until we had learned some of the basic information about Dagobah. Grudgingly, it seemed, they fell to the simple chore of cataloging and imaging as many of the various specimens as possible.

Specimen sketches: many creatures on Dagobah seem unclassifiable. These, for instance, seem to be animated, carnivorous fungi.

With only eight people to dissect the life-forms on an entire planet, I sent a tight-beam transmission back to Coruscant, beseeching the Republic for assistance, but my requests either were ignored or were given low priority. It is a shame, because with all the plants and fungi, insects and venomous creatures, a further investment in Dagobah would repay itself a hundredfold with unimaginable advances in med-

Gnarltree roots provide a habitat for many camouflaged predators.

ical science, pharmacology, and genetics. But receiving nothing but static in response to our pleas, we dutifully returned to work.

In only two weeks we have already filled our archives with massive amounts of data on thousands of strange organisms.

THIRD WEEK SUMMARY

A great botanical discovery this week, as we began to explore beyond the fringes of our camp. Our researchers went out in two groups of three, fully armed, with the remaining two people left behind and prepped as a rescue squad, should emergency measures be needed.

he most prominent living things in the swamp are the ancient petrified forests of "gnarltrees," huge roots rising out of the bog, buttressed in the muck, gathering into wide trunks. The knobby roots and outer layers of the trunk have been calcified through centuries and centuries of slowly growing and rising toward the forest canopy high above. Because of their obvious importance to the Dagobah ecosystem, these trees were our first focus of investigation.

Each gnarltree itself is a microcosm of life-forms, with lichens, moss, and shelf fungus filling the crannies in the calcified trunk. These parasitic growths draw nutrients by breaking down outer layers of the gnarltree and absorbing moisture from the mists in the air. Insectlike organisms build nests in the

knotholes and tangles of the webbed branches, while larger animals take shelter in the cave-sized hollows beneath the overhanging loops.

One common creature, the knobby white spider, is intimately connected with the ecology of the gnarl-trees. Understanding the life cycle of the fearsome-looking albino spider proved quite a challenge to us, and upon learning its secret we realized how alien

this world was, how evolution had taken a bizarre and unexpected path here.

All the specimens of knobby spiders we obtained were about the same size, as big as a landspeeder, each with a lumpy, large body and gnarled legs that seemed designed for camouflage among the towering roots. Though the white spiders are

common, nearly to the point of being pests, our field teams found no nests or eggs or young that would give a clue as to the spiders' development.

Finally, by dissecting one of the knobby spiders, our arachnid specialist discovered that the creature's body core was made primarily of calcified wood, the same as the trees. The knobby spiders *are* part of the gnarltrees' life cycle!

I cannot describe to you our arguments and discussions, the skepticism we held, during our evening summary reports inside the main camp dwelling under the comforting glow of artificial light, surrounded by the wildness.

As we gathered more and more data, the evi-

Striking example of gnarltree root structure.

(pages 82-83) The knobby white spider, the mobile predatory stage of the gnarltree life cycle.

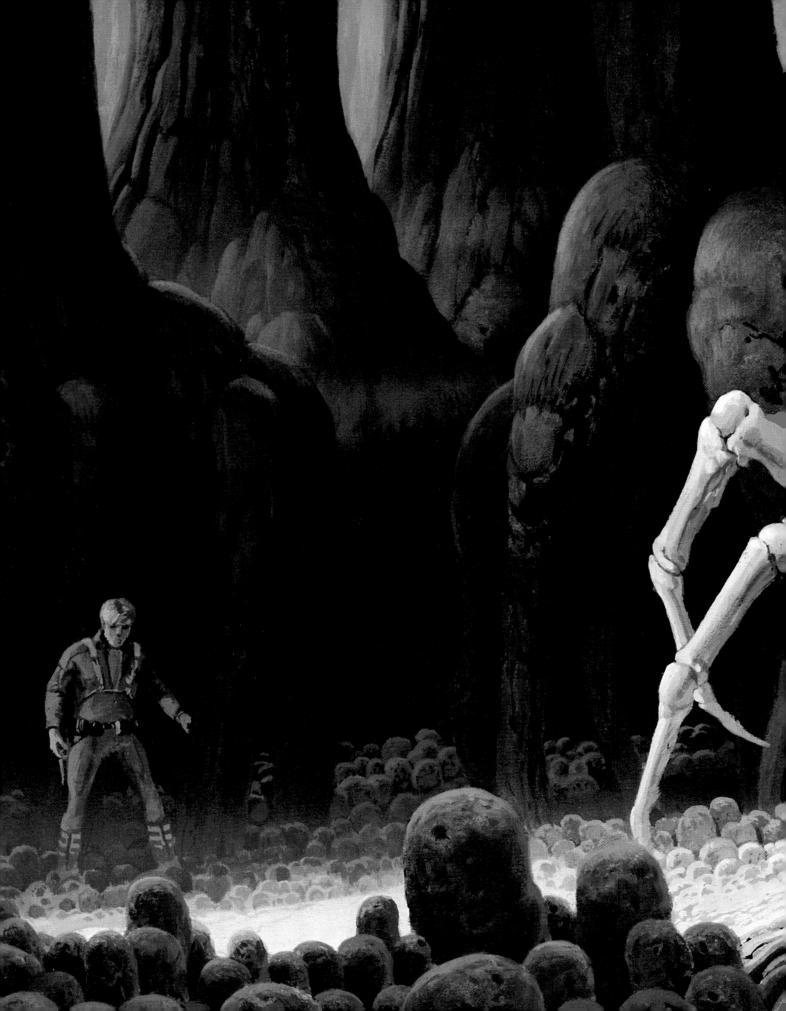

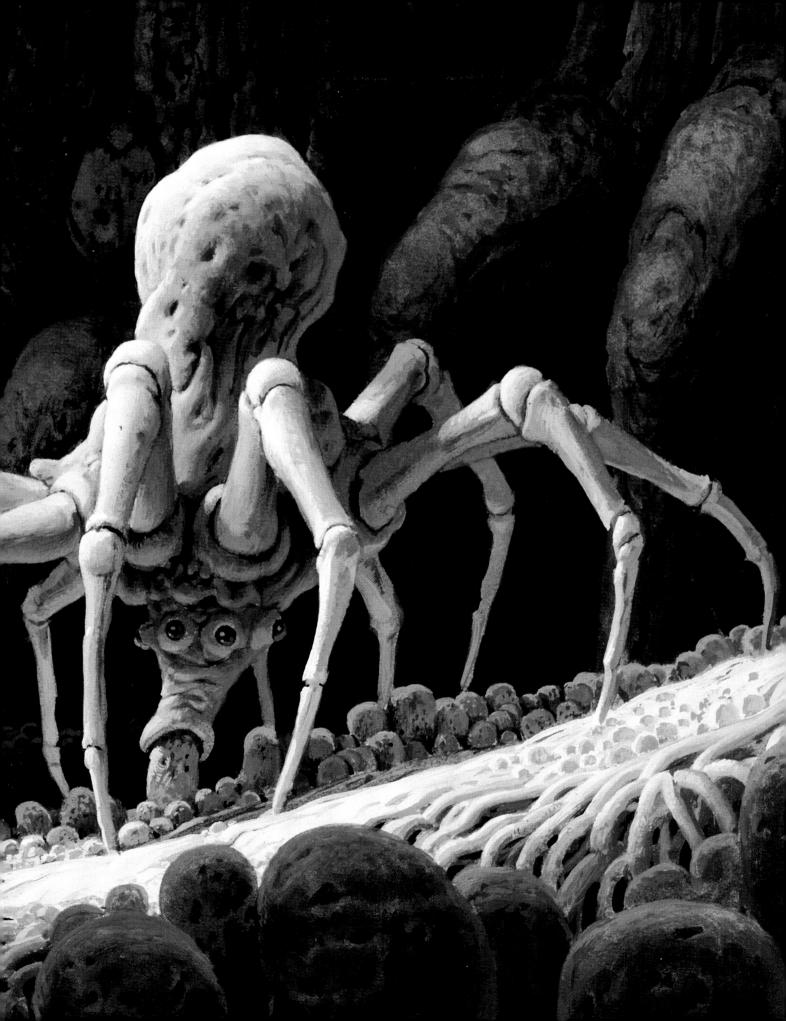

dence became incontrovertible; even the most vehement skeptics accepted the theory: In much the same way as some familiar plants send out runners to reproduce and spread, the gnarltrees grow a special kind of detachable, *mobile* root—the knobby spider—that breaks free of its parent gnarltree and begins the predator phase of its life.

The knobby spider roams the swamps, hunting and devouring other animals, storing energy in its

The titanic dual between two of the most fearsome creatures we discovered on Dagobah. The swamp slug and the dragonsnake are natural enemies. At right, preliminary sketches of swamp slug anatomy.

bloated, bulbous head. When it has gathered enough nutrients to support itself during its metamorphosis phase, the knobby spider searches for a clear spot in

the undergrowth, where it will remain for centuries.

In preparation for its anchored phase, the spider uproots all competing plant life within about ten meters—sometimes even including other implanted knobby spiders—and then plunges its eight sharp legs deep into the spongy ground. As the spider drains its stored energy, the gangly legs transform into roots, tapping deeper into the soil. The bloated head shrinks and hardens, and then begins extending upward into a rudimentary trunk, eventually reaching the canopy above.

We know this hypothesis will be challenged by other members of the scientific community, so we have redoubled our efforts to image this transformation in progress and to place a wealth of specimens in our stasis boxes for transport when our assignment here is finished.

Some members of our team have already begun counting down the days.

FOURTH WEEK SUMMARY

Plenty of new discoveries again. This planet's penchant for exotic life-forms seems inexhaustible!

One multilegged armored creature—which we named the butcherbug—spins a tough, microfine wire between the roots of the towering gnarltrees. The wireweb is invisible unless seen under exactly the right conditions. When a flying creature blunders into this trap, the microwire slices it into pieces, which the butcherbug then scuttles down to devour before meticulously cleaning the gore from its invisible web.

In the dimmest underworld of the swamp, some animals have developed bioluminescent patches to light their own way through the undergrowth or to attract prey.

One hairy herbivore, the spotlight sloth, patiently forages until it finds a large succulent plant on which it prefers to feed. When it has located a succulent studded with tough-skinned flower-fruits, the sloth illuminates bright glowing patches on its chest. Then it waits. After an hour or so, the tough skin of the flower-fruit unfolds to bask in the light, revealing a treasure of sticky purplish berries, on which the spotlight sloth feeds.

arger predators are rare in the bogs, but deadly. This week we had the great good fortune to observe the titanic battle between a giant swamp slug and a mammoth dragonsnake. Both huge creatures inhabit the water channels through the swamp, swimming through the black, peaty water and rooting out their food.

The giant swamp slug is an omnivore, eating anything it can pull into its lipless gash of a mouth. Small animals, decaying vegetation, even larger aquatic life-forms, are sucked through a long throat/mouth lined with thousands of tiny, grinding teeth that can pulverize all organic matter into a digestible mass. Like construction machinery, the swamp slugs plow an inexorable path through the bog, devouring everything in their way.

The dragonsnake, on the other hand, is a more active predator, seeking out victims that venture too close to the water's edge. The snake can rear up and slash at an animal with its fangs or its razor fins, knock it into the oily water, and then crush the prey in its coils.

We were collecting fungus specimens when the duel

between the swamp slug and the dragonsnake took us by surprise. Reconstructing the event afterward, we believe the incident began because the slug had blundered into the dragonsnake's nest, chewing the beast's home as it went.

During the resulting battle, the dragonsnake managed to bore through the slug's main body and slash off great chunks of meat. But swamp slugs have few vital organs, and this one seemed unaffected by the injuries. Dripping green-brown ichor, the slug reared up and plunged down again on top of the writhing dragonsnake, opening wide its huge, lipless mouth. Once the swamp slug managed to get the snake's barbed head into its tooth-lined gullet, the battle was over.

e watched and recorded for nearly an hour as the swamp slug ponderously swallowed the entire length of the armored dragonsnake, rumbling and chewing, before it wheeled about and continued devouring its way through the bog.

Our team members stood stunned. We had never before seen such a struggle.

FIFTH WEEK SUMMARY

Ranging even farther this week into the wilderness, discovering new environments.

In some sections of the swamp, where the ground is too rocky and rugged for anything other than scrubby ground cover, clearings appear, opening up rare canyons through the canopy high above. Fog clings in these low areas, drifting over rounded boulders and dense fungus forests.

Lightning flickers deep beneath the stormclouds and mist. Above, unpredictable air currents create only occasional rifts in the cloudbanks.

For a few minutes each day, a shaft of sunlight pierces the rift in the treetop canopy to shine down on the moorish ground. As the ribbon of

light touches the rounded fungus balls, the mushrooms expand rapidly and explode, showering spores across the ground.

We discovered these exploding fungi accidentally when we came upon one of these mushroom

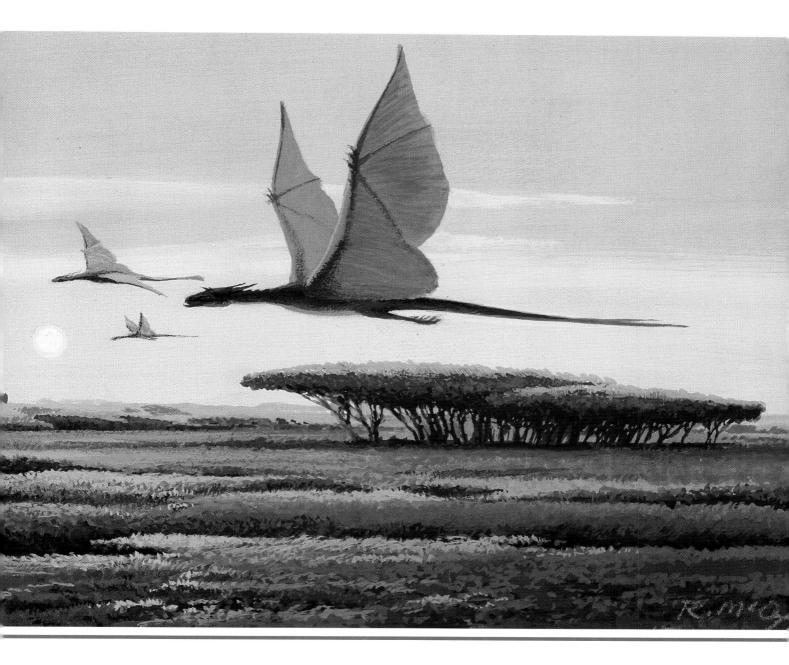

Above Dagobah's dense canopy, we found a different world entirely. Here, reptilian flying predators search for rodents rustling in the leaves. Rifts in the branches let shafts of sunlight burn all the way to the swampy ground.

covered clearings, shining our portable illuminators into the fungus forest. In every direction in which we turned our lights, detonations sent spores flying thick through the air, like a devastating battle. Already on edge from the uneasy silence of the swamp world and covered with foul-smelling and sticky spores, my team members and I fled.

Related now, in the safety of our camp shelter, the adventure seems somewhat amusing to me, but the spraying white spores and the loud explosions echoing through the misty forests made for a terrifying experience indeed.

SIXTH WEEK SUMMARY

Our short-range vehicle had so far proven mostly useless for travel through the dense tangle of the swamp. But we did manage to pilot it straight upward through a gash in the thick trees for a three-day expedition to Dagobah's astonishing canopy level.

Parts of the canopy rise above the swirling soup

of mist and break free into intermittent sunshine. Separated from the boggy, decaying landscape far below, the treetops offer an entirely different ecosystem.

When our small vehicle breached the thick murk, my team let out a collective gasp upon seeing the dazzling sunlight after so many days in the gray dampness of the lower levels. It seemed to me that I had never seen anything so beautiful. I could not remember natural light being so *bright* and so warm. Our morale jumped several notches in only a few seconds.

Under the nourishing sunlight, the stretching gnarltrees bring forth a blanket of tender leaves. Vines wind among the treetops, displaying brilliant flowers and dangling long, feathery roots to absorb moisture from the clinging mists. One species of vine-flower bears a segmented crystalline coating that acts like a prism, breaking the reflected sunlight into glittering rainbows.

Numerous small rodents scurry across the dense, matted roof of leaves and intertwined twigs, feeding on tender shoots and nesting only a few inches below the leafy surface.

iding thermals overhead, reptilian flying creatures search for movement in the canopy and swoop down to snatch up the rodents. When shadows of the flying predators pass over the treetops, the rodents set up a chattering alarm and flee in hidden channels to their nests—as they did whenever we flew over. (Apparently they thought we were some new and enormous flying hunter.) Seen from above, the panicked rodents make a churning storm through the leaves. The reptilian flyers cannot dig deeply enough into the tangled twigs to go after their prey—but we noticed that the rodents usually did not all manage to get to safety in time.

We compared these reptilian flyers to a similar creature that inhabits the lower reaches of the swamp. Perhaps they are the same species, although with the denser foliage, the lower-level denizen grows to barely half the wingspan of its larger cousins.

In the darkest levels of the swamp, some creatures resort to bioluminescence to light their way and to attract unsuspecting prey.

[Ed. Note—several records here are missing.]

TWELFTH WEEK SUMMARY

Dagobah seems to resent our presence now.

Though we have cataloged as many different life-forms as possible, even imaging and documenting the plants and creatures we encounter have proved too much of an effort.

There is no answer yet from the Republic on additional support-staff or new equipment. I am afraid we are not up to our assigned task. Morale is at its low-

est point. Fights have broken out between some of the team members. Three of my companions are no longer speaking to each other.

Tension hangs in the air thicker than the mists.

Instead of doing our assigned research, we spend most of our days simply fighting off the encroaching jungle, maintaining our modular settlement against the constant onslaught of growing vines, creeping insects, and foliage that seems to charge forward every time we turn our backs.

The currents of the swamp change after every heavy downpour, often undermining the foundations of our sealed-off dwellings, labs, and storehouses. We have had to move camp twice in the past two weeks.

Today one member of the team died from an insect sting. In a separate file I have included images of her last convulsions, the remarkable purplish discoloration of her skin, and our utter helplessness. Our medicinal supplies did nothing to save her, and we could do nothing more than watch as she died. We buried her in the swamp, but I have no doubt that within days the various life-forms of Dagobah

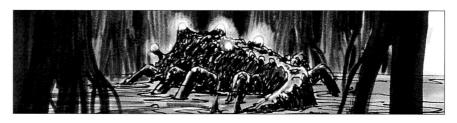

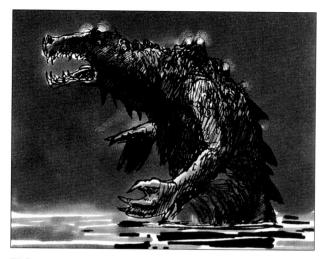

This predator lunged out of a still pool and dragged one of our team members under before we could effect a rescue. The body was never recovered.

will have erased all signs of her grave.

I have sent message after message to the Republic government, explaining the wealth of possible medicinal discoveries the plants or insects of Dagobah have to offer, the opportunity for exotic pets or flora, the possibility of strange new drugs.

I have begged for assistance, but I have received only silence. Is some turmoil happening out in the civilized systems? Why would the Republic ignore us?

THIRTEENTH WEEK SUMMARY [Final Entry]

Our carefully protected food supply has begun to spoil, and this causes me greater fear than any of the previous disasters that have befallen us.

The tenaciously adapting life-forms of Dagobah have found ways to breach even our most careful seals. Much of our work now centers on finding edible plants and animals in the swamp around us, simply in order to survive.

wo more dead this week: one torn apart by a large, unseen predator, one dead from a poison plant. This latter death distresses me the most—according to all our analysis, the plant should have been edible, even nutritious. And yet it was deadly. At least the poison was fast-acting. I will have to remember it if...in case our situation becomes untenable.

I have sent out a broad-spectrum distress signal. Soon we will have to eat the native plants and hunt animals for our own food. Only five of us remain.

But we have all been highly trained. I have every confidence that we can survive.

[Editor's Postscript—By the time a passing spice freighter responded to the distress signal and shuttled a rescue party down to the location of the research station, the entire team had disappeared. The modular buildings had been partially dismantled by the encroaching swamp and large animals. Some of the domes had caved in from the weight of clinging vines; all the team's food supplies had been devoured.

The would-be rescuers collected all the data records they could find, then left the abandoned station. No sign was ever found of Halka Four-Den or the remaining members of her research team.

It seemed the Republic had forgotten all about them. With the corruption, disorder, and decay of the cumbersome old government, this was unfortunately not an unusual occurrence. We have found numerous "lost archives" in the databases on Coruscant, many telling sadly similar stories.

Though some of the Dagobah records were damaged by exposure to the harsh environment, the Republic archives still retain volumes and volumes of information on the life-forms observed and recorded by Halka Four-Den.

Other expeditions to Dagobah have been proposed, usually halfheartedly, but each one was rerouted or can-

celed at the last minute. Many library records have been garbled or misfiled, as if mere mention of the swampy planet is cause to draw a blanket of mystery around it. The system has been missed on any number of other surveys, records lost, coordinates mixed up. Even veteran space navigators have rarely heard of it. We hope this article will rekindle interest in the world of Dagobah. The swamp planet

has made itself terribly elusive ... a perfect place to hide, as if something on the swampy world does not want to be found.]

A vast number of creatures still remain to be catalogued on this world—and I do not envy any team assigned the task.

HOTH

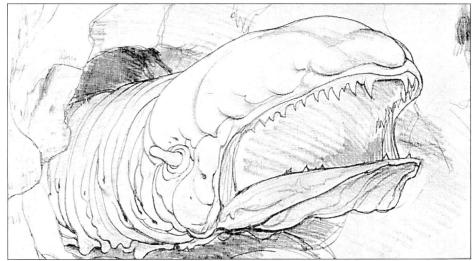

ABOUT THE AUTHOR:

Major Kem Monnon, chief of the Rebel
Alliance Corps of Engineers, held the
responsibility for establishing the
protected Echo Base on the frozen
world of Hoth. Drawing upon his
uncanny resourcefulness and his ability

to motivate his crews despite
miserable living conditions, Major
Monnon suceeded in building a secure,
hidden, and defensible base.
He describes the difficulties and joys
encountered in establishing a secret
home on the harsh arctic planet.

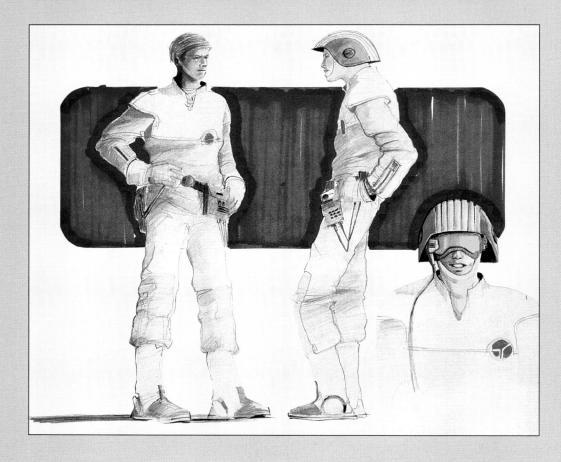

нотн

oth is an isolated world distant from its blue-white sun, the sixth planet in the system. Tactically insignificant, unnoticed by the Imperial Navy. A perfect hiding place for a Rebel base.

Near the planet is a broad and hazardous asteroid belt, making hyperspace passage through the area extremely difficult; even

travel at sublight speeds is risky for all but the most skilled pilots. Due to scattered debris from the asteroid belt, the planet Hoth itself has high meteor activity, thereby camouflaging our routine activities. All of which are great advantages, as far as the Alliance is concerned.

Hoth is far from a soft assignment, though. Daylight temperatures average only -32°C even in the temperate zone near the planetary equator. At

night, temperatures can plunge another twenty to thirty degrees, made worse by high-velocity winds tearing across the tundra. Few life-forms can survive in this environment, and those that do survive

are not...pleasant.

fter the destruction of our secret Rebel base on the fourth moon of Yavin, the entire Alliance scrambled to find alternative locations. I had collected a great deal of direct and anecdotal information during my years on tramp space freighters before hooking up with the Rebel Alliance. I offered my own suggestions, particularly emphasizing Hoth. The ice planet seemed a terrible option, a horrendously difficult place to establish living quarters...but it was also a place where the Empire would never suspect us. That was more important than our personal comfort. Besides, we could always wear thermal mittens and bring extra blankets.

Instead of marching in and converting the surface of the planet to our own needs, as the Empire would have done, we tried to work with the environment of a world not considered habitable by humanoid life-forms. Instead of shipping huge cargoes of supplies and prefab structures, my Corps of Engineers used the natural resources of Hoth to establish Echo Base. It was a good military tactic, efficient and leaving few traces on the surface.

Initially, we had sent a reconnaissance and survey team in a rapid loworbital mapping expedition, scouting possible locations for a new base. Particularly close to the northern edge of the temperate zone, we found many places where volcanic and seismic activity had cracked the thick ice sheath, breaking vast networks of caverns in the ice. As soon as I saw these images, I knew these ice caves would prove ideal

and adaptable for our purposes.

While the rest of the Rebel fleet made their way to the Hoth system through convoluted hyperspace paths to elude any possible pursuit, my surveyors mapped the ice labyrinths. For completeness, because I do not like surprises, they probed much deeper than what eventually became the main complex of Echo Base. The surveyors traveled far underground, where the distant sunlight barely managed to penetrate through the thick ice, leaving only a dim rainbowlike glow.

y scouts found solid rock inclusions and deep lava tubes where volcanic steam rose up to freeze against the cave walls in fantastic trees of sulfur-and-ice stalactites that hung down from the ceilings. While we did tap into some of these heat sinks as power sources, I considered the deep lava tubes too far beneath the ice to serve adequately as a

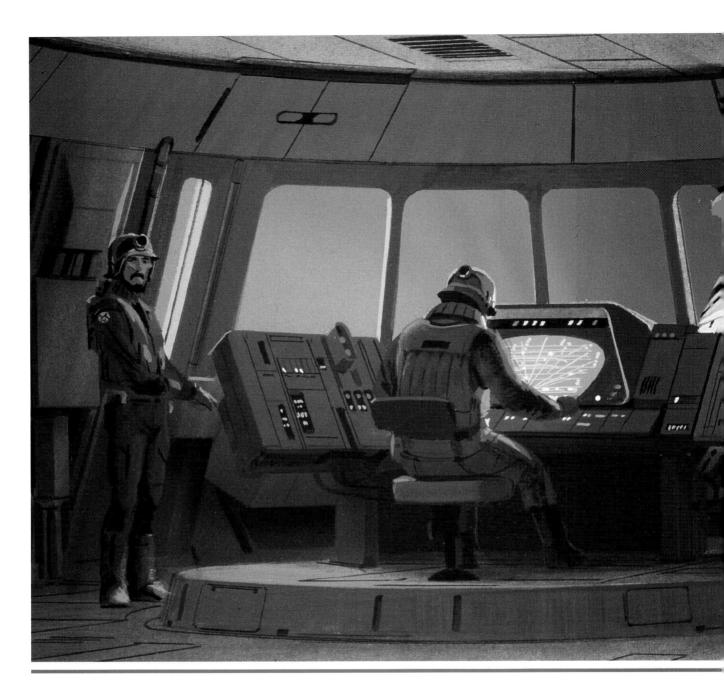

Echo Base on Hoth is a marvel of military engineering, excavated from packed snow and solid ice. The command hub (above) is the nerve center of the entire Rebel outpost. Rebel troops made the best of their situation, creating a tolerable home within the ice (right).

supply and command base. Besides, the possibility of being trapped underground in an Imperial attack made me decidedly uneasy.

The first major part of the work of constructing Echo Base involved expansion of the natural ice caves. My Corps of Engineers worked day and night, using excavator machinery and laser cutters to blast larger grottoes and to install connections between chambers. Power conduits and communications tubes ran along the walls, mounted directly onto the smooth ice and solidly packed snow. It wasn't elegant or pretty, but it worked. We opened

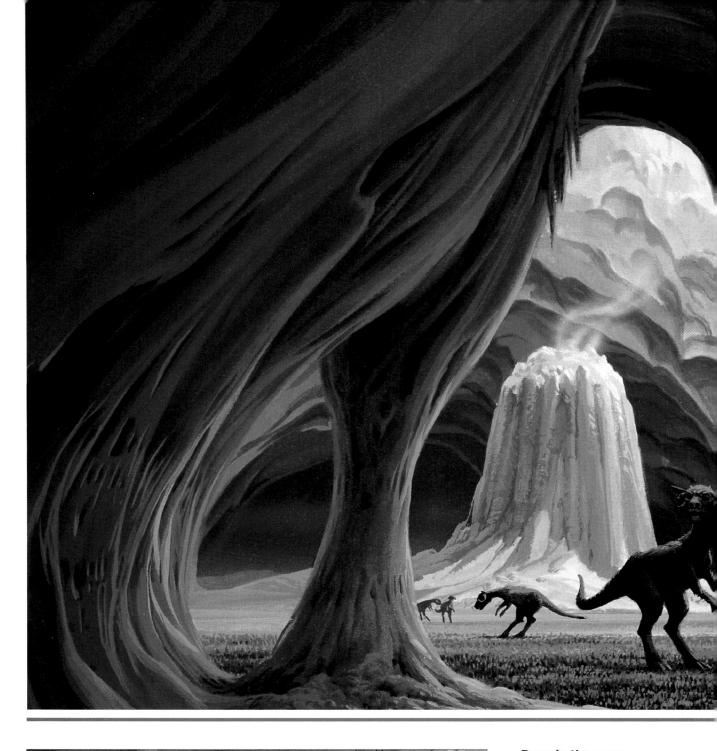

Deep in the cave grottoes (above), wild tauntauns graze on lichen growths, oblivious to the struggle for freedom in the galaxy. Excavating machines (left) work to enlarge hangar chambers in the ice.

up Echo Base in record time.

Initially, our equipment could not withstand the cold. Comm units failed frequently, forcing my engineers to rely on old-fashioned messengers—non-combat-trained personnel who ran with white breath puffing from one corridor to another. Some of the lesser functionaries and diplomatic runners in exile carried recordings back and forth from deep tunnel excavations to the upper command centers, processing supply requisitions from our matériel ships, requesting design and computer assistance from other specialists in the Alliance fleet.

Large chambers in the ice caves served as main equipment rooms and hangar bays, while some of the largest items of machinery—the enormous shield generator, for instance—were located outside under thick layers of insulation to protect their fragile components from the deep cold.

by the time we opened Echo Base, we had completed the quarters and accommodations for several thousand people, including the government-in-exile of the Rebel Alliance. Representatives from the Civil and Military Government and top

military advisers as well as high-level civil servants and their assistants learned to cope with the miserable conditions.

Because the structural material was solid ice, we were forced to maintain Echo Base at freezing temperatures. The walls of the living quarters were coated with an insulating plastic, which allowed the

rooms to be heated to a comfortable temperature. However, several mishaps did occur when well-

Even in the bleakness of Hoth, nature has still wrought marvels, such as these glistening ice geysers, built up over centuries—destroyed in a moment by Imperial aggression.

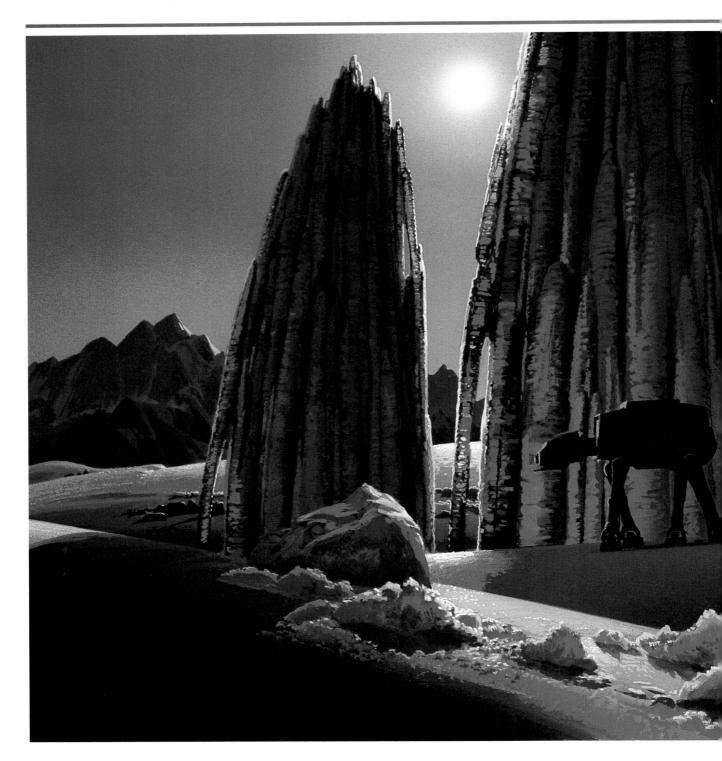

meaning droids (hearing people grumble about the cold) increased the temperature in certain rooms, causing drastic meltdowns.

Base personnel adapted to the chill by wearing flexible insulating uniforms and comfortable standard-issue thermal suits. Some of the more temperature-sensitive inhabitants of the base found it more comfortable to remain living in their cramped—but heated—quarters inside the transport vessels parked inside the huge hangar grotto.

We did our best with the few amenities on hand; but life during wartime is hard, and no one who signed on expected a relaxing vacation.

Nevertheless, people under fire are quite resource-

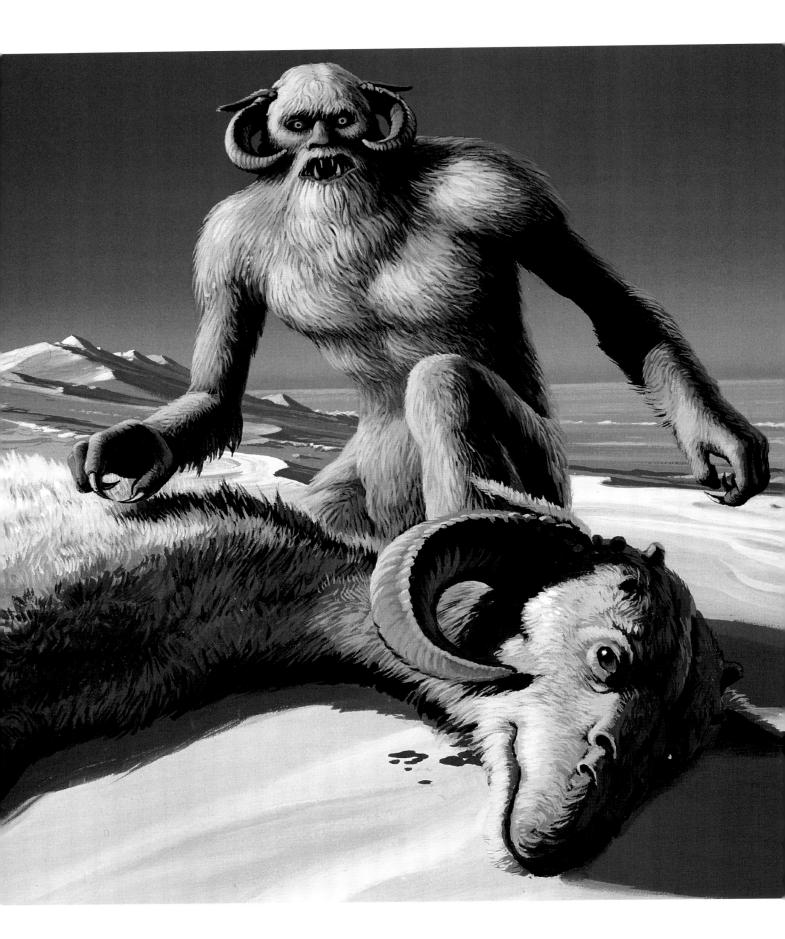

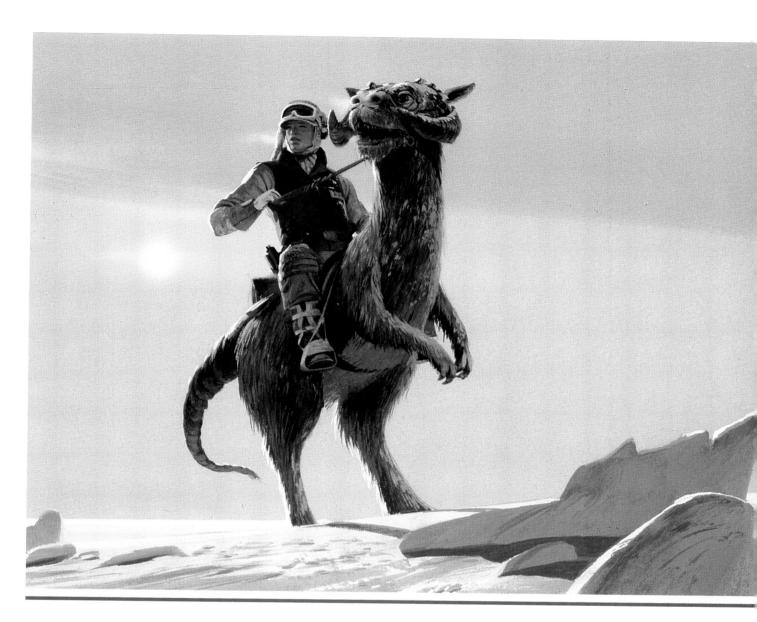

The wampa ice creatures are the most fearsome predators on Hoth, vicious monsters bred for a cruel environment. Their primary food source is the tauntaun...as well as any unfortunate rider.

ful in finding ways to amuse themselves, even under strict alert conditions. For example, frequent meteor impacts have blasted circular craters in the surface ice sheets; at the floor of each crater the melted water has flash-frozen into a mirror-smooth lake. During their off-shifts base personnel supply their own recreation and exercise by ice-skating on these natural rinks.

Also, ostensibly as part of their training, new Rebel scouts put together a bizarre "tauntaun rodeo" out on the snowfields, riding the smelly, uncooperative beasts in various stunt activities.

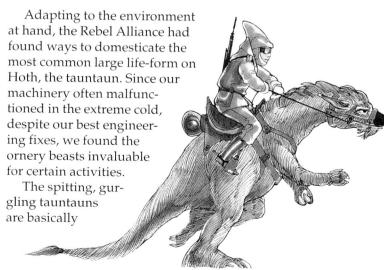

reptilian, covered with an insulating gray-white fur that gives them the nickname "snow lizards." Their body temperature is low, and some of the Alliance exobiologists have remarked that they seem to have antifreeze for blood. They have evolved into several different species to adapt to the smallest habitable niches in the frozen wastelands.

Their cold-resistant blood allows them to survive extremely low temperatures; however, this is at the cost of shutting down many of their bodily organs. Forcing a tauntaun to perform arduous tasks in the deep cold frequently proves fatal.

Some species of wild tauntaun live on the surface, foraging across the tundra during the warmest periods of daylight, searching for edible lichens and moss on exposed outcroppings. Their strong, rough-textured lips are able to scour the hardy coatings of plant cells from the rocks. These tauntauns have splayed tridactyl feet and long claws to allow them purchase on the snow as they run. Their large hind legs make them powerful sprinters.

Beneath the insulating white-gray fur, the tough reptilian skin exudes oils and waste products from numerous tiny pores. This gives

the tauntauns a distinctive and extremely unpleasant odor. I caught one of my engineers insulting a coworker by saying, "You smell like a tauntaun!" I considered that such a terrible insult that I gave him outside perimeter inspection duty for a week.

Other breeds of tauntaun look more reptilian, with narrow bodies and longer forelimbs. These types are usually denizens of the deep ice caves. They live near subterranean volcanic vents and forage among the species of foul-tasting fungus that grow in the lightless chambers.

While rounding up captive tauntauns to tame and

ride, we saw that they frequently travel in herds, moving en masse to seek any form of food, whether on the surface, in the rock outcroppings, or deep in the ice caves. From what we can tell, tauntauns will eat just about anything, including frozen carrion and small rodents they catch.

Immediately upon

Immediately upon arriving at Hoth, some daring members of our Corps attempted to taste the tauntaun meat to see if it could

become a dietary

staple during our assignment on the frozen world. But they learned their lesson after only one taste. The meat was stringy, sulfurous, and practically indigestible. We would be eating prepackaged rations for the foreseeable future—and,

looking at the spitting, foul snow lizards, I can't say I was disappointed.

Once the base was open for habitation and the primary routine established, the job of my Corps of En-

gineers was finished. But since

I find sitting around on alert immensely tiresome, I was fidgeting with boredom after only a few days. I spoke to General Carlist Rieekan, the man in charge of Echo Base, and he gave me permission to continue exploring Hoth and to compile my report for possible further strategic use by the Rebel Alliance.

Security and watchfulness are prime concerns in a secret base. Scouts riding tauntauns or snowspeeders watch the perimeter. Even the side doorways of Echo Base are gaurded by vigilant sentries.

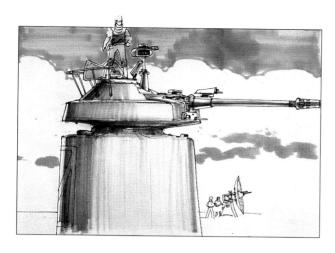

The stark, hostile landscape of Hoth may seem terrifying to many life-forms, but the frozen scenery has its own sort of beauty. It grows on you after a while, and I found the stark, bright *cleanness* to be refreshing after spending so much of my life in the Alliance in run-down, out-of-the-way bases or smelly spice freighters.

of the frequent, severe windstorms, right around local sunset. As the distant blue-white

touched the horizon, the ice crystals that were whipped into the air from the storm created shimmering rainbows, painful to look at in the crackling cold air. The fading light refracted prismatically from great mounds of transparent ice, washing the landscape with brilliant colors. The temperature drops so rapidly at night, though, that few of the base personnel are willing to go out sight-seeing, even for a spectacle like this.

Another day, some of my people went with me to explore the flatlands north of Echo Base. As we had seen from the initial reconnaissance flights, underground springs near deep volcanic sources periodically flash into steam and spray through narrow channels

toward the planet's surface. But we did not expect the weird landforms caused by this phenomenon.

When the steam strikes the subzero cold of Hoth's atmosphere, it freezes into delicate powder that slowly builds layer upon layer around the geysers' mouths. Over decades, these ice geysers build up fantastic castle-like formations, tall turrets and spiky frozen forests. The ice trees show a broad

palette of colors, yellows, tans, reds, blues, and greens. I'm no chemist, but I suppose the colors come from sulfur and other mineral impurities in the volcanic springs. When the wind picks up, tiny fragments of the fragile trees break off and tinkle to the ground. It's a strange, ethereal music.

Ice caps cover most of the deep oceans of Hoth, though tidal motions caused by Hoth's three moons (and large meteor impacts, too, I suppose) crack through the frozen shelves, releasing the trapped water to gush upward, jetting high and coating the glacial wound. The intense cold needs very little time to seal these breaches, returning Hoth to its motionless, frozen state. Still, the new ice is darker and smoother, and you can see it plainly even from a low-flying snowspeeder.

In one of our far-ranging expeditions to Hoth's southern hemisphere, we found a great chasm that stretches for nearly a thousand kilometers. I thought it looked as if the ice planet had started to split at the seams, but then had thought better of it. This huge canyon is filled with water barely above the freezing point, kept liquid by the immense pressure from both sides trying to slam back together.

On the rims of the canyon, glaciers slump over the sides in a horrendous, slow-motion plunge. It

looks like a time-slowed image of a huge waterfall. The great walls of ice relentlessly move, less than a meter per year according to our measurements, as they press down and grind side channels down to the open, blackish water below.

The glaciers themselves are a deep blue, veined with swirling colors from primitive algae that manage to survive by leaching dissolved nutrients and minerals from the frozen water; they must metabolize it with the dim sunlight that penetrates the murky ice.

Even locked inside the glacial prison, the algae are not safe. Wirelike ice worms burrow their way through the frozen walls, feeding on the algae. The ice worms tunnel through the glaciers, leaving

honeycombed shafts along the outer surfaces of the ice, where the algae are most prevalent.

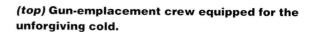

(bottom) Though Hoth is a barren world, the Rebel Alliance never lets down its guard.

When the wind blows from the right direction, the tiny holes in the glaciers emit a flutelike music, rising and falling into the bleak emptiness in an eerie, lonesome melody.

The most fearsome and the deadliest inhabitants of Hoth are the wampa ice creatures. In fact, in my travels prior to joining the Rebel Alliance, any time I heard the name of Hoth spoken, these beasts were mentioned in the same shuddering breath. I thought that rumor had exaggerated their fearsomeness—but even the hyperbole of lowlife traders could not overestimate the ferocity of these monsters.

Wampas are huge, standing three or four meters tall, with yellow eyes. They are covered with wiry white fur that allows them to roam the tundra of the ice planet even during storms, perfectly camouflaged.

The snow monsters have only a very faint scent that would alert their prey—unlike the filthy tauntauns. By the time a tauntaun can smell the wampa through its own stench, the monster is too close for the prey to escape. I suppose the lack of scent could be because the wampas keep themselves meticulously clean—but that's not likely considering the cluttered, bone-strewn lair we found.

Wampas are solitary creatures, each living in its own ice cavern. If the creatures cannot find an appropriate grotto for themselves, they are capable of ripping a new chamber from a wall of ice and snow with brute strength.

Luckily, wampas seem to be very rare. My guess would be that, because of their large size, wampas require a great deal of fresh meat. Since life is so sparse on Hoth, each wampa needs a vast and exclusive hunting domain. The creatures must spend

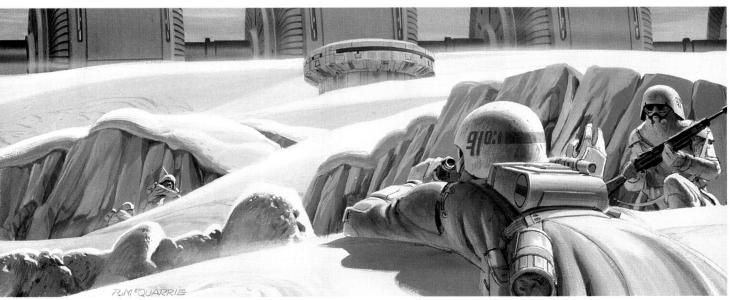

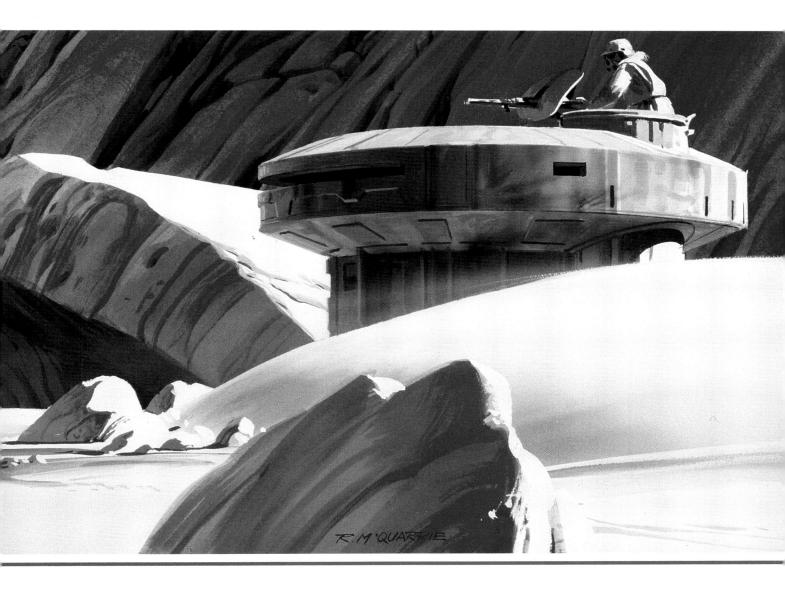

days wandering across the tundra, covering more than a hundred kilometers in search of food. Again, this may be an exaggerated tall tale told in a cantina over too many drinks, but I have heard poachers tell how wampas guard their territory jealously, engaging in bloody duels to protect their hunting grounds, leaving splashes of red-stained snow across the desolation.

hen a wampa attacks, its intent is to stun, not kill outright (although from the few souvenir/trophy claws I glimpsed, I would say that one swipe is probably enough to slaughter lesser animals). The wampa drags its victim across the tundra back to the lair; it then suspends the hapless being from the ceiling of the ice cavern until the wampa grows hungry.

Though the ice creatures appear to be violently solitary creatures, there is evidence that they do act

Fearing an Imperial attack, all troops at Echo Base are placed on alert at the gates of the installation, manning blaster cannon (top) and defending the energy shield generator (left).

as a concerted team at times. While we were out alone far from Echo Base on our own bivouac, we slept in small thermal shelters. As the night winds gusted across the snows, we could hear a deeper, more mournful howl overlapping the sounds of the breezes. We knew it had to be wampas crying out across the vastness—perhaps seeking mates, perhaps making complicated plans.

Because of their violence, the size of their claws and teeth, and the thickness of their pelt, wampas are legendary as targets for unscrupulous big-game hunters and thrillseekers—and this is how I had heard so much about them. In my travels I had seen occasional trophies on the black market: hides,

stuffed heads, and claws that commanded astronomical prices. I can remember one rugged blackmarket poacher loudly offering shooting expeditions to Hoth for "the best hunt in the galaxy!" —although I don't know what he would have done had anyone taken him up on the offer.

I had heard of one other ill-fated illegal poaching operation, which I told to my companions as we shivered in our shelters—and believe me, that story was on all our minds as the wampas howled at each other in the frozen darkness.

a business as guides to take the highest-paying big-game hunters to track down and kill wampas. The profits were high and, given sufficient weaponry, the game was not too difficult. But on the fourth such expedition, the wampas fought back.

By this time the ice creatures had learned their enemies' tactics and weaknesses. The wampas found the spaceships left by the group and tore them apart during the night, leaving the hunters and their guides with no comlink and no way to get off the frozen planet. The wampas raised their howling voices in the night, terrifying the hunters,

and making them waste their ammunition by shooting at shadows. Idiots, of course. But then, these were *failed* stormtroopers.

The perfectly camouflaged snow monsters struck, attacking in unison—these supposedly solitary creatures acted together like a precision killing machine. They came seven nights in a row, and each night they took only one victim, dragging him out into the cold darkness. No amount of fighting could stop them, and even though several wampas were slain, the monsters kept coming until they grabbed their chosen human. The terrified hunters, seeing their numbers diminishing with each passing night, could do nothing.

Finally the last two survivors made a pact and turned their weapons on each other rather than become tortured victims of the wampas. Of course, as with many such tall tales, the question remains who told the story, if no one survived? But we could not be bothered by trifles like that as we heard the howling wampas in the distance.

All through that empty, cold night of bivouac, we posted two guards, edgy and ready to shoot at any movement outside. It was a very long night, and we were glad to get back to Echo Base, ready to spend

our time in even the most tedious chores of maintaining our defenses.

ecause of its inhospitable conditions, Hoth is a great place to hide, a perfect isolated base for the Rebel Alliance. But we did not allow ourselves to grow overconfident that the Empire would never be able to locate us. Though it may have seemed unnecessary, Base Commander Rieekan insisted on a full defensive posture at all times, with no exceptions.

The other Rebel soldiers in Echo Base considered him a grim man, but Rieekan had good cause to be jumpy, unwilling to ignore warning signs until it was too late. I knew his past, and I respected him for it. I don't know what I would have done in his place, but he had already made the mistake of waiting too long—and as a result his beautiful home of Alderaan had been destroyed by the Death Star.

The hanger bay of Echo Base is a large, natural bubble in the ice, shored up with raw materials, designed for flexibility and serviceability—used to its fullest extent during the evacuation of the facility.

He won't tell you the story, keeping his sorrow to himself, but I made sure every member of my Corps of Engineers knew it. I tolerated no grumbling about his "unreasonable" demands, or his hard-driving work schedules, or his seeming paranoia about being discovered and attacked.

A native of Alderaan and a secret member of the Rebel Alliance, Rieekan had been inspecting satellite transmitters around Delaya, a nearby sister world of Alderaan, when he saw the terrible Death Star approach his home planet. Through covert operations, the Alliance had already learned of the battle station being built by Grand Moff Tarkin, and so Rieekan knew what might occur when the Death Star approached Alderaan.

But he was also terrified that if he signaled a general evacuation of Alderaan, the Empire would know its security had been breached. Why else would the people of Alderaan flee at first sight of the secret battle station, unless a spy had brought knowledge from the Imperial think tanks? That would be tantamount to admitting Alderaan's ties to the Rebel Alliance, and Alderaan had always pleaded neutrality. Torn by indecision, Rieekan held off on the evacuation, hoping that Tarkin was only

bluffing, not wishing to blow his cover.

But Tarkin was not afraid to use his new weapon, and all the people on Alderaan were destroyed. General Rieekan still bears the guilt on his shoulders. He has vowed never again to hesitate, never again to let the Empire's cruelty surprise him. He insisted on the constant defensive posture of Echo Base, no matter how unlikely discovery might seem.

e assisted in modifying snowspeeder vehicles to function at peak performance in the worst cold of Hoth, though these modifications were difficult and took some time. When the snowspeeders were functioning properly, long-range scouts flew in a wide radius around Echo Base, ensuring the security of the site.

Various "Echo Stations" were placed around the planet to monitor meteor activity and search for any sign of an unwelcome visit from our friends in the Imperial Navy.

A powerful energy field protects Echo Base from a space attack. This shield is strong enough to deflect the heaviest Imperial bombardment from orbit. Echo Base's great ion cannon is the single most powerful artillery piece in the Alliance arsenal.

One thousand Special Forces troopers are specially trained for ground defense in the frigid environment. They are armed with numerous antivehicle and antipersonnel artillery pieces specially adapted to function at low temperatures. For greater versatility, some scouts ride the perimeter on tauntaun mounts during daylight hours.

Despite our full spectrum of defenses, we maintain our vigilance, waiting, always waiting, for the Empire to find us again.

THE ASTEROID BELT

[Ed. Note: This supplementary file, compiled by the Orko SkyMine Asteroid Processing Corporation (owned by Durga the Hutt), was originally written to describe the resources available in the Hoth system's extended asteroid belt. The appended Incident Report describes the untimely end of Orko SkyMine's Automated Mineral Exploiter project.

The author of these reports is unknown because Durga the Hutt purged his/her/its identity following the Automated Mineral Exploiter disaster. Presumably, the anonymous author was similarly eradicated.] Executive Summary: The Hoth asteroid field consists of the scattered remains of an ancient collision between two large, rocky planets. The impact destroyed both worlds and scattered chunks of debris in a wide swath through the system. Over billions of years, this debris has wandered into erratic orbits, forming a great hazard to all ships traveling in the ecliptic of the system—and a great mineral resource for those with the will and the wherewithal to exploit it.

Astronomical projections have confirmed that the asteroids continued to collide and grind each other down, leaving a great range of debris sizes, from microscopic dust particles, to tiny pebbles, to large boulders, and even to irregularly shaped plane-

toids massive enough to hold a scant atmosphere. Given the proper machinery and element sorters, the asteroid belt provides a wealth of material—heretofore untapped by any of the other large processing consortiums.

Since Hoth is an isolated system with little traffic, no one has bothered to map all the components of

The ferocious space slugs, whose slow metabolism allows them to survive even in near-vacuum conditions, have proven to be severe hazards to mineral exploitation of the Hoth asteroid belt. Such creatures lie in wait, lurking in crevices or mine shafts, prepared to devour any unsuspecting ships.

the asteroid belt. Because the large fragments continue to tug gravitationally at each other, consistent orbital maps are impossible to maintain.

his lack of information can only be an advantage to Orko SkyMine Corp., however. Naturally, some hardy independent miners have attempted to exploit the asteroid belt, searching the shattered rocks for precious metals and crystals. But the majority of the treasures has gone unnoticed for a great many years. Orko SkyMine could claim everything for itself.

Points of Mineral Interest: One rare finding among the asteroids is a strange transparent growth, "crystal ferns," that occurs on some rocks exposed

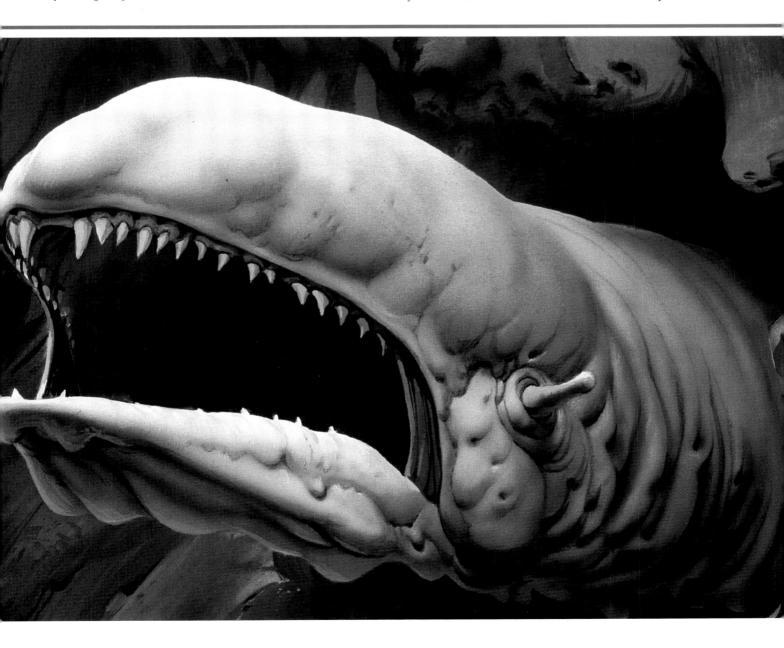

to hard radiation and cold vacuum.
The silicon-based crystals grow several meters tall, sprawling out in delicate, weblike tangles in the low gravity.
Since the crystal ferns propagate from asteroid to asteroid, broken in shards that are carried to other rocks through orbital vagaries, there is some speculation that they are actually a primitive silicon-based life-form. Such an item would be worth a great deal on the collectors'

market and to those dealing in exotica.

We have received reports of independent miners and surveyors eagerly seeking forests of these crystal ferns, though they are incredibly difficult to harvest without shattering the fragile structure. Given the technical resources of Orko SkyMine Corp., though, a sophisticated solution could no doubt be found.

We have also obtained many anecdotal reports of a particularly persistent legend: Somewhere lost

among the asteroids is a huge chunk of ore, nearly pure platinum that was spat out from the metallic core of one of the broken planets. This asteroid is known popularly as Kerane's Folly because it drove the prospector Kerane mad after

he supposedly found it and took a sample back to verify that it was indeed the pure, precious metal he suspected—but then could never find its location again. He spent the rest of his life among the Hoth asteroids, trying without success to recover it. Other prospectors, believing the story, have continued the hunt. Perhaps with a systematic search, Orko SkyMine could rediscover this treasure.

Potential Mining Hazards: Unfortunately, independent prospectors are not the only inhabitants of the debris field.

The maze of the asteroid belt has also proved to be a favorite hiding place for notorious smugglers and space pirates. Over the centuries, the records show that many hostile criminals and their henchmen have established hidden bases inside some of the larger asteroids. They were able to elude pursuit by various Republic, Imperial, and independent planetary police authorities by vanishing into the forest of deadly flying rocks. After numerous enforcement ships were lost in fruitless pursuit attempts, it is generally acknowledged that once a refugee manages to reach the asteroid belt,

continuing the chase is futile.
Such pirates may still be in evidence and could pose a threat to regular mining activities.
However, given a sufficiently armed mercenary escort, Orko Sky-Mine could proceed without fear.
Indeed, some of these sophisticated pirate bases could be

occupied and used as processing platforms in a large-scale exploitation of the belt.

We have learned that the major pirate strongholds were formed on the largest asteroids, those harboring minimal atmospheres. The most notorious of the smugglers and space pirates was a man named Clabburn, popularly portrayed as a hairy humanoid with oily, greenish skin and no compassion whatever for other sentient beings. Clabburn would lie in wait with his attack ships along the most heavily traveled hyperspace paths on the Anoat trade corridor, attacking wealthy tourists heading for the cloud resorts on Bespin.

pon sighting a luxury liner, Clabburn's swarm of ships would surround the target and immobilize the engines with a barrage of precision shots. Then the pirates, wearing vacuum suits, would crawl

over the outer hull of the crippled ship, planting small charges that would detonate and puncture the hull. Instantly all the air inside the passenger liner gushed into space, killing the passengers without a struggle, without letting them ever see the faces of their attackers. A cold-blooded tactic, perhaps, but highly efficient. Clabburn and his accomplices could then dismantle the ship at their leisure, taking the valuables from the frozen bodies. Last of all, they would set the vessel to selfdestruct, leaving no evidence of their crime.

Bounty hunters, police forces, and vengeful relatives hunted Clabburn for decades, but they could never

These sketches of the mechanical parasites, called mynocks, show these vermin in their natural configuration. In any operations in the asteroid belt, these pests must be dealt with.

locate his base in the asteroid belt. He kept moving from one planetoid to another, always covering his tracks and leaving unpleasant booby traps for anyone who might be one step behind him.

On first consideration, it seemed as if it would be advantageous to find one of Clabburn's abandoned bases as a central administrative site and use it for asteroid mining operations—however, the pirate made a habit of leaving behind a deadly legacy for anyone who might follow.

t the openings to his discarded bases, Clabburn planted huge wormlike guardians known as space slugs. The space slugs are hardy, primitive organisms with very low metabolisms. They subsist on virtually no

atmosphere, surviving for incredibly long periods by breaking down the rock of the asteroid itself.

In low asteroidal gravity, space slug bodies can grow to enormous proportions—estimated at 750 to 900 meters. The slugs are primarily smooth and vermiform, but long root tendrils snake out of the rear portion and burrow into the veins of rock to leach nutrients.

Space slugs are plagued by large parasites known as mynocks. Common mynocks have leathery black wings and a specialized suction-cup organ for draining energy.

Frequently traveling in packs, mynocks are common throughout the galaxy, having adapted themselves to drain energy from their host. They prefer concentrated energy, such as power couplings and battery cells, but they will also digest other forms of food—from the soft inner membranes of the space slug itself to the thermal energy the creature radiates as heat.

hunters or law-enforcement troops trying to track down some hidden space pirate. Unwitting intruders land inside an inviting-looking cave deep within a large asteroid, imagining it might be an active pirate base. But then the space slug closes its mouth and secretes powerful digestive fluids to break down the long-awaited meal. Because of its low metabolism, though, a space slug is often very slow to react to a ship waiting right inside its mouth, which causes it to lose many choice morsels. This could be used to our advantage should we ever encounter one of these creatures.

Granted, some of these hazards could be severe; however, we believe the potential wealth in the Hoth asteroid field cries out to be exploited. If not by Orko SkyMine Corp., then someone else will certainly fill the gap.

INCIDENT REPORT

This report lists the facts in the recent incident involving Orko SkyMine's two Automated Mineral Exploiter ships.

It is a matter of record that the largest mining venture ever undertaken in the asteroid belt involved these two automated ore-processing ships. Completely unmanned, these Automated Mineral Ex-

ploiters were programmed to detect
a large mass, fly toward it, and
begin to dismantle it.
Equipped with detectors to search and select for
high concentrations of metals,
the Orko ore processors were enormous, the most expensive constructions
ever undertaken by this corporation.
Unfortunately, the Automated Mineral
Exploiters were able to harvest only two
full shipments of ore. We should point out

that *mechanically,* these massive haulers performed flawlessly. Unfortunately, a simple and understandable error was made in the search programming. It is rather amusing in a way.

We have determined that due to the random vagaries of their search patterns, the two ore processors detected *each other*. Apparently each Automated Mineral Exploiter identified a large target of fabulously pure metal. The titanic ships came together and began dismantling each

other for the ore. From our distant vantage on one of the former pirate bases, we could only watch as the ore processors became the largest scrap heap in this sector.

We should emphasize that other than this minor error, the Automated Mineral Exploiter concept worked perfectly. The proof-of-concept has been completed, and all blueprints remain in the databanks of Orko SkyMine Corp. Given the potential wealth of the Hoth asteroid belt, it only makes sense to begin a second attempt.

In the meantime we apologize for our error and throw ourselves at the mercy of the chairman, Durga the Hutt.

—END INCIDENT REPORT

ENDOR

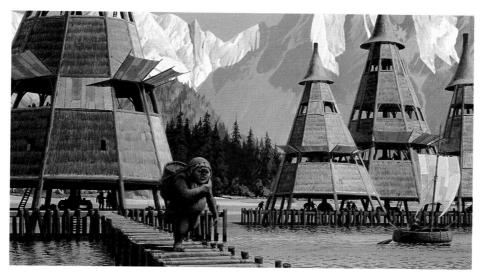

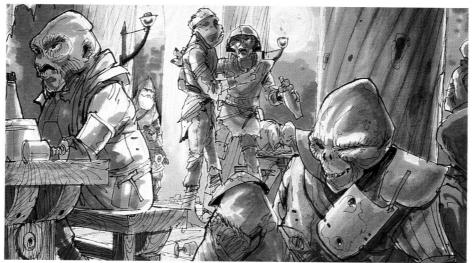

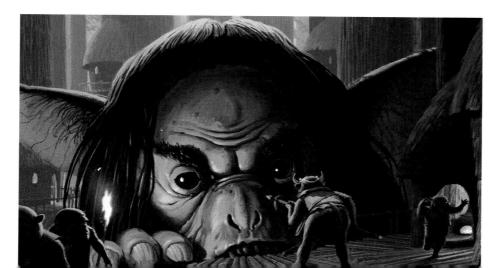

ABOUT THE AUTHOR:

Sergeant Pfilbee Jhorn served as records officer for the Emperor's second expeditionary force to the Forest Moon of Endor. Displeased with the superficial reports of the first scouting team, the Emperor requested a detailed summary.

Sergeant Jhorn filed several memos before his departure, insisting that he was not qualified for the job, but these memos were misfiled and never delivered to Sergeant Jhorn's superiors. Such circumstances account for the rather bitter and resentful tone of this report.

Imperial military records show that shortly after Sergeant Pfilbee Jhorn filed this report, he was transferred to a lengthy tour of duty alone riding the solar focusing mirrors in orbit around Coruscant. Following this assignment, he was sent to Tatooine, where he served as a custodian in the Imperial desert garrison.

ENDOR

hough my superiors have not seen fit to give me full details as to the Emperor's purpose in seeking further information on the Forest Moon of Endor, I am filing this report as requested. I will state up front that, since I was never given specifics as to the information of interest, this report will perforce be broad and general. As I have had no training in planetary survey techniques, I have avoided details of a technical nature.

The trip out here was horrendous. Endor itself is a silvery gas-giant that is difficult to reach even by convoluted hyperspace paths. As shown in the attachments, the huge planet is encircled by banded high clouds and orbited by nine moons of varying sizes. The largest moon, called the Forest Moon of Endor, is the size of a small, rocky planet. As the Forest Moon is the focus of this report, I have designated it Endor for simplicity.

The Endor system is extremely remote, not just from the Core systems but also from other Imperial bases, common trade routes, and other inhabited worlds. The captain of our transport claimed that simply reaching Endor involves half a dozen tricky hyperspace maneuvers (something to do with the enormous gravity of the gas-giant and the uncharted space in the sector). The captain rather snappishly told me to leave him alone, even after I informed him that I was on a fact-finding mission for the Emperor. (His name and service number are on file, should anyone wish to initiate formal disciplinary action.) These navigational uncertainties may rule out the establishment of an important base in this system.

Given such circumstances, it is no surprise that numerous ships have crash-landed on the Forest Moon, making it something of a "desert island" in space. The lush and wild environment provides resourceful victims the opportunity to eke out an existence, but I would envy no one the job of living under these primitive conditions. Give me Coruscant any day.

However, I do not know the Emperor's purposes

here. Given that Endor is isolated, yet able to support human life without expensive and difficult environment systems, this large moon may be an ideal place. My job is only to provide information, add recommendations if I feel they are relevant, and correct the numerous sketchy errors made by the initial survey team. If only they had done their job well enough in the first place, I would not have been given this redundant assignment.

(For example, the report of the first survey team stated that the only significant life-forms inhabiting the moon were the fuzzy and annoying Ewoks, who were presumed to be harmless. Not only did the survey team entirely miss the deadly giant Gorax, but also bloodthirsty condor dragons, packs of tall and timid yuzzums, and an entire settlement of off-planet marauders. The members of this first team are a disgrace to Imperial military service. Practically their only useful bit of information is that the furry Ewoks pose no serious threat and should be exterminated strictly because of their nuisance value.)

f course, the first team's lack of thoroughness may be understandable if they were as poorly equipped as my team proved to be. When the transport ship dropped us off and shuttled our supplies down, we were appalled to find that only a group of two-rider AT-ST scout transports had been assigned to the entire task of covering a world. The food packs contained only the worst sorts of rations, left-overs from the Clone Wars, no doubt! The garment bins contained ice-assault suits decommissioned after the raid on Hoth! I had heard grumblings about incompetence, nepotism, and corruption in the Imperial Navy, and now I had no doubt.

Sworn to duty, though, my team and I set to work. We consisted of four scientifically trained troopers plus five stormtrooper escorts. We climbed aboard several jerky scout transports and clomped off through the undergrowth. I believe the AT-STs were in need of serious maintenance. The other members of my team performed the required duties, while I sat back and observed (as was my job). I took copious notes.

Much of the surface is densely covered with leg-

endary tall trees, giving it the name of Forest Moon; but other parts of Endor are rocky savannas and snow-topped mountains. Badlands to the south are dotted with sulfur springs and perilous pools. Bleak, rocky highlands are inhabited by the giant Gorax. The low gravity of the Endor moon encourages living things to become large, not just the mammoth conifer trees, but also many indigenous species.

The dense, primeval forest is the most striking feature of Endor, and most likely to cause serious difficulties for Imperial construction projects. Overhead, through the tapering treetops, the bright planet Endor fills much of the sky like a mirror, breaking through the blue of daylight or shining down like a spotlight in the night. (One side benefit of this would be the reduced cost of illumination for a security perimeter on any proposed base.)

Flowers grow high above the ground, sprouting from wind-borne seeds that have lodged in damp crevices in the enormous tree limbs. Their colors are so bright and so varied as to give one a headache, and even with my facemask filters toggled to their densest settings, the disgusting pollens still managed to penetrate, making me miserable with extraterrestrial allergies.

The thickly overgrown forest floor, with its groves of free-palms and ferns, proved extremely hazardous even for the flexible capabilities of our scout transport. If Imperial engineers think they can simply land on the moon, ignore the indigenous life-forms, and set up their base of operations without difficulty, they're in for a large, unpleasant surprise.

While our AT-STs could maneuver through some of the thickest foliage, I'd consider it impossible for a larger AT-AT to make its way beyond the largest clearings. This does not preclude, however, the use of such armored walkers for intimidation around, say, a big landing platform in the depths of the forest.

Still, even our smaller scout walker suffered several mishaps on our plodding journey through the forest: I can't begin to list all the times we stumbled in treacherous and hidden gullies concealed by the underbrush. We wasted many hours disassembling twisted metal knee joints and repairing them, occasionally even battering bent components with rocks just to make them fit back into their appropriate sockets. Naturally, our AT-ST repair kits contained none of the spare parts we needed.

The Forest Moon of Endor orbits a silvery gasgiant—called *Endor*, for you dim-witted readers which rises high and bright every day.

The animal life on Endor is none too friendly. (I couldn't begin to say whether any of the game is edible; our old military rations were tasteless, but even that seemed preferable to eating some stringy, musty rodent grubbing in the underbrush.)

While our scout walker was being repaired—again—several of us explored the perimeter and encountered a dangerous decoy creature, which we named a tempter. The tempter lives inside a dark, hollow stump, waiting for other predators to pass by. The tempter apparently exudes a provocative smell that makes predators salivate. From the shad-

The open skies of Endor, showing only primitive trees and dirty "natural" beauty, are ripe for exploitation by anyone who can stomach this primeval world.

ows of its tree den, it opens its yawning black mouth, using its articulated tongue as a lure.

The tempter's tongue is an astonishing piece of camouflage, with a small and furry appendage that looks just like a particularly stupid rodent. The tongue appendage has its own muscles and even a dense nerve cluster that may act as a primitive sec-

ondary brain. The decoy appendage moves, making strange and tempting sounds, then ducks back into the blackness of the hollow tree.

hen one of our scouts reached into the hollow trunk to secure the rodent specimen, the tempter nearly bit his entire hand off. As we struggled to free him, the gray, serpentine form lunged out of its hiding place in the trunk, hoping to finish off the wounded prey. We blasted it, then dissected the remains of the carcass.

The tempter looks like a long, blunt eel, with pale, fleshy skin covered with a thick mucus that allows it to slither into tight spots and also to strike outward, freeing itself in a flash. Apparently once it has had its meal, the tempter cleans blood and debris from the area, then lies in wait again. Once the lair in the hollow trunk is filled with bones and refuse, the tempter must move out—probably at night, under the silvery light of the gas-giant, slithering among the free-palms to find a new place to set up a trap.

We tended our wounded comrade and bandaged his arm, but his injury greatly diminished his use to us for the rest of the survey operation.

The most common creatures on Endor are the obnoxious Ewoks, feral and deceptively cute hairy things that seem to consider themselves our equals. Ewoks practically infest the forests with their tree villages. It would give me no greater pleasure than to burn down these clumsy and primitive structures,

but the task is far too great for our small party. I would suggest, though, that if the Emperor intends to make any substantial use of this Forest Moon, he see to it that the Ewoks are exterminated before they can cause significant damage with their ignorant meddling.

ne member of our team unwisely became enamored of the Ewok society and culture. He squandered valuable time studying them and wrote copious descriptions of his impressions, though he did not bother to do a single dissection to add to our *real* knowledge of these...these creatures. I have reprimanded him severely for his misplaced priorities, but I include his observations here for completeness, though I have rewritten some of the insipid and overblown prose.

The Ewok civilization is extremely primitive and simple, with little of unique interest to warrant study by

already overworked Imperial exoanthropologists. Somehow, by sheer accident, the Ewoks have performed many spectacular engineering feats, including catapults, waterwheels, and skin gliders that allow them to soar on the winds and remain aloft for a long time in the small moon's low gravity. Even the gruff engineer on our team admitted his grudging admiration for their discoveries.

It is humorous to watch the Ewoks attempt to create weapons from the crudest raw materials: stone knives, spears, bows and arrows, nets, clumsy animal traps, even catapults. Nothing the Ewoks invent would have a chance of even scratching our Imperial weaponry, though the contest (and resulting Ewok slaughter!) might be amusing to watch.

ven when viewed from the level of the forest floor, the Ewok tree villages do seem marginally impressive. It appears obvious that the tree cities grow and evolve over the generations, as the scurrying little creatures build annexes to the core group of dwellings in a cluster of the towering conifers called lifetrees.

These hardy conifer trees are long-lived and durable, able to survive the onslaughts of disease, lightning strikes, and forest fires. They continue to grow for centuries, towering up to a thousand meters tall.

The thick protective bark of the lifetree exudes a natural pesticide that drives away all but the most persistent insects. Knowing no better methods of chemistry, the aboriginal Ewoks distill an insect repellant from the lifetree bark for their own uses. They also use the trees as sources of wood and bark fiber for weapons, garments, utensils, and furniture; as storage places for pure drinking water; and as a good place to find medicinal plants and herbs.

The Ewoks have developed a deep and superstitious connection with the lifetrees.

To cement this bond, each village plants a new seedling for each baby Ewok born; then they carefully nurture the seedling as if it were a sibling to the baby. Throughout that Ewok's

life, he or she is linked to this "totem tree." When the Ewoks die, they believe their spirits go to live inside their personal totem trees. Of course it is impossible to believe such a preposterous idea, but the Ewoks as a species do not appear to possess more than a rudimentary intelligence.

In times of crisis, Ewok shamans attempt to communicate with the ancient spirits residing within the oldest trees to ask for advice. Being the village con artists, the shamans naturally insist that this is an intensely private ritual. No one else has ever heard such ancestral voices, but the gullible Ewoks do not question the sacred advice brought back by their shamans. After all, why would the spirits inhabiting their totem trees ever lie?

As for the design of the tree villages themselves, the structures at first seem to have been arranged at random, wherever the short attention of the furry creatures halted for the moment. But when our team member took the time to observe the villages thoroughly—too thoroughly, in my opinion—he noted a

basic blueprint

that all Ewoks seem to follow.

The central "village" of thatched-roof huts is built into the primary limbs, situated high enough above the ground that they are out of reach of most predators. Suspended

bridges between trees link adjoining and distant huts; knotted rope ladders allow access up or down.

The thatched-roof huts offer plenty of warmth, shelter, and protection in the mild climate of the Forest Moon. But the whole thing could be made

to go up in flames
with minimal effort,
simply by tossing in a
few incendiary devices.
In a typical tree city, the
Ewok elders—funnylooking, gray-haired
little beasts—order
the largest huts built
directly on the trunk of the

tree. These central dwellings belong to the chief of the tribe, who uses the largest open areas for village gatherings, meetings, council fires, and storytelling ceremonies.

amily groups live in their own dwelling clusters on outlying trees, though separate communal huts are built for groups of unmarried females, respected elders, and visitors. A sealed cluster of structures, higher than the main tree city, is used for the communities food storage.

Unmarried Ewok males often spend a contem-

plative period living alone in the forest, building

their own small dwellings near enough to the main tree city to assist with the Ewoks' daily work, but otherwise fending totally for themselves. Unmarried females leave gifts of food, clothing, weaponry, or trinkets on the door-steps of the solitary males as a sign of their attraction, ostensibly to tell the males how much the city misses them and wishes them to come back as part of a new family unit, preferably as that

Ewok children (top) and Ewok dwellings (above) show how these primitive creatures attempt to make do with the squalor of their existence.

female's mate.

Such bizarre and rigid marriage customs seem like an artifact of some of the oddest practices in the early days of the Old Republic.

If the male Ewok wishes to end his solitary time, he must build an acceptable family dwelling in the larger tree city as a place for him and his mate to live. When an Ewok bachelor begins building his new dwelling, signaling that he has decided to take a mate, the unmarried females step up their work at

wooing him (at least the ones who are interested). The Ewok male does not announce his choice of mate until he has completed his home; the chosen female has the right to refuse him, or the dwelling he has built. I could barely refrain from rolling my eyes at hearing such barbarities.

s with nearly all primitive races, the Ewoks developed a religious system based on superstition, worshiping the bounty around them and the forest from which they draw the necessities of their lives. Religious ceremonies are designed to please various gods of weather, deities representing

deities representing the trees, the hunt, engineering prowess, fertility—as well as darker spirits who symbolized the threats and terrors of the forest.

cause the Ewoks to

have vivid dreams.

At various times of the year, the Ewoks hold extravagant festivals of the rain and sun, springtime flowers, and fruits, as well as certain "Dark Rituals" involving bloody sacrifices. These rituals are held at night by the orange light of smoky bonfires, into which the shamans toss the green leaves of spiny hallucinogenic herbs that

Every Ewok village appoints its own male or female mystic/shaman—the previously described con artist—who makes up answers about what the gods really want, how they can be pleased, how the Ewoks can make their prayers heard. For this "service," the village grants the shaman anything he or she could want: crystals, shells, polished skulls, and other items they find interesting. Most mystics wear a large animal skull on their head.

Some shamans are said to be "as old as the trees,"

apparently symbolizing their connection with the lifetrees and their imagined ability to communicate with the ancient Ewok spirits that dwell inside them. The shamans caper around with fetishes, beating drums and dancing. They also seem to know a few simple illusions, tricks, parlor magic. Their advice to the tribe leader is usually common sense delivered with an aura of mysticism.

Village mystics also pretend to be powerful healers, applying vile-smelling herbal medicines supposedly passed from generation to generation. Admittedly, many types of fungus, lichens, roots, berries, flowers, epiphytes, and bark may have some minimal medicinal effect, but I suspect the greatest effectiveness of these "cures" comes from the imagination and faith of the hapless Ewok patients. Ewok villages adhere to a rigid clan system, like the Imperial military. Only, instead of molded white body armor, they use different raggedy garments for head coverings or hoods, apparently to signify an Ewok's place in the hunting order or the family unit. Ewok warriors wear wooden chest shields, the jawbones of small animals, and sharp teeth. Others ornament

themselves with

feathers, necklaces

made of crystals, pendants

An example of an Ewok "shaman"—the ones who talk to trees and get mysterious messages from the forest, and who call upon primitive superstitions and "magic" to defy Imperial authority.

(pages 122-123) An Ewok lake village in a mountainous section of the terrain. These tenacious creatures find some way to inhabit every spot of the terrain on this forest moon.

of polished rock or shells, making their bodies look like a clutter of trinkets and junk. Prominent members of the Ewok village carry totems as symbols of rank. The lead warrior wears a headdress made of pale feathers, "the white wings of hope." The eldest son of the tribal leader's family wears the "red wings of courage," while the second son wears the "blue wings of strength."

Ewoks share strong family ties, appearing especially attached to their fuzzy, grublike children. The whole village fawns over newborn babies, smothering them with affection and attention, considering the care of the young a shared responsibility, even though the things look like bristly rodents to be squashed underfoot.

The Forest Moon provides plenty of food for scavengers to eat and sweet mattberries to squeeze for their juice (which is mixed with water and fermented into a bitter but intoxicating brew).

Even with their diminutive size, the Ewoks laughably consider themselves great hunters. Solitary hunters snare small animals, but occasionally an entire hunting party of Ewok warriors will set a deadly trap for larger meat animals—such as the boar-wolves.

Shaggy boar-wolves have tusk teeth, a keen sense of smell, and saberlike claws that can tear holes in trees. Though they have a penchant for howling at the silvery gas-planet in the night sky, these truly impressive predators possess an incredible patience to hide and wait out of sight once they have cornered their prey. They have fed on many Ewoks this way.

Though the boar-wolves are three times as tall as the Ewoks, the scurrying little creatures have somehow stumbled upon effective methods for fighting the monsters with spears and poison darts: The Ewoks first bait a clever trap with scraps of bloody meat from other kills and carefully hide a vine net on the forest floor. When a boar-wolf attempts to rip into the fresh meat, the net tangles around its huge armored body, enough to slow and confuse it while the Ewok hunting party charges out of the underbrush. One such kill provides enough meat to feed an Ewok tree village for days, if one could stomach the pungent and stringy meat.

In our travels across Endor, we also encountered a shallow, placid lake on which live another tribe of Ewoks. The squeaky vermin have built their huts on stilts out in the glassy-smooth water, where the water and surrounding marshes protect them from large predators. These Ewoks get most of their food by setting wicker traps for succulent crustaceans in the lake.

Older Ewoks spend their time harvesting the

tough marsh grasses and flattening them to dry in the sun; they plait the dry, fibrous grasses into ragged mats, clothing, baskets, and decorative tapestries. The young lake Ewoks love to splash in the water and dig in the mud for buried shellfish, which keeps them filthy with caked dirt.

A tribe of cliff-dwelling Ewoks has made its home on a sheer rock face beside a spraying waterfall. Suicidally ignorant Ewok engineers somehow installed a primitive but intricate set of waterwheels, driven by the force of falling water. These turning waterwheels drive large wooden gears that rotate grindstones, operate conveyor belts from one part of the cliff village to another, and run a set of lift platforms up and down the cliff.

We happened to witness a revered annual event, at which representatives from the scattered Ewok tribes gather for a series of games. These "tribal games" allow them to show off their primitive antics. The Ewok revelers engage in dancing and storytelling, though some of the other activities are far more dangerous.

The most popular game among young Ewoks is to show off their prowess in tree-jumping. Ewok contestants climb to the top of the tallest lifetree, then leap off the highest limb. They must somehow catch themselves on lower limbs, jump off other

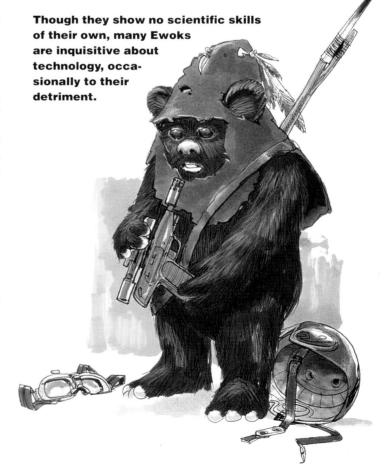

branches, and continue to descend all the way to the ground at a breathtaking breakneck speed. Tragic accidents occur when an Ewok athlete misses a branch and plummets to the hard forest floor amid much shrieking and chattering from the other spectators. It is enough to give one a headache.

Though Ewoks enjoy tribal ceremonies, singing and playing music on primitive drums, they spend endless hours exchanging incessant stories in their bubbly, jabbering language. They have kept alive a strong oral tradition, spending many an evening's entertainment telling and retelling the exploits of legendary (and probably imaginary) Ewok warriors, great hunts against huge predators, and lone quests to other parts of the Forest Moon. Even now they are probably still telling of the marvels of truly impressive Imperial technology, which we showed them for the first time.

On our travels we found that the initial Imperial survey had missed yet another race of intelligent creatures (not that it was any surprise). These troublemakers are similar in size to the Ewoks but able to move much faster. If it is possible for a life-form to be even more unlikable than an Ewok, these creatures succeed in that area.

Teeks are rodentlike, simian creatures that live in the forest, scavenging and stealing things

from animal nests and from Ewok dwellings. The Ewoks don't like Teeks at all, considering it a sure sign of trouble even to be seen with one of the creatures.

Though Teeks are accomplished thieves and collectors of all kinds of things, they do not consider themselves dishonest, since they leave a trinket or token of equivalent value. What the Teek considers "equal value" is often very different from what the original owner of the stolen object might expect. We learned this upon finding some of our scanners and sophisticated tools replaced with dried

seedpods and polished beetle shells.

Teeks have long, pointy ears and scruffy white fur, beady black eyes, and a propensity for constant Some Ewoks have inadvertently stumbled upon the secret of flight through the use of crude gliders (above). Teeks (below) are fast-moving troublemakers.

chattering. A set of buckteeth makes them look stupid and goatish, but their hands are agile and fast, amazingly so. Teeks wear rudimentary clothing, with many belts, pouches, and pockets for those items they manage to snatch.

Teeks have evolved an enormously fast metabolism, which allows them to put on bursts of incredible speed, for fleeing both from enemies and from the

victims of their thievery. We attempted to shoot a specimen for our collection, but each time the chattering, dashing Teeks escaped.

As my team and I continued our mechanical march across the landscape, all of our AT-ST transports broke down at the foothills of the rocky highlands. All of them at once! Muttering about low-bid Imperial contracts, we left the defective vehicles sitting at the base of a steep ridge and set off on foot. The retrieval teams would come and get us in a few days anyway, and we were sick to death of the towering forests.

Give me a stark landscape any day. To the north the dense, claustrophobic

forests ended in an abrupt line of the sheer Yawari Cliffs, where the land has dropped away in a titanic slump. I could imagine ignorant Ewoks jour-

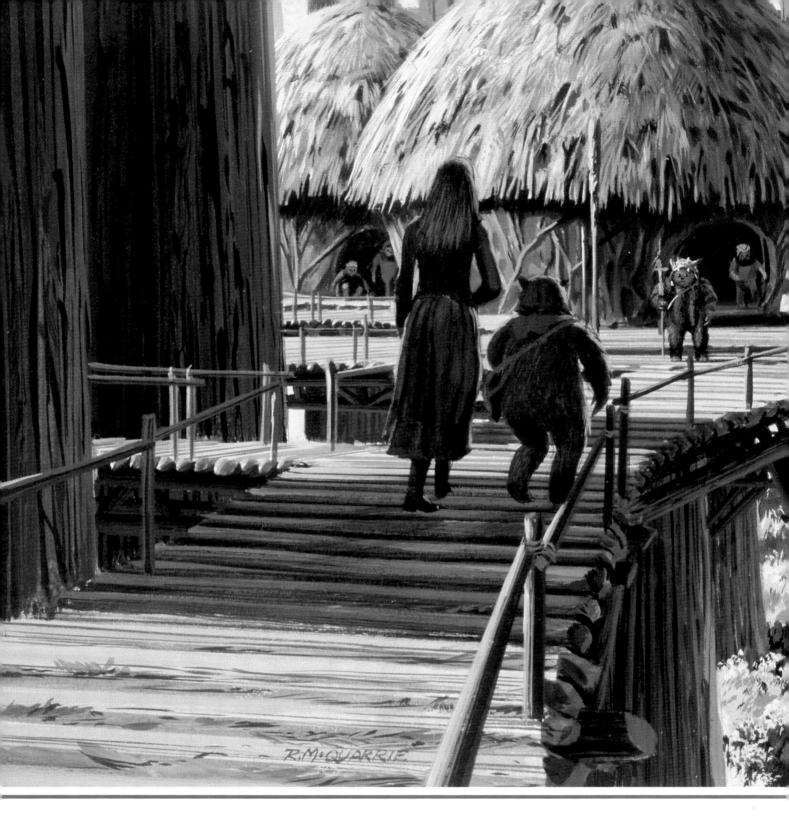

neying to the edge of the cliffs from above, seeing the world below swathed in morning mist—they must have believed they had found the edge of the world.

Inaccessible, wind-tunneled caves dot the open face of soft sandstone, and we made our way to the shelter they offered. Apparently the Ewoks had invented a crude skin-glider to fly in the thermals rising against the bright rock face and to land on broad ledges.

At the time, though, we did not know that inside some of the larger caves live the carnivorous condor dragons, flying reptilian creatures with bony ridges along their spines and grasping front claws for capturing prey in flight. The condor dragons walk on

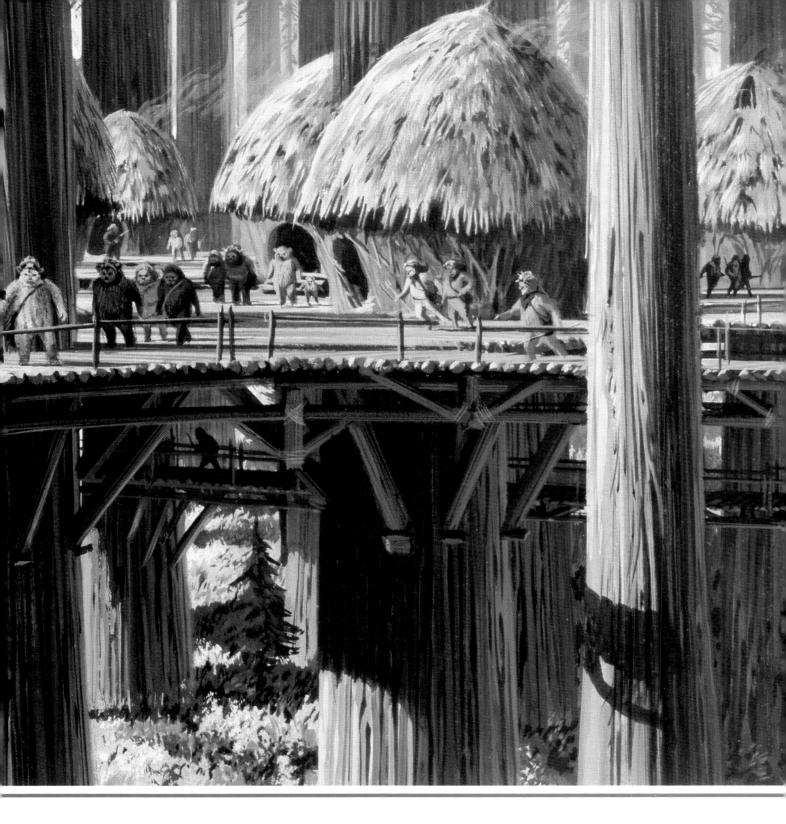

Ewok tree cities are quaint, primitive structures built from the natural materials on Endor and inhabited by generations of these furry vermin.

two legs inside their eyrie caves, hunched over with wings curled in front of them. We know—we saw one firsthand, and it took the combined firepower

of our stormtrooper escorts just to stun one so that we could examine it.

A condor dragon has a single fused fang for tearing through the thick hides of its prey, and two long lower tusks for brutal stabs and a quick kill. Large yellow eyes with round black pupils have extremely sharp vision, able to spot moving prey even through

dense treetop foliage.

Agile flyers on their leathery wings, the condor dragons cry out with piercing shrieks, hoping to startle small animals from cover. Impressive beasts. The condor dragon snatches its victim, then flies back toward its eyrie cave. If the prey struggles too much during the flight, the dragon simply drops it, then swoops down to snatch the smashed body from the sharp tangle of branches below. The condor dragon will eat its fresh meat dead or alive; it isn't picky.

Back in its cave and stuffed with a heavy meal, the condor dragon falls into a stuporous sleep,

curled in a dark corner, where it looks like a leathery boulder. Luckily the one we encountered had not yet recovered from its groggy slumber, and so we survived. If our timing had been different, we would have joined the bones strewing the cave floor....

Once we had succeeded in scaling the Yawari Cliffs, we found the terrain becoming worse yet, dryer and harsher, with few living plants and only poisonous insects. Rather like the stormtrooper academy on Carida.

The terrible Desert of Salma is a land of acid pools and dry lakes, where the ground is caked, dried mud. Frequent dust storms, powered by brutal high winds, scour away all trails and would have blinded us except for the sensors embedded in our visors. Many bones and mummified corpses lay buried among the baked rocks and the lifeless chemical soil. I hope some of them are Ewoks.

eyond the blistering desert rise limestone bluffs, like bone-white mounds of ancient candlewax. Very picturesque. However, in this harsh landscape dwells the most fearsome of all creatures indigenous to the Forest Moon of Endor—the giant Gorax.

Incredibly massive, the Gorax is a true behemoth more than thirty meters high, pushing the limits of growth even

Natural predators of the Ewoks, the giant Goraxes break into even the highest of tree villages and take captives for their own amusement back to their caves in the rocky highlands. in the low gravity of the Forest Moon. The Goraxes live in their high crags, making their homes inside immense grottoes.

The Goraxes look vaguely humanlike, with tapered primate faces and narrow chins. They make grunting, roaring noises that seem to convey raw emotion—anger, amusement, hunger—but no discernible words. The Goraxes wear fur clothes held together by large, rough stitches. For weapons they fashion stone axes from slabs of rock lashed onto handles made from entire tree trunks. Imagine what fighters they could be, if the Emperor could

figure out how to train them.

The Goraxes hang enormous ornaments upon their bodies, rings the size of docking ports dangling on their earlobes, beads the size of boat anchors in their hair. Their large, pointed ears are the size of dragons' wings, swept back and curved to be highly sensitive to the noises of smaller creatures.

The giants thrive on heat and keep a bright fire blazing in their caves at all times. Since they live out in the deep desert, the Goraxes must make frequent expeditions to the forest to gather fallen trees. Because the Goraxes live in shadowy caves, their glittering-black eyes are unaccustomed to bright lights, and they are easily blinded. Therefore, the Goraxes hunt primarily at night.

I ceased being so enamored of these monsters, though, at about the time our entire party was captured by one of the behemoths.

Ithough they are primitive and powerful, Goraxes like to keep pets. For instance, a Gorax will find a boar-wolf mother who has gone to ground in a cave to give birth to a litter of young. The Gorax smashes open her whelping place, kills the new mother, and selects a young boar-wolf pup it wants for its pet. In keeping with its own fondness for

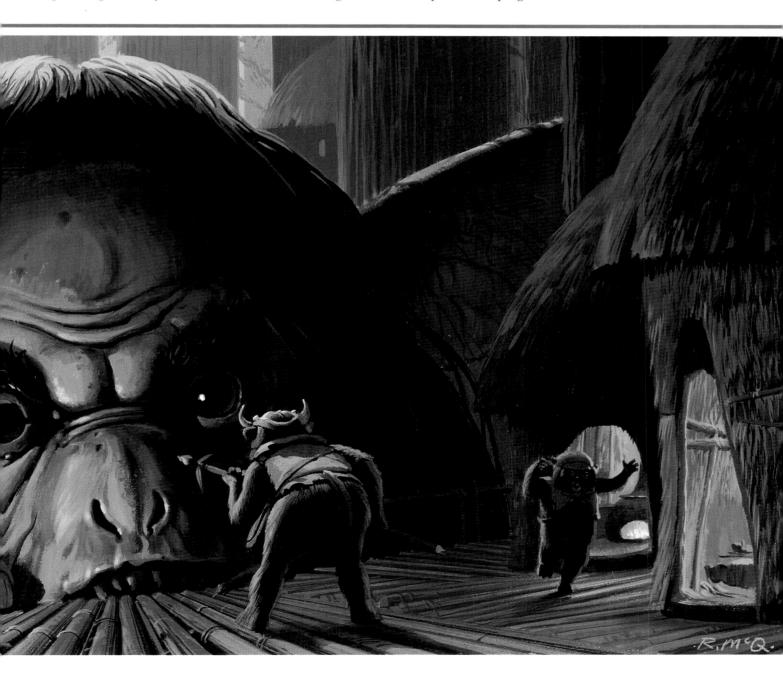

bodily ornamentation, the Gorax will strap leather collars and harnesses on his pup, raising it as a hunting companion.

In search of other pets, the Goraxes kidnap Ewoks, smashing through the walls of their tree-city huts and grabbing a handful of wriggling furry captives. Unfortunately the giants have limited intelligence and an extremely short attention span. Some of their pets starve through lack of attention; others die when the Gorax grows bored and kills them.

similarly, the Gorax took great delight in finding our bright white-armored forms scrambling among the rocks, and it managed to capture all of us. Hunting by night, as usual, one Gorax was attracted by the defensive lights around our camp perimeter. The Gorax smashed the bright lights and then chased us around the rocks, scooping up every single member of our party.

As the stormtrooper escorts rushed out, setting up tripods for their portable blaster cannons, the Gorax grabbed the struggling white captives and stuffed them into a sack at its hip. Before long, I found myself shoved in with them as well. There seemed to be no escape.

Satisfied with its night's work, the Gorax marched back to its cave, where it placed all of us in a huge hanging cage made of lashed logs. Apparently curious, the Gorax wanted to see what lay beneath the shiny white shells of the new creatures, and so the giant prodded the five stormtroopers to peel away the armor. The Gorax grew frustrated, then tore the armor away itself. None of its new pets survived the inspection.

Luckily the Gorax lost interest quickly and collapsed onto its heap of sleeping furs, snoring like a thunderstorm in the close confines of the cave. Seeing our chance, we used the laser cutters in the packs—finally, a piece of Imperial-issue equipment that actually worked!—to hack our way free of the crude cage and flee out of the winding caves to the lower catacombs.

ne fearsome creature that has formed a symbiotic—or perhaps parasitic—relationship with the giant Gorax is the "rearing spider," a massive but slow-moving beast. Six-legged, with large tusks instead of piercing fangs, rearing spiders reside in the bottoms of caves inhabited by the Gorax, living on scraps discarded by the giants and disposing of the remains of forgotten pets. The rearing spiders spin large, thick webs across expanses of the caves—but these webs are primarily nests, rather than traps to capture prey. While they will attack intruders when provoked, rearing spiders mainly hide in the

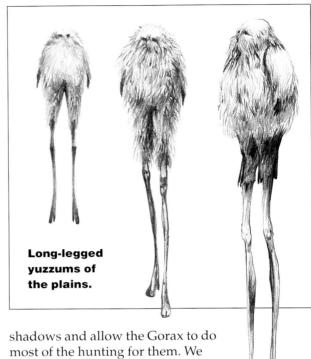

shadows and allow the Gorax to do most of the hunting for them. We encountered one of these large creatures on our escape, but luckily it had no stomach for battle and fled into the shadows as we charged out of the Gorax's lair. In the dimness of the Endor-lit night, we raced across the desolation, fleeing the land of the Gorax.

est of the densely forested terrain lie oceans and oceans of grass, plains of dry brown in summer, blankets of velvety bright green after the spring rains. The delineation between arid savanna and thick forest is very abrupt. In clumps in the hollows of rolling hills are islands of trees, a slash of dark green on the wind-rippled plains, where small animals make their homes.

We trudged out into the vast grasslands, seeking safety and shelter until the return ship could retrieve us. My Ewok-loving comrade told me that the furry vermin call this savanna the Dragon's Pelt. I told him to shut up.

As far as the eye can see, the rolling brown grasses are studded with dark lava rocks that jut like blackened teeth out of the ground. A range of snowy mountains, the Dragon's Spine, lies across the horizon in the distance, but it was much too far away for us to reach.

One night on our plodding journey we were visited by what I can only call fairylights at our evening campfires. These tiny, luminous flying creatures come out at night with buzzing, squeaking noises. Swarms of them were attracted by fires and our

Yuzzums wade through the grass, hoping to catch *ruggers*, succulent rodents that they roast over open fires on the prairie.

presence. We tried to shoo them away, but nothing seemed to work, and the things continued to pester us long into the darkness. The fairylights did no obvious harm, other than forcing us to lose sleep with their flashing, spinning, dizzying light shows.

We could not tell for certain what the fairylights eat, or even whether they are true life-forms rather than just strange bright phenomena. The lights seemed to absorb firelight as a source of nourishment, but one of my surviving companions insisted that they thrived on happy emotions and expression of warm feelings, such as laughter or giggles.

If this is so, then they got very little nourishment from me.

n the following day we ran into a swarm of yuzzums, creatures even less intelligent than Ewoks, that dwell on the plains of Endor. Standing tall on stilt-like legs above the whipping dry grasses, yuzzums wade through the savanna, looking down and searching for rodent-like ruggers running through the grass to their communal warrens.

Yuzzums have a wide mouth with protruding teeth, and a shock of dark hair on top of their heads. Groups of yuzzums stride side by side through the tall grasses, searching for a fresh rugger meal. At times, when a yuzzum manages to snatch a rodent sunning itself on a rock, he will eat the rugger raw, snapping the entire thing down his gullet, fur and bones and all.

At other times, a yuzzum hunting party will burn narcotic weeds into the holes of the rodent warrens. The small furred creatures stagger out, seemingly dizzy and delirious—easy pickings for the yuzzums to thrust into large sacks. Then the yuzzums have a rugger-roast over a crackling bonfire near one of the clusters of dark trees in the hollows. The yuzzums skewer the small creatures on sticks and, after roasting them, ritually stride about on their stilt-legs, feeding each other the sizzling meat, offering pieces to their companions and eating only what others offer to them. We found the whole ritual sickening and disgusting.

Yuzzums are partially intelligent, but seem unable to understand any life-form but their own. Which was fine, since we ignored them right back. I had, of course, heard of yuzzums before, as they were kidnapped at one time to be sold throughout the Empire by black marketeers as slaves or pets.

I recalled vividly that one smuggler had tried to pay off a long-outstand ing debt to Jabba the Hutt with a cargo of yuzzums. Instead Jabba fed the smuggler to his rancor in the pit, along with several of the yuzzum prisoners. The rancor didn't much care for the yuzzum meat, though. As I understand it, some of the kidnapped yuzzums can still be found hanging, mostly forgotten, in Jabba's dungeons.

a sort. But our choices were limited on Endor. Some of the most fearsome creatures on Endor live out on the Dragon's Pelt savanna. The reptilian marauders work together in a powerful military fashion to bring terror to the Ewoks and cause damage out of sheer spite. How could we not like them? The marauders have greasy, thick strands of hair, usually pale, sometimes dark, sprouting from the crowns of their flat heads, occasionally from the skin on their faces.

Heavy protective brow ridges thrust like hoods over glittering eyes; pug nose-holes give the marauders a skull-like appearance.

They captured us, dragging us into their castle, but we could tell we were among like-minded creatures. The long-lived marauders originated off-planet and crashed nearly a century ago on the Forest Moon. As they tortured and interrogated us, we picked up a few details of their situation as well.

The marauders had once imagined themselves to be great pirates of the spaceways—but because none of them understood how to pilot their stolen ships, their reign of terror and plunder proved much shorter than they had expected. They came in a stolen ship they were barely able to pilot under the best of circumstances, and the navigator could not handle the complex gravity patterns in the Endor system (see my earlier comment).

Though the navigator survived the crash, he was executed immediately for his unconscionable failure. None of the other marauders had the slightest

idea how to repair their ship and get off the moon, and with the navigator dead they had no idea where to go on to from here.

esigned to their fate, the marauders built a large ancient-style castle, which comforted them with its imposing stone walls. They cannibalized parts of their wrecked spaceship as furniture. For his throne, the marauder King Terak tore the captain's chair from the bridge of the dilapidated ship and placed it in his royal audience chamber.

Carved, horned lava-rock obelisks guard the front approach to the castle, warning off enemies and boasting of the murderous prowess of the marauders. The castle itself looks clumsy and squarish, with no finesse—but it is very sturdy, made of quarried stone blocks hauled by blurrgs, their beasts of burden.

Stones around the castle entranceway shout out with crude carved hieroglyphs, but many of the words are impossible to interpret, since few of the marauders can read or write Basic.

The castle is surrounded by a deep moat filled with black water. While constructing the castle, one of the marauders suggested installing the still functioning automatic defense mechanisms from their crashed ship for further protection against assault. A selective disintegrator field, shaped like a torpedo, targets any object that touches the water. (The marauders themselves fear this defense greatly, because they have forgotten how to turn it off!)

Terak, the king of the marauders, holds his mercenary pirates together while he searches for a new power source to be installed in their long-disassembled attack ship. He expects the solution to their exile to be a simple one, a gadget he can add to the abandoned ship so that it can take off again even after decades of disrepair.

Terak himself doesn't remember why he is searching for a power pack, but he is obsessed with get-

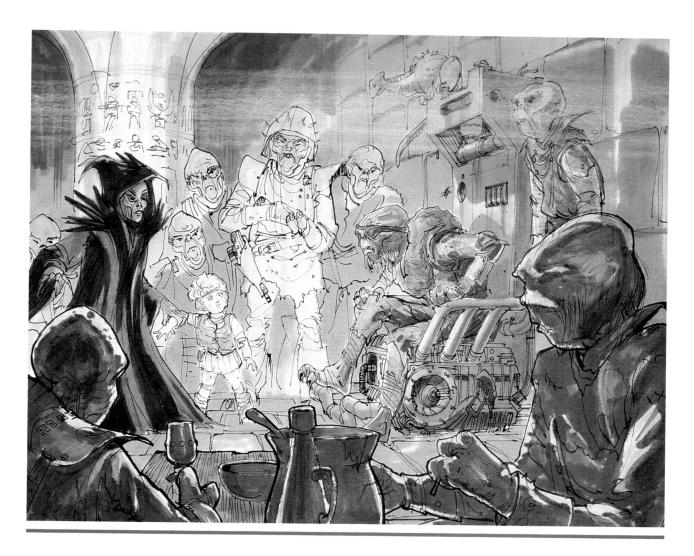

The marauders of Endor are creatures more akin to Imperial understanding, though pathetic in their own way. They revere their powerful technology, though they have forgotten how to use it.

ting the power—even though he would not know what to do with it if he held it in his scaly hands. However, he could be a useful ally, if the Emperor wishes to join forces (in name only) with a warlord already on Endor.

is companion, Charal, is a female shape-shifter, a Force-wielding witch who apparently escaped from her exile on a planet called Dathomir. Working by her form-changing deception, Charal fell in with the band of reptilian marauders when they were already in their last days, while they were being hunted down by combined space law forces...as was Charal herself. She intended to stay with Terak and his raiders only long enough to get herself another passage to freedom—but the shipwreck on

Endor ruined everything.

The lower-ranking marauders are staunchly loyal and subservient to their leader, but otherwise they are obsessed with rank and title among themselves. Over their decades-long exile, the marauders have made up new ranks and titles for themselves so that everyone has an impressive-sounding place—but no one exactly understands the hierarchy anymore. Nevertheless, these communal creatures prefer to be in large groups, feasting in banquet halls, playing card games with each other, even marching out to raid the Ewoks. They do not feel comfortable being alone.

Because they are stranded on Endor, and because they know no way other than preying on weaker people, the marauders regularly raid Ewok tree villages just inside the forest boundary, burning their dwellings and taking the Ewoks prisoner for use as slaves to perform manual labor. See, another reason for accepting them as allies!

When marching out for battle, the marauders wear helmets and armor cobbled together from scraps of their old protective suits, junk, metal, and thin shielding plate peeled off the abandoned ship. Inside their helmets and boots and across their chests they wear yuzzum-fur ornamentation, as well as capes and suits made from blurrg hide and condor dragon pelts. Before marching out on a great attack, the marauders blow battle horns and carry banners to symbolize their individual ranks. Despite the imposing appearance of their blockish castle and their leftover blasters and other high-tech weapons, the marauders have a very rudimentary understanding of technology, which often causes more harm than good when they try to use it. The one technological thing the marauders understand is their weapons—most of which are simple old-style blasters and blaster cannons. They have managed to keep most of their weapons working decade after decade, though now many are cloth-wrapped, rusted, and barely functional.

As a last resort, the marauders are also proficient with long swords for hand-to-hand combat.

The marauders have successfully domesticated large two-legged savannah beasts—blurrgs—for their heavy labor. The topheavy monsters look primarily like a bloated reptilian head standing on two meaty

legs with splayed three-toed feet, balanced from behind by a lashing tail. The blurrg's mouth, huge out of proportion even to the size of its enormous head, is a constant eating machine for shoveling savannah grass, weeds, saplings, and

anything else edible that gets in its way.

The blurrgs are stupid and slow, but very strong. Marauders control them with spiked chain bridles, riding on their smooth backs with stiff saddles, though occasionally the beasts fight back in a slow, reflexive way.

At first the marauders attempted to use blurrgs as attack creatures, but the creatures simply did not react fast enough, nor could they be provoked into anything more than a slightly riled stupor.

lurrgs are so stupid they walk right into small trees, knocking them down with their massive-stone-skulled heads. A blurrg might overestimate its own strength, or underestimate the strength of the tree, and batter itself senseless trying to crash through a thicket, rather than just going around. Blurrgs can get hopelessly tangled in the underbrush, unable to remember how to get back out again.

The marauders took us down into their dungeons, and they took all of our weapons and posses-

The marauders of Endor are a brutal lot, stranded on the Forest Moon because they do not have the skills to fix the technology they have stolen. Their leader Terak (top) and his shape-shifting Nightsister partner Charal (left) keep the rowdy marauders in line through sheer intimidation.

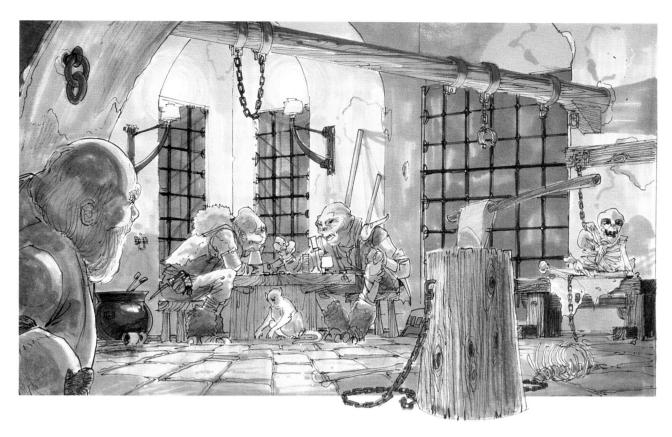

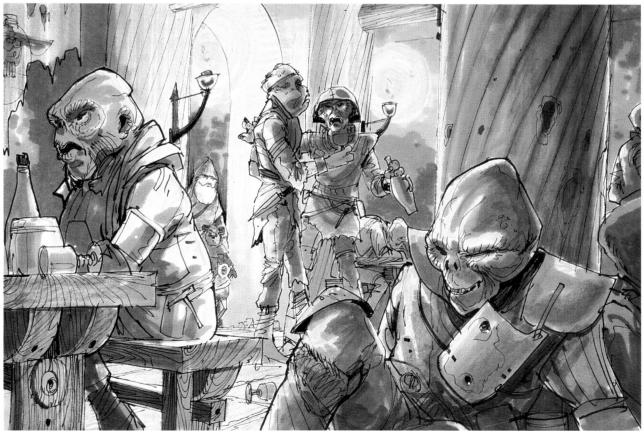

sions, but in the end they tortured only one of us to death. The Force witch Charal, who called herself a Nightsister, freed us after making us promise to take her with us when the retrieval ship homed in on our beacons—but Terak grew angry with her and tossed her into a cage even as we escaped into the savanna, watching the lights of the retrieval ship plunge through the evening skies.

We ran to the open doors of the retrieval ship, only three survivors out of the original nine, as the marauders pursued us, but a few blaster shots from the ship frightened them off.

We left Endor with nothing more than our memories and my report. The final decision is up to the Emperor, of course, but I hope he chooses never to return to this unpleasant Forest Moon.

Marauders often take captives, using *blurrgs*, their dinosaur-like beasts of burden. In this manner, they maintain their reign of terror and keep the Ewoks under control.

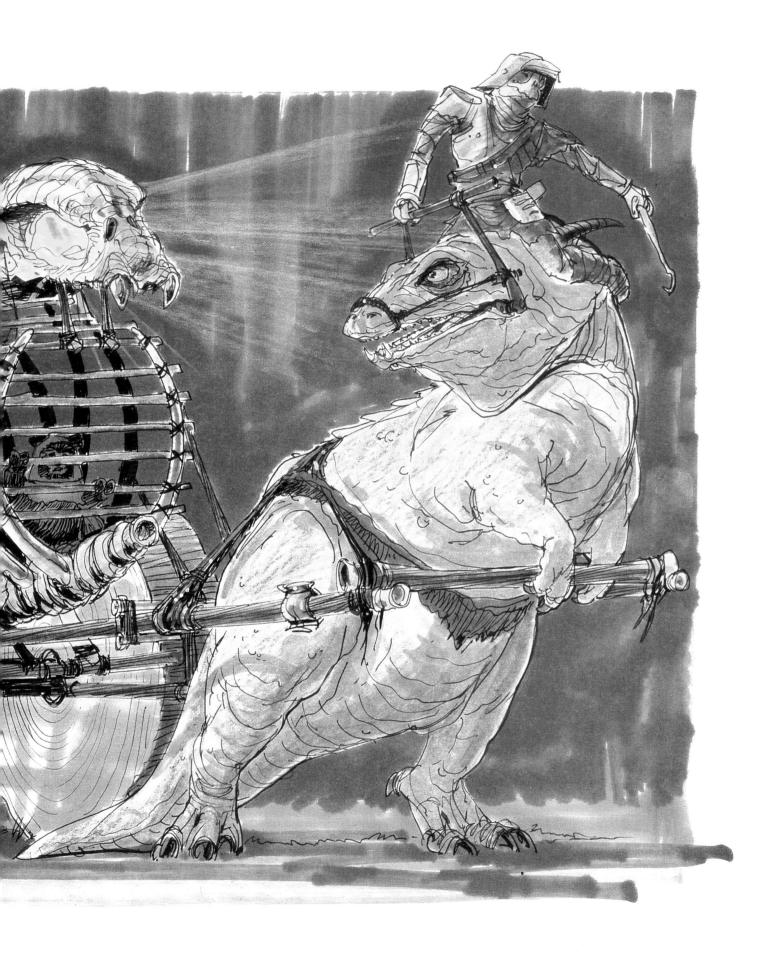

BESPIN

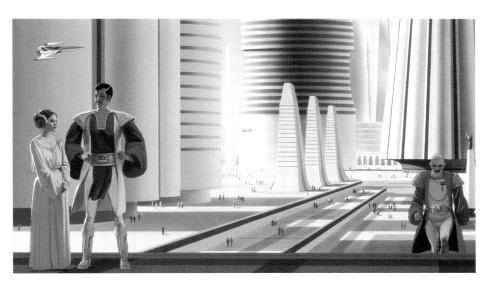

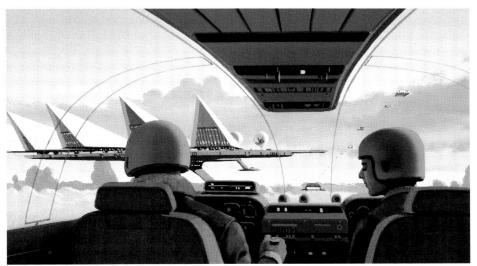

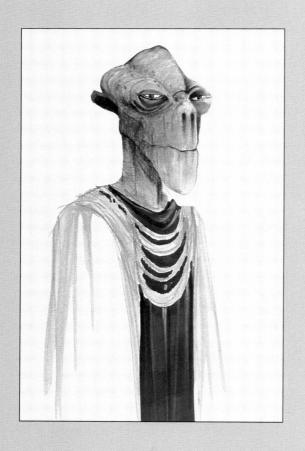

ABOUT THE AUTHOR:

Councilman Po Ruddle Lingsnot is an amazing success story in the annals of Cloud City: a former used-cloud-car salesman who got himself elected to the Council on Tourism and Extra-Planetary Investment, he is now an established member of the Exex, the ruling bureaucratic class in the city. A tireless promoter, Councilman Lingsnot is not content to remain in his plush offices or simply attend meetings—he is present at every vital civic event, a smiling welcome for each interplanetary dignitary who comes to Cloud City. He makes no secret of the fact that he would love to be Baron-Administratory someday. In person, Councilman Lingsnot spends his every breath extolling the virtues of the planet Bespin, as he has also done in this report describing his cloudy world.

BESPIN

he gas giant Bespin is an isolated world renowned for its productive gas-mining facilities and its peaceful relaxation environment, as well as wildly extravagant gambling in the luxury resort levels of Cloud City, which is itself the most famous floating metropolis in the galaxy. Yes, Bespin is an untapped resource, one of the best-kept investment secrets in high-rolling financial circles—a world that has something for everyone.

The planet Bespin rotates rapidly, once every twelve hours, giving two full "days" and "nights" for every standard day. The

cloud layers are 1,000 kilometers thick above a metal core buried deep within tumultuous outer layers of seething high-pressure liquid and denser gases reaching temperatures of some 6,000°C. This cauldron has brewed some of the most valuable chemicals and gases in the sector,

and mining activities have so far barely touched the potential of this world's wealth.

Bespin's economy has branched out in two primary directions—industrial-

ized gas mining to exploit the rich resources of the gas giant, and lavish tourism catering to the wealthy classes looking for a truly exotic holiday.

BESPIN'S INDUSTRIAL INVESTMENT OPPORTUNITIES—TAP INTO A FOUNTAIN OF WEALTH

as proof that this is no fluke, no fly-by-night mineral strike, the resources of Bespin have been quietly excavated for many years. Our history is a saga of foresight, daring, and extravagant riches.

The legendary Lord Ecclessis Figg, well-known Corellian explorer and investor, discovered a pleasant surprise on his inspection of supposedly unremarkable Bespin: Large concentrations of pure Tibanna gas lay in the upper atmosphere. Tibanna

gas has long been treasured as a hyperdrive coolant; no better substance has ever been found to serve this purpose, and thus it has been widely sought after by entrepreneurs in every sector.

Usually found in stellar chromospheres and deep in nebular cores, Tibanna gas has always proved difficult to extract from the

source. Unlike other concentrations, Bespin's Tibanna gas was—and is!—easily accessible. Further assays, which Figg conducted in strict secrecy, showed the clouds to be filled with extractable quantities of other valuable gaseous compounds as well, which were often flung into the upper atmospheric levels by deep storms.

eing a shrewd businessman, Figg saw his chance to become enormously rich—if he could pull his scheme off. With his flamboyant personality, Figg wooed and then married a lesser

noble from the Royal House of Alderaan; she made her private fortune available to him and his eccentric pursuits. His previous ventures had been

marginally successful in various parts of the galaxy, but finally he paid her back ten times over with his fabulously successful gas mining facilities on Bespin.

A technical note: When it is excited by high frequencies, Tibanna gas produces intense packets of

light that can be focused into destructive blaster beams. If compressed and "spin-sealed," Tibanna gas produces

four times the energy output

of other competing gases for weapons production. Normally the spin-sealing process requires incredi-

On Bespin, marvelous air transportation systems are available for all of our valued tourists, regardless of body size or configuration.

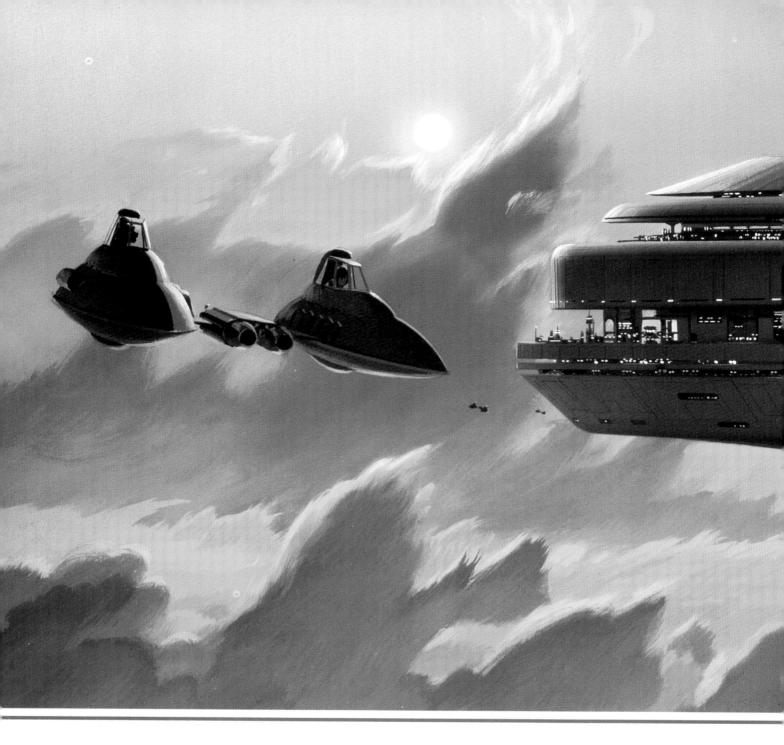

ble energy, so few companies have tried it on a commercial scale—but Lord Figg also discovered that Tibanna gas from deep in Bespin is *naturally* spinsealed. Thus, Bespin Tibanna gas is superior to all competitive products on the market.

igg's first mining stations were simple automated containment vessels that descended into the thick clouds, filled themselves with atmospheric gases, then returned to processing ships in orbit. As with many first steps in a large operation, however, these nonselective mining stations proved very

Cloud City is a magnificent sight, particularly at dawn, when the pale sun slants through the highrising clouds. The skyline displays a wealth of fine hotels.

wasteful, since most of the captured gas was useless.

The next foothold established on Bespin occurred when Lord Figg erected the *Floating Home* mining colony, our first permanent settlement. As a gathering point, *Floating Home* launched the boom of fortune hunters trying to strike it rich mining the gas clouds—a boom that continues unabated to this day.

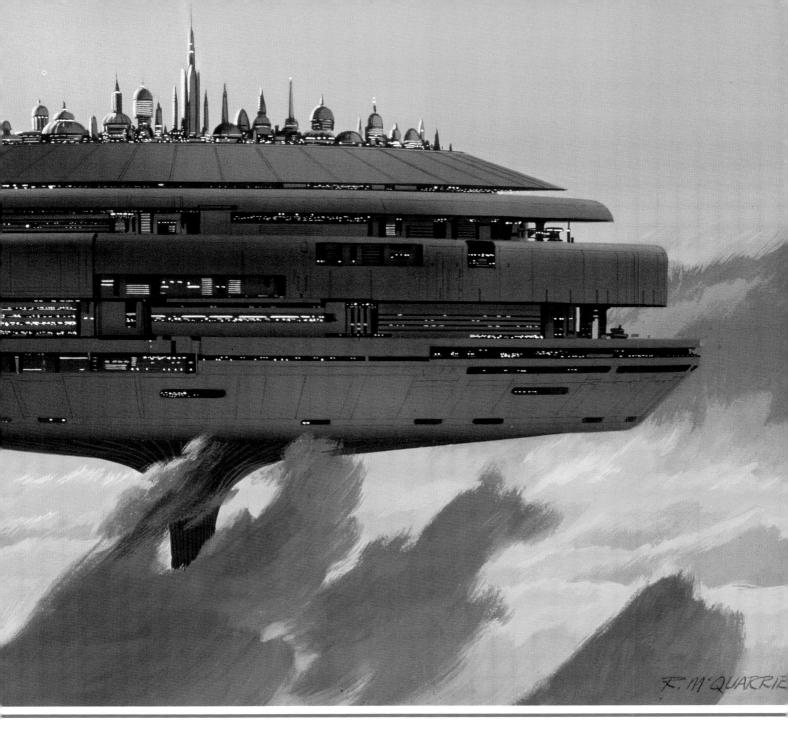

In iding the wind currents around the planet, numerous other airborne mining installations were constructed—floating automated refineries, storage tanks bobbing above the clouds, and skimmer facilities to scoop gases from different levels of Bespin's cloudbanks.

For the more volatile gases and other elements extracted from Bespin's atmosphere, stand-alone floating refineries dot the clouds. These refineries are carefully isolated, given special detection and motivation systems to keep their industrial odors and noises away from populated floating cities.

The skies of Bespin are large, giving plenty of room for everyone and every purpose.

In a major mining installation such as Cloud City, the Tibanna gas is drawn up through the central core, where it is pressurized, refined, encased in carbonite, and stored. With hyperspace shipping systems in place, the freshly mined gas is efficiently distributed across the galaxy.

Since Tibanna gas is also a crucial component in the phasing chambers of high-powered blasters and turbolasers, the Empire has restricted its distribution, but Cloud City business-creatures have found

GAS PROSPECTORS

Bespin welcomes free spirits, and not all commercial exploitation is under the control of Figg & Associates. A small but important group of hardworking individualists ply the clouds as gas prospectors.

Gas prospectors pilot their own container ships, scrappy, cobbled-together vessels, sometimes assembled from components scavenged from abandoned gas refineries. These picturesque folk are a colorful, albeit infrequent, sight across Bespin's skyscape.

The prospectors search for "gas strikes," such as when a plume of deep gas spurts into the heights because of deep internal storms in the lower levels of the atmosphere.

Bespin's rapid rotation gives rise to intense storms and high winds, occasionally belching up gas products synthesized in the churning furnace far below. Often these gas geysers are detected by our orbiting satellite network, and the race is on between behemoth-sized corporate mining ships and scrambling gas-prospector crews to see who will reach the lucrative strike first.

Some gas prospectors, seeking riches from a fruitful outburst, ride extremely close to storm systems, hovering on the edges and waiting for gas eruptions. Unfortunately, the unpredictable storms frequently prove too much for the heroic lone prospectors, and many vanish without a trace. The violent storms take the prospectors, their rickety vehicles, and their gaseous cargo into the depths of the clouds.

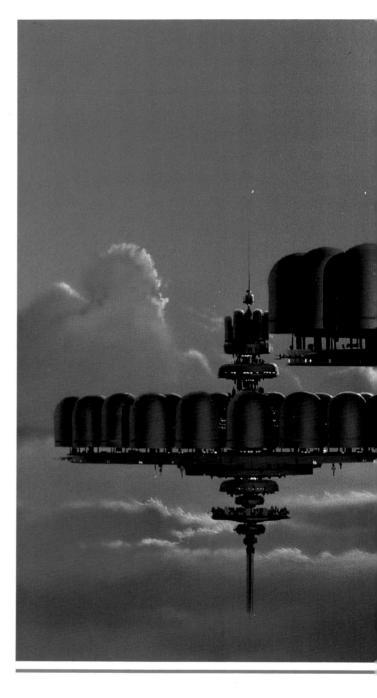

ways to work within the law to arrange distribution through alternative channels. While it has been suspected that much of the contraband Tibanna gas used to manufacture weaponry used by the Rebel Alliance comes from Bespin, no conclusive proof of this has ever been presented.

Infortunately, due to the too-rapid industrial expansion at the beginning of Bespin's boom years, not all of the floating installations proved profitable. Hopeful investors overestimated the de-

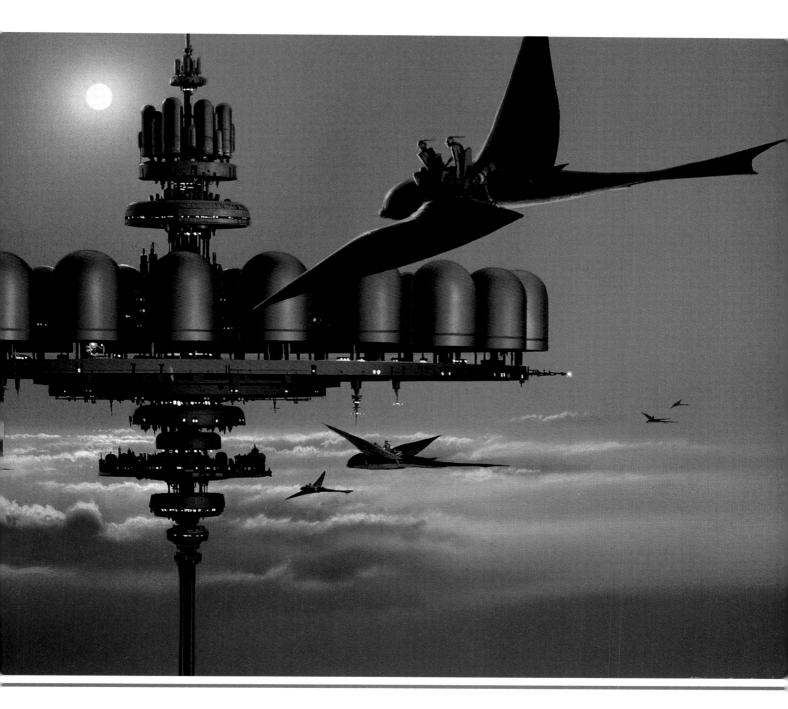

Tibanna gas refineries process and store this valuable substance on which the economy of Bespin rests (above). Other, smaller levitating cities drift near the refineries (left).

(pages 146-147) The abandoned city of Tibannopolis, a derelict boomtown in the sky, is a landmark that is often visited by young students of history.

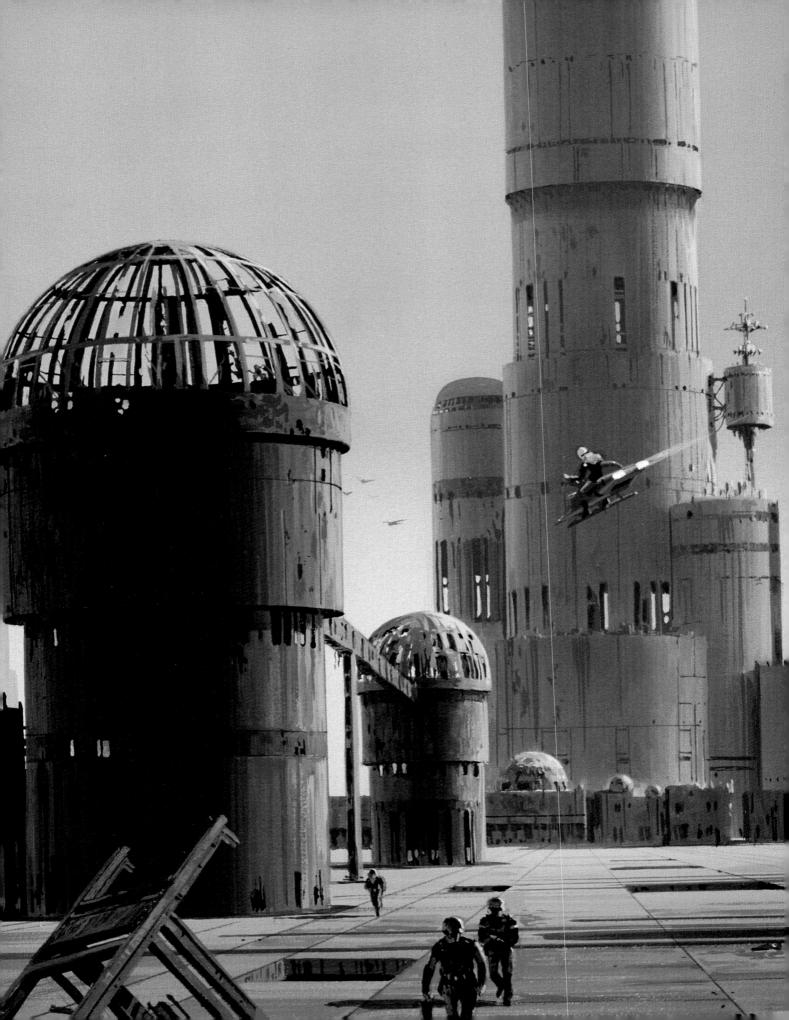

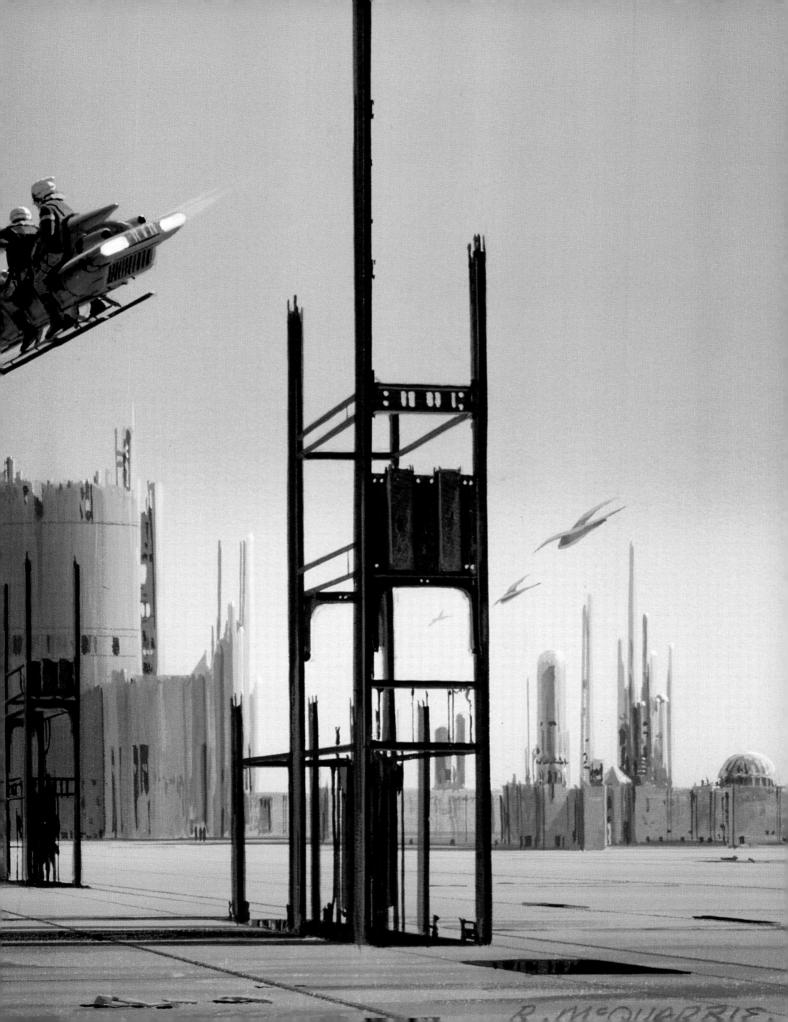

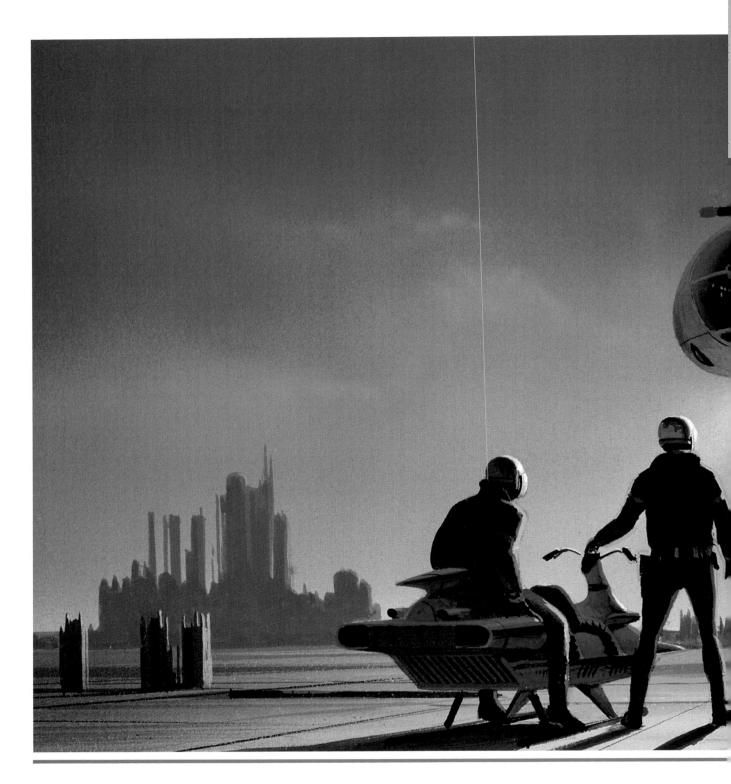

Sky traffic patrols
ensure the safety
of all cloud-car
passengers and
pilots, especially
around restricted areas
such as the damaged sections of Tibannopolis.

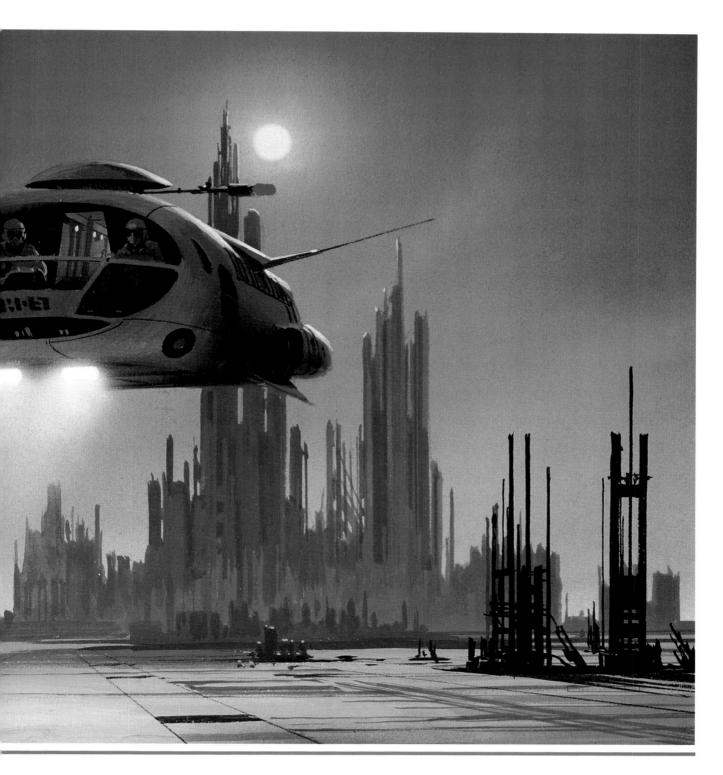

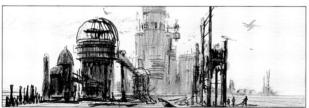

mand for certain gases, and prices fluctuated disastrously. Independent, self-sustaining operations ran into enormous expenditures just to keep the repulsorlifts operating for huge metal constructions. Unlike space stations in orbit, Bespin's floating cities hang free in the atmosphere, requiring great force literally to "keep themselves afloat."

When such facilities went bankrupt, their owners usually shut down the repulsorlift reactors and sent the entire construction plunging into the cloud depths below.

ne drifting colossus was left hanging empty, though—a huge creaking ghost town in the sky, named Tibannopolis. The ruins of Tibannopolis, tilted at an angle, still hang above the roiling, dark clouds. The energy cores of the repulsorlift generators are slowly dwindling over the years, beginning to malfunction.

Because the people of Bespin are so hardworking and resourceful, the roof, decks, and sides of derelict

Tibannopolis have been picked over. The empty structure looks like a floating skeleton, with its buckled

plates and twisted support girders in a broad hemisphere and its dented ballast tanks slung below. Numerous antennae and weather vanes protrude from the joints.

The wreck of Tibannopolis is a popular place for sight-seeing, though. Daredevils frequently go there, as if they consider it the neighborhood "haunted house." On a warmer note, the empty city is also a spot frequently used by young lovers for

secret trysts—what it lacks in luxury, it makes up for in privacy!

In a misty transition layer of clouds, a marvelous and surprising ecosystem thrives among floating rafts of stable algae. Sightseers might encounter exotic flying creatures (left and above), many of which have never been catalogued.

NATURAL WONDERS—EXOTIC LIFE IN THE CLOUDS

With only air and mist and clouds, and its only surface deep, deep below and at immense pressures, Bespin might not seem a likely place for a broad ecology. But life is wonderful and tenacious across the galaxy, and this planet is no exception.

Rudimentary floating life—from microscopic algae clusters to huge balloonlike beldons—thrives in the temperate atmospheric levels, metabolizing the sunlight, breathable gases, water vapor, and concentrations of other nutrients. Some of the galaxy's most prominent exozoologists have come to study the creatures of Bespin, and tourists marvel at their color and their beauty.

Self-contained plankton bubbles drift about in clumps, beside wispy concentrations of algae.

The algae nodules form around ice crystals and water droplets in the clouds. The algae clusters eventually fill with air pockets, causing the greenish mass to

settle at an atmospheric level where their pressure is equalized. One species of floating algae, "pinks," is so plentiful that the clouds of Bespin have a distinctive rosy tinge.

nother species of algae, "glowers," inhabits the deeper cloud layers. On the night side of the planet, a purplish glow can be seen. Wind currents and convection bring wisps of mist teeming with glower-algae, causing the night sky below to look like a bizarre luminous landscape. Often at night the people of Cloud City sit out and watch from the upper decks or the lower observation lounges to see the eerie, swirling purplish clouds, backlit by occasional flashes of lightning buried under the thick mists. It is a breathtaking sight.

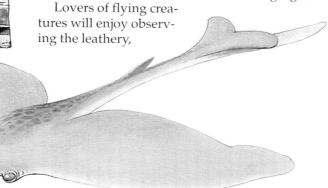

batlike scavengers, called rawwks, that inhabit many of the floating structures, especially the abandoned ruins of Tibannopolis. Flocks of rawwks cluster in open girders, nesting and reproducing. Every day they fly in great waves down to feast on floating algae beds.

In the high-pressure levels of the atmosphere, much like the deep-sea lifeforms on ocean worlds, are extremely bizarre uncataloged creatures, as well as the enormous floating animals called beldons.

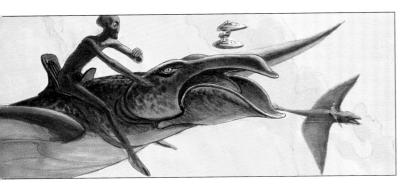

Beldons are giant balloonlike gas bags that metabolize the natural chemicals at the slushy gas-liquid-solid interface far down in Bespin's atmosphere.

Beldons occasionally rise high enough to be ob-

served in the temperate levels of the atmosphere. Anecdotal accounts

from solitary gas prospectors and station managers on isolated gas refineries tell of seeing huge beldons like giant sails floating above colonies of algae, dipping down with their numerous hair-thin tentacles to feed. The most frequent sightings

occur at Bespin's poles.

Beldons may be long-lived, and they may be herd

animals. Only one specimen has been studied closely, found floating dead after apparently being burst apart in a lightning storm. But the carcass was so huge it could not be hauled anywhere for storage much less a thorough dissection.

It has been postulated, with a great deal of enthusiasm and only circumstantial evidence, that beldons possibly give off Tibanna gas as an exhalation product.

Beldons are surrounded by a small electric field, which they use to detect the approach of intruders. This electric field helps them avoid ships, approaching storms, and natural predators. When clustered together as a herd, the beldons' electrical "sensor net" can extend for hundreds of kilometers, occasionally going so far as to interfer with vehicular traffic in the area.

Beldons move about by pumping exhaust gases, self-generated electric fields, or they just drift about on the winds. Their only defense against the predators of Bespin—such as packs of flying velkers—is their massive size. Even so, one beldon will sacrifice itself to allow the rest of the herd to escape.

Pelkers are V-shaped natural killers, with tough claws and armored wings evolved to tear and disable the tough outer skins of beldons. Velkers hunt in packs because it takes a large group to rip apart their enormous prey. When killing a beldon, the velkers swarm onto its outer skin and begin to systematically shred it with meter-long claws, chewing the beldon flesh with rows of mouths that line their bellies.

Once a beldon's hide is breached, it begins leaking the gas that keeps it aloft, and slowly it sinks to lower levels. The velkers continue feasting for days until the beldon descends deep enough that the velkers fly off in search of other prey. The beldon victim eventually crashes into the liquid-gas interface layer far below.

Velkers can attain remarkable speeds in flight, soaring to extremely high altitudes. The flying predators have an electrical field surrounding their bodies as well, creating discharges that can damage passing cloud cars as well as beldons. Velkers seem to thrive on energy discharges from the great storms; it may be that they reproduce during such enormous electrical disturbances.

Velkers will attack small ships that approach them too closely. A large pack of velkers has even

The silent mysterious thranta riders (above and left) often paint themselves with amazing skin patterns. Only a few lucky tourists ever catch a glimpse of their tantalizing culture.

attacked Cloud City itself, as if mistaking the giant floating metropolis for a strange beldon. However, these incidents are rare, and usually cause no damage.

Some of our most interesting creatures, though, are not native to Bespin. A small herd of the flyers known as thrantas was transplanted from their world of Alderaan as possible beasts of burden to be used here among the clouds. Thrantas are floating beasts with broad, saillike wings and body cores composed mostly of a lighter-than-air bladder. After the destruction of Alderaan, Bespin's small herd of thrantas comprises the only surviving representatives of their magnificent species.

The Alderaanian thrantas were brought to Bespin with alien riders and wranglers. The riders perform a monthly "sky rodeo" of breathtaking feats, in which the talented alien riders leap out into the open sky, falling and falling until the thrantas swoop down to the rescue. The sky wranglers ask for volunteers from the audience, but they rarely have any takers.

CLOUD CITY—THE SILVER LINING OF BESPIN'S CLOUDS

Cloud City, one of the marvels of the galaxy, is a place to invest, to relax, to entertain... it is like nothing you have ever seen before.

This glamorous and beautiful metropolis is located at the planet's equator in a "temperate" band thirty kilometers deep. The atmospheric pressure and temperature are pleasant to human life, allowing Cloud City to dispense with expensive closed environments and sophisticated life-support systems.

The entire floating metropolis is over sixteen kilometers in diameter, seventeen kilometers from the top of Kerros Tower to the bottom of the reactor stalk hanging far below. Through the core of the city runs a vast hollow wind tunnel. Side tunnels, called

airways, bleed out of the wind tunnel to the surface, to dispel pressure differentials. Hatches open and close as winds caress the outside of Cloud City. Inside the wind tunnel, large rudderlike stabilizers direct the flow of air up and down, to keep the city level and stable even in gusting winds.

Cloud City is safe even during occasional heavy weather. The tall buildings on the upper surface of Cloud City are designed to be flexible and adaptable, to sway with Bespin's changing winds. Sophisticated weather-watching systems and dispersed satellite buoys have been deployed at various points in the atmosphere to provide an early warning of Bespin's occasional large storms, but most of the time the environment is idyllic and pleasant.

The upper surface of Cloud City displays many landing platforms, towers, and spires. In honor of Ecclessis Figg's wife, most of the city's architecture is based on Alderaan styles—polished white synthetic stone, high ceilings, parklike recreation areas, gently curving corridors. Consistent, soothing decorations with geometric designs and lines run throughout. Plazas and open areas give the impression of empty space and freedom even in a densely packed metropolis.

The popular upper levels of Cloud City contain hotels, spas, casinos, clubs, and museums (mostly describing the triumphs of Figg & Associates and their historic mining operations). Restaurants cater to their clientele's varied tastes and biochemistries, from human to Wookiee, Ithorian, Ugnaught, Twi'lek, and other cuisines.

The upper levels are also jammed with casinos and clubs, for which Cloud City is well known. To

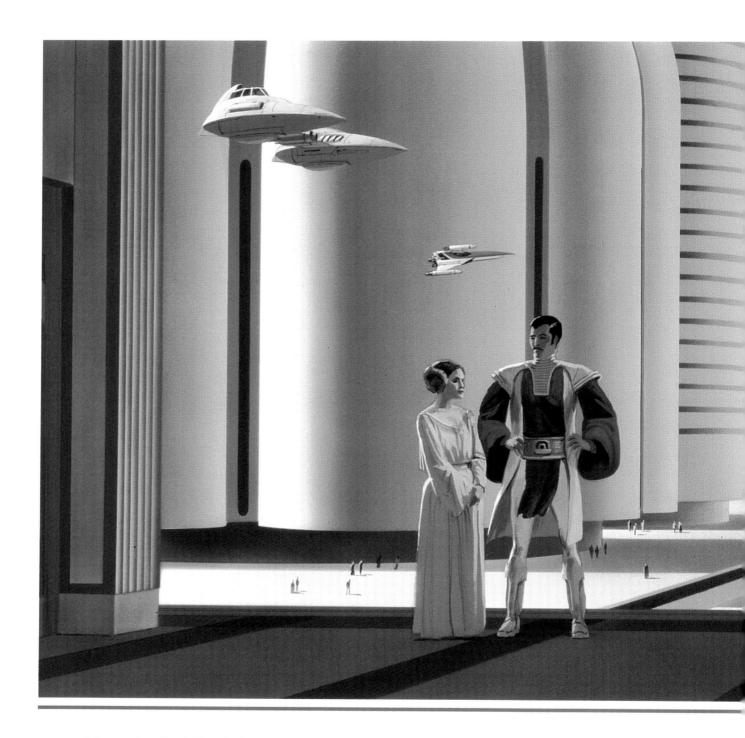

ensure fairness in all of Cloud City's games, the Gambling Authority conducts frequent surprise inspections to flush out dirty dealings and occasional underworld interest. Cloud City prides itself on running clean games. The Gambling Authority also imposes taxes on winnings (10 percent of house winnings, 7 percent of personal winnings), which is fed back into the city's infrastructure and maintenance to make Cloud City a clean and beautiful place to live or visit.

Though originally established as a Tibanna gas-mining station, Cloud City has been called the most precious resort in the galaxy, a place of culture, relaxation, and excitment.

Under endless skies, the open pavilions and plazas of the upper decks are places to relax, meet new friends, and enjoy the riches Bespin has to offer.

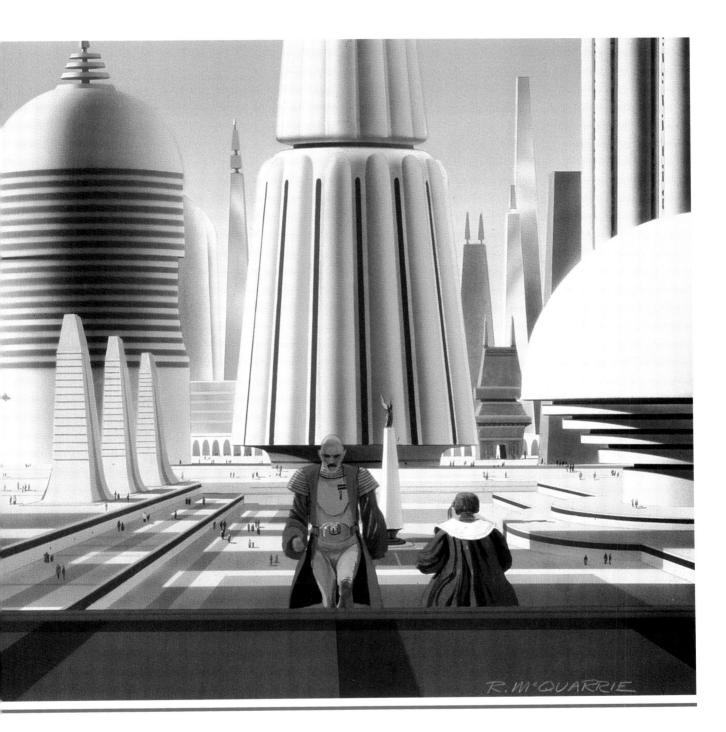

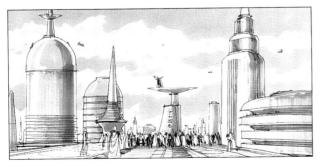

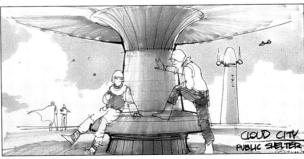

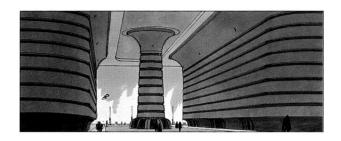

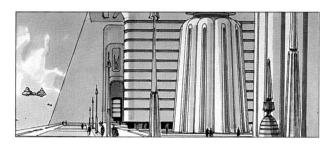

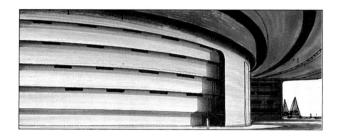

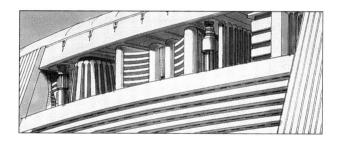

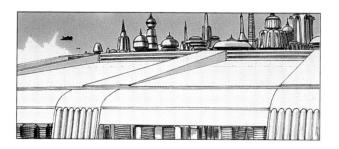

The architecture of Cloud City is clean and smooth, with sweeping, peaceful curves as gentle as the winds. Even on lower levels, staterooms look out upon the cloud vistas or inward to fountains or entertainment centers.

The next levels contain merchant quarters and expensive housing for high-level bureaucrats. Below that are administrative offices. The Merchants' Guild boasts 100,000 members, sellers of tourist items, luxuries, foodstuffs, contraband alcohol, gems, and other trinkets.

ore economical real estate extends toward the core. Levels 121 through 160 are the low-rent areas, collectively called Port Town. Port Town is the home of many unlicensed casinos and gambling establishments—cantinas—hidden among the industrial loading docks. Port Town has gained its own sort of fame as home to all manner of smugglers, bounty hunters, and information merchants.

Sadly, these unlicensed Port Town casinos frequently prey on desperate people, those unfortunates who have bribed or smuggled their way onto ships bound for Bespin, trying to parlay their meager possessions into enough money to survive. Despite many significant social welfare projects, the Cloud City Ruling Council is at a loss for a solution to this problem.

The bottommost levels of Cloud City are devoted to the service sector, factories, gas processing plants, and mining quarters, as well as the tractor beam and repulsorlift generators.

Carbon-freezing chambers are used to lock volatile Tibanna gas into transportable chunks, the best way to transport the dangerous, high-energy spin-sealed material. An object is flash-frozen and then encased in carbonite, which holds the inner temperature constant, as if in stasis. Precious carbonite, which has a variable thermal conductivity, is mined from other systems—particularly the thick outer rings of a gas-giant in the Empress Teta system.

The citizenry of Cloud City consists of humans, droids, and aliens of all species and descriptions.

ertain factions in the city government disagree over major issues, such as whether to support the Empire or the Rebel Alliance in the growing political turmoil—though all branches are unified in their interest in keeping the Tibanna gas mining operation at a low profile to maintain our privacy and productivity. Publicly, Cloud City has declared itself neutral in the matter of the Rebellion, hoping to avoid Imperial peacekeeping forces. Our neutrality declaration also reassures tourists of safety when they travel to Bespin.

Three official branches of government exist in Cloud City—the Baron Administrator, the Exex, and the Parliament of Guilds. The post of the Baron Administrator, in a tradition established by Ecclessis Figg himself on his deathbed, is filled by appoint-

ment of the outgoing Administrator (or, failing that, a majority vote of the Exex). This has led to a wide variety of skill levels among those who have held the position, from inept, to corrupt, to master leaders.

The position of Baron Administrator has been bought, gambled away, or earned through blackmail, intimidation, and even assassination. Lando Calrissian himself became Cloud City's Baron Administrator when he won the position in an incredibly high-stakes game of sabacc.

The Exex are Cloud City's distinguished executive class, who perform the rigorous and ever-increasing paperwork duties without which no great metropolis could function. The Exex are a bureaucratic aristocracy formed from the managers of the original Figg & Associates gas mining operations. Their jobs are handed down from generation to generation, further fostering the impression of a nobility.

The overriding concern of the Exex—as of politicians everywhere—is to maintain the status quo and to minimize drastic changes for the citizenry. The Exex spend much of their time and energy hosting grueling diplomatic receptions, raffling off free cloud cruises to important officials in all governments on all planets. Exex often make highly effective use of small black messenger droids, motorized boxes that seek out a certain person to deliver important messages.

The third branch of government, the Parliament

of Guilds, represents the workers and craftsmen in Cloud City. Delegates from the various guilds throughout the enormous city comprise the parliament, often haggling over new terms and rights among the working people.

UGNAUGHTS—AN EFFICIENT AND ENTHUSIASTIC WORKFORCE READY TO SERVE YOUR NEEDS

mall, hardworking, and loyal, the pug-faced Ugnaughts were the primary constructors of Cloud City. Ugnaughts are renowned for their mining ability, and Lord Ecclessis Figg used them to great effect in his various operations, which was one of the keys to his legendary success.

The Ugnaughts' stocky, compact bodies are efficient energy converters. They can withstand long periods of discomfort. Their original homeworld is long forgotten by them—they were taken away as slaves and dispersed many centuries ago. In this dark time, entire groups of Ugnaughts were sold or leased as "tribes" to large corporations for work on hellish worlds.

The benevolent Lord Figg, however, made an enormous investment to exploit his discovery of Tibanna gas—he bought three entire Ugnaught tribes and gave them a huge task and a huge incentive to do it: If they would build his Cloud City, he would grant the Ugnaughts their freedom and a

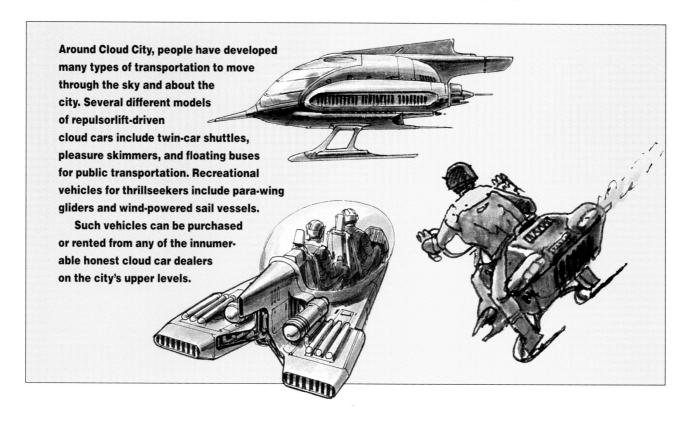

place to live. The little creatures succeeded admirably, and Lord Figg kept his word.

Currently the free Ugnaughts have a lower level of the city to themselves, living in a burrow network, enclosed tunnels with dim reddish light and high humidity. They have also established access tunnels through all portions of the city, with completely concealed access hatches. The network is a veritable labyrinth of conduits, but even so, it

still makes the Ugnaughts comfortable.

The Ugnaughts also have a rich oral tradition, keeping alive stories about other worlds on which they have served as slave workers. They have their own ruling councils, their own apprenticeship traditions, even representatives among the ruling councils in Cloud City. They have never forgotten Lord Figg for granting them their freedom.

Ugnaughts are fast-breeding, with a high propor-

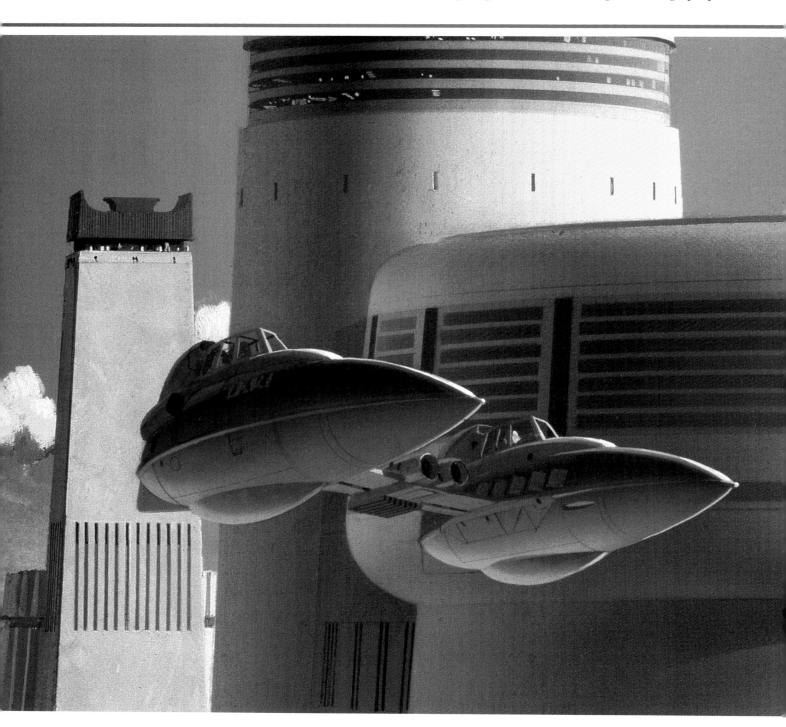

Cloud City (*left*) is also built on industry. In its lower levels, valuable Tibanna gas is spin-sealed and preserved in carbonite for shipment to meet the galaxy's needs.

The Yerith Bespin, Cloud City's finest hotel, is the favorite spot for visiting dignitaries and VIPs. More moderately priced lodging opportunities such as the Holiday Towers or the Stratosphere, are also available.

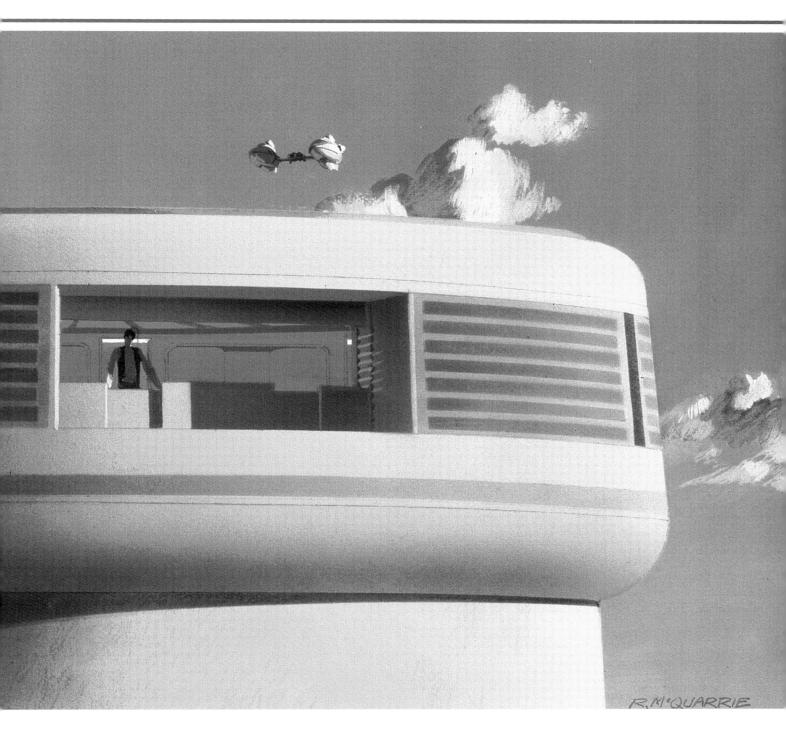

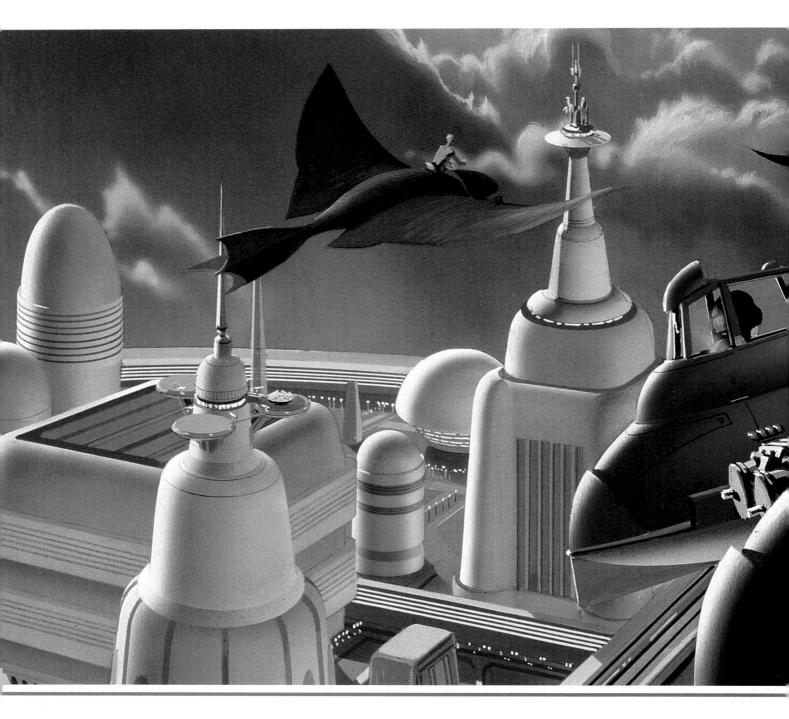

tion of females to males—all of whom are hard-working, providing a reliable and available work-force immediately on hand and at the proper location for those wishing to open a business in the city.

RECREATION OPPORTUNTIES—A PLACE TO PLAY, A PLACE TO RELAX

Though Cloud City was established primarily as a great gas mining installation, it grew and gained fame

as a resort and vacation spot for the rich. Now the luxury accommodations on Cloud City can be enjoyed by all sentient beings, on any budget.

Some alternative health schemes have extolled the air of Bespin for its therapeutic qualities. The wind has a bitter chemical tang from trace gases wafting to higher altitudes. Doctors still take dozens of patients out on circular platforms under floating parasols, flying into the mists of high-rising clouds. The patients lie prone on the smooth deck, wearing

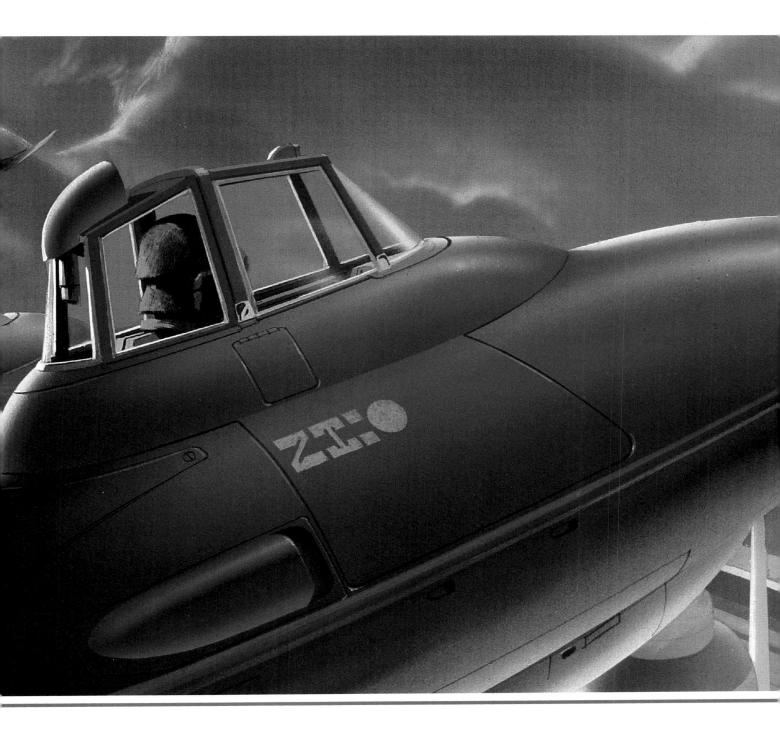

only wispy sheetlike wraps, while the barge pilot flies through the chemical haze. The effectiveness of this treatment has not been clinically proved, but many visitors to Bespin are lavish in their praise of the technique.

ven while his mining operations were proving such a success, Ecclessis Figg saw an enormous opportunity to increase the offsystem money available to capitalize his investment. He remodeled and Bespin's infrequent storms have an awesome beauty of their own—large, dark clouds and high winds that are braved only by the top-notch cloud-car pilots and skilled thranta riders.

(pages 162-163) Other sky complexes have appeared on Bespin to meet the needs of the growing tourist trade. Here travelers can relax and enjoy famous Bespin hospitality while waiting to be shuttled to Cloud City.

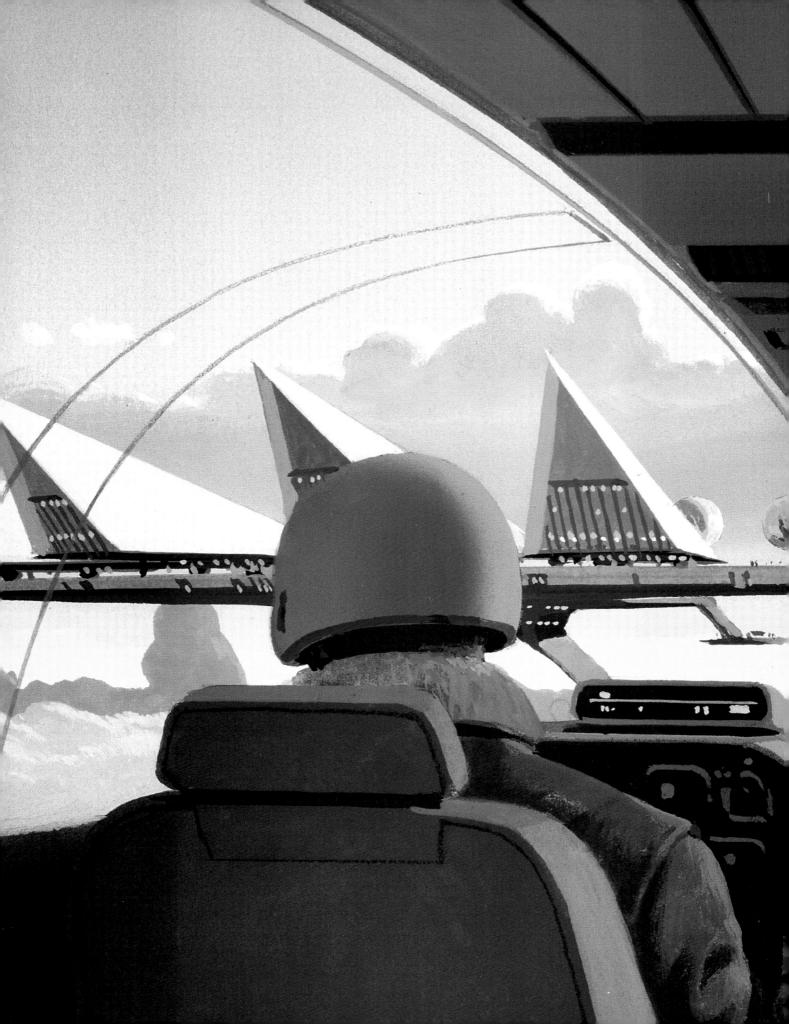

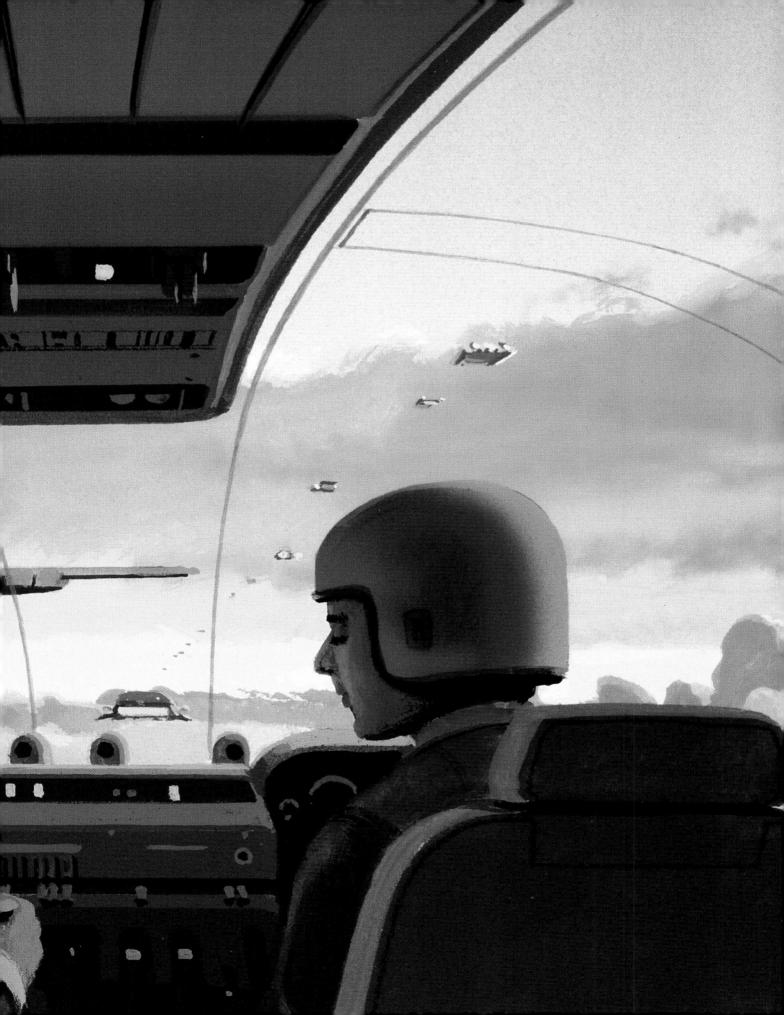

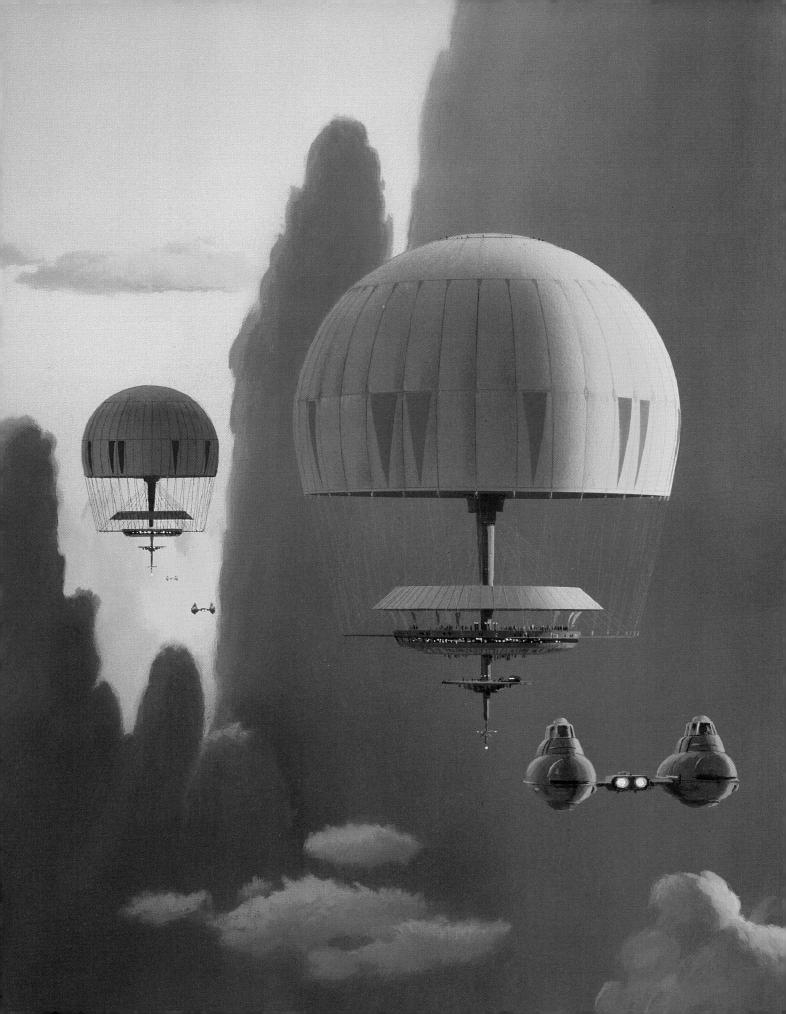

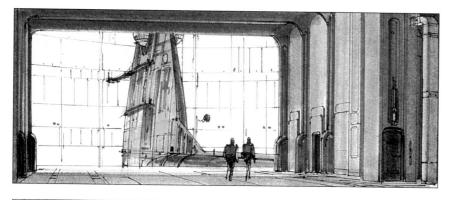

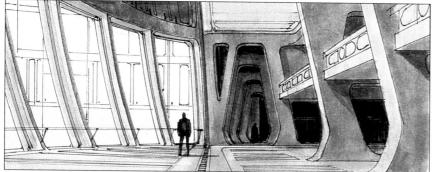

Some of Cloud City's interior decks look out upon the great wind tunnel in the central core.

promoted Cloud City as a wondrous vacation spot, with live shows, entertainment, gambling, and gourmet dining for all species. Much like the gas mining operations themselves, this idea proved successful beyond Figg's wildest dreams. Bespin's new flood of tourists was welcomed, and they continue to be pampered by the citizens and workers of Cloud City.

he city offers several dozen hotels, from the high-class Yarith Bespin atop the upper plaza to the moderately priced Holiday Towers and the budget-priced Stratosphere located in the lower tourist levels.

With Bespin's twelve-hour rotation cycle, vacationers get a full two days and nights of fun for every standard day, letting them enjoy the nightlife without missing out on sleep patterns. Tourists pay no attention to the clock, while the other inhabitants of Cloud City, such as the Ugnaughts, humans, and other species, work their own diurnal schedules.

Other than the popular casinos, for evening entertainment tourists can enjoy traditional platform danc-

Floating health spas take customers out to experience an invigorating "cloud bath" through highrising wisps of vapor. Many believe that such gases have extraordinary value.

ing on raised stages, or riskier wind dancing. Platform dancers, or simple music appreciators, can go from small synthtone lounges to more frenetic laser-pulse dance arenas. Wind dancers climb the high towers, strap on floater packs as life jackets...and then they dance, flinging themselves into the updrafts and swirling breezes that eddy like small cyclones around the top of Cloud City. The best time for dancing is at dawn or sunset, when shifting atmospheric temperatures cause the most spectacular gusts.

uring the day, cruise captains take tourist groups out on large launch platforms, treating the vacationers to daylong expeditions among the clouds, to see the transient sights and the bizarre life-forms. Tour captains usually keep a protocol droid as an assistant for translating any number of known languages. The

tourists are thrilled to see the floating gas refinery complexes, the ruins of Tibannopolis, and the deep gullet of knotted storm systems in the clouds below. Bespin is full of things to see and do.

hether for investment in industries with extremely high growth potential, or important scientific studies on the natural wonders of life in the clouds...or simply to relax and unwind in the gentle winds, take advantage of Cloud City's numerous recreational opportunities—Bespin is the place to be.

Get carried away on the winds!

YAVIN4

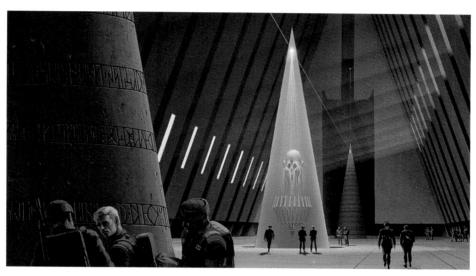

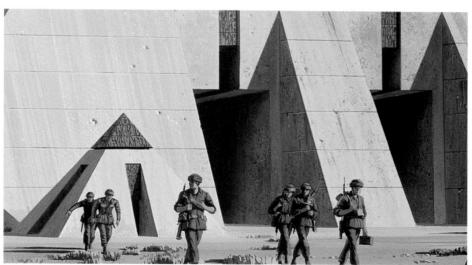

ABOUT THE AUTHOR:

Dr'uun Unnh, while little recognized during his life, has proved to be one of the most thorough and exacting naturalists in recent history. His meticulous notes and voluminous electronic journals have described life on the jungle moon of Yavin in great detail. This article is a fictionalized version of parts of his life and his activities with the Rebel Alliance, most particularly about the base in the temple ruins on Yavin 4. With the recent resurgence of interest in Yavin 4, this article will perhaps bring Dr'uun Unnh the fame and respect he deserved during his tragically short life.

YAVIN 4

r'uun Unnh wrote, "The fourth moon of Yavin is small but lush, an isolated jungle world covered with dense and uncharted rain forests, dotted with deep clear lakes, and wrinkled with up-thrust volcanic mountains—

a naturalist's paradise, uncataloged, a whole world waiting for the sharp eye of a trained nature lover."

And nature lover he was. The mousy, bright-eyed Sullustan saw the vast ecosystem of Yavin 4 as a challenge, and he spent his every waking moment studying new plants, new animals, trying to understand the order of the universe. In his own modest memoirs, Dr'uun Unnh said he hoped to contribute just a small dollop to the enormous knowledge base of civilization—and he did so much more.

ar from the usual paths of commerce through the galaxy, the Yavin system seemed a prime site for the Rebel Alliance to construct a new secret base. From this small jungle moon the Rebels launch-ed their successful attack upon the first Death Star, and then abandoned it in their continued flight and battle against the Empire. But Dr'uun Unnh did not live long enough to see the fruits of their struggle.

THE NEW SECRET BASE

Dr'uun Unnh had been a member of the Alliance since the early days of the Rebellion, when the growing group of dissidents needed to establish a secret base far from prying Imperial eyes. At this safe base, they could discuss strategy and lay plans for their struggle against the Emperor's New Order. They could also hide if the situation got worse.

For one of their first safe havens the Rebels chose the planet Dantooine, a mild world of empty steppes and open savannas, inhabited only sparsely by a few aboriginal tribes who wandered across the vast plains and left the civilized inhabitants alone. Here the Alliance set up primitive facilities, portable selferecting living modules, and the best defenses they could cobble together. They used weapons stolen from smuggler outposts and gun runners, strippeddown Imperial equipment, and a small energy shield liberated from an Imperial correction facility. Dr'uun Unnh's journals of this period are fascinating glimpses of the early, tense struggles of the fight against Emperor Palpatine.

cording to Dr'uun Unnh, the Rebels always considered their Dantooine sanctuary a temporary home. But over the months they began erecting more permanent structures, digging in and erecting a fortresslike setup. Their scouts and recruiters continued to spread word of the Rebellion far and wide, while other members of the Alliance, such as Princess Leia and her father, Senator Bail Organa, continued to work through political channels to overthrow the Emperor.

As time went by, the inhabitants of the Dantooine base grew lax with their own security measures until one day they were horrified to discover an Imperial observation device hidden in a cargo of equipment they had brought down to the surface. The unpacking crew reacted quickly and destroyed the tracking unit, but they could not be certain that the device had not transmitted its deadly information to Imperial listeners.

Instantly the Rebels packed up their base, collapsing the self-erecting shelters but leaving the half-built permanent structures intact. They piled aboard every transport they could find, leaving behind only a few dismantled vessels that had not yet been repaired.

The Dantooine base evaporated in a single day.

The ragtag Rebel fleet then drifted aimlessly in space, flitting from system to system, until one of their wide-ranging scouts finally located an uncharted gas-giant planet—Yavin, with its thickly forested fourth moon. This remote location appeared to be the ideal hideout.

In their desperate circumstances the Rebels took little time to make detailed maps of the moon's surface. From a cursory orbital inspection they discovered many anomalies among the jungle canopies, riverbeds, and lava mountain ridges. They found a

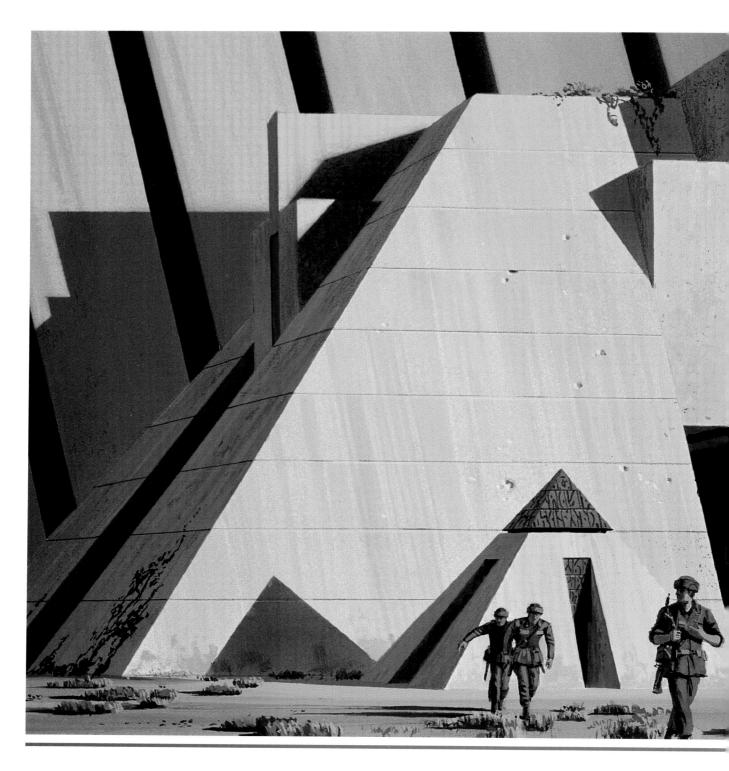

scattering of ancient temple ruins, all crumbling and empty, but had no time for detailed archaeological investigation.

The abandoned temples had been standing for thousands of years, resisting the encroachment of the jungles. The scouts chose the largest, best-preserved pyramid and set to work converting it into a well-defended stronghold. Teams of soldiers and the Rebel Corps of Engineers settled in to excavate and reinforce the fortifications.

With his sharp mind and lifelong store of practical knowledge, their commander—General Jan Dodonna (formerly retired) was one of the most important people in the entire Alliance. Under his

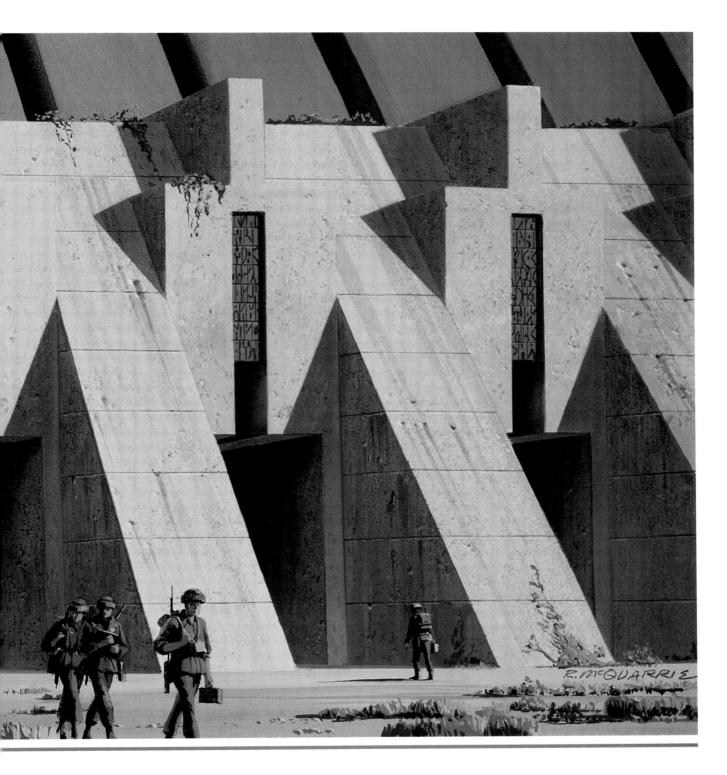

The rear of the Great Temple, an ancient Massassi structure restored and placed in service as the new Rebel base on Yavin 4.

command, the military and refugee arm of the Rebellion settled in on Yavin 4, eager to establish their new base and to begin the work of liberating the galaxy from the clutches of the Empire.

Upon Dr'uun Unnh's arrival, the Yavin moon seemed to call to him with its mysteries, its ruins, its hidden past, and its lost temple builders.

Digging through the undergrowth, the Sullustan naturalist found clear indications of a deep and widespread destruction that had taken place thousands of years ago. He noted in his logs a question about this ancient but devastating conflict, long before Rebels and Empires and Death Stars. Though he found few details of this long-ago conflict, his best guess was that it was linked to the extinction of the temple-building race, the Massassi. (We note that his hypothesis has still not been confirmed or dismissed.)

pr'uun Unnh's people, the Sullustans, lived in underground warrens on their native world, and he was good at digging through

shadowy places to explore tunnels and caves. Due to his small stature, he was unable to help with the heavy labor of clearing the dense jungle debris that had grown over the temples, nor could he be of much assistance in repairing

the collapsing wall sections of ancient stone blocks.

Collecting information was Dr'uun Unnh's specialty, and he proved his worth many times over. Before joining the Rebellion, he had studied many of the great archaeological artifacts in the galaxy, and he had also gained a broad working knowledge of natural history and alien ecosystems. The information in his head was a valuable addition to the Rebel Alliance, far more important than another shipment of weapons or heavy machinery.

When the Rebels set up their base on the jungle moon, the main priority was to make the crumbling stone structures habitable and defensible, so Dr'uun Unnh had to put his investigations on hold for a short while.

Teams of Alliance soldiers worked round the clock, clearing out weedy vegetation that had grown

undisturbed for centuries in the crannies of the massive stone blocks. They chased out small rodents and giant insects that had made their nests in the darkened chambers. Dr'uun Unnh,

however, took every chance he could to study the fascinating details of the jungle at every place it intersected with his work.

Outside, the Rebel Corps of Engineers erected a power-generating station, a large cluster of turbines stolen from the framework of an Imperial Star Destroyer that had been under construction at the Kuat Drive Yards. Finally, the Rebels could use laser-cutting machinery and power exfoliators to clean out the Great Temple, which they had chosen as their main base headquarters.

Chittering with amazement at the wonderful archaeological artifacts around him, Dr'uun Unnh at first had difficulty maintaining his concentration on the task at hand. He kept his datapad with him at all times, recording his impressions, photographing strange inscriptions nearly weathered away from

the rock, and keeping precise before-and-after records of the modifications made by the Rebel engineers.

Despite his small stature and

limited physical strength, the construction

engineers frequently needed Dr'uun Unnh's services. They enlisted the compact Sullustan to crawl through tight tunnels where cave-ins had occurred, dragging power conduits behind him and mounting illumination devices to assist in the repair activities. Occasionally they had to call to him, startling him out of the close inspection of a nest or fungus he had found while performing his duties.

The greatest disaster to befall the Rebel engineers occurred when they attempted to use one of the underground levels of the Great Temple as a storage chamber. Unfortunately they had not sufficiently reinforced the ceiling and shored up the wall with plasteel girders. A massive cave-in occurred, killing eighteen Rebel soldiers and destroying a cache of valuable equipment.

When two of the levels in the Great Temple were finally cleared for occupancy and the soldiers had moved out of their temporary bivouac shelters, Dr'uun Unnh began to do further exploring, compiling an enormous database of everything he found.

Though many of the computer records were damaged in the subsequent Imperial attacks, most

Among the unique life-forms in the jungle on Yavin 4 are mucous salamanders (above), tree ticks (left), and armored eels (right). The naturalist Dr'uun Unnh could not begin to classify the major species here.

of the information still known about Yavin 4 comes primarily from his brave and diligent researches.

CLIMATE

Though small, the jungle moon is blessed with a mild climate and thick atmosphere. Humidity in the air is high, and as temperatures drop in the deep night, moisture condenses out of the air and settles as thick fog that clings to the canopy or penetrates to the ground below.

Because it is a moon orbiting a gas-giant, Yavin 4 experiences two different kinds of nightfall: When the moon rotates on its axis, facing away from the distant sun but still staring down upon the pale orange face of Yavin itself, the light in the air dims to a pastel glow, which Dr'uun Unnh called twilight night. When the moon goes behind the planet and the gas-giant eclipses the sun, blocking both direct light from the sun and reflected light from Yavin, the moon experiences what he called dark night.

Once every several months, because of the dance of the moon's rotation and its orbit around the primary planet, dark night lasts excessively long. The resulting deep temperature drop causes enough turbulence in the atmosphere to generate severe storm systems that rip though the jungles. During their first few months on the jungle moon, several unexpected storm periods forced the Rebels to barricade themselves inside the stone temples against the fury of the weather.

During one of these first storm cycles, Dr'uun Unnh found himself far out in the thick jungles studying the ruins of a small, isolated Massassi temple. He wrote with great emotion of how he had spent the longest night of his life inside the cold, slick temple, listening to the howling wind and feeling a chill deeper than the night eating into his bones.

r'uun Unnh also discovered another amazing atmospheric phenomenon, which he called a rainbow storm. He witnessed his first rainbow storm on the morning after a dark night. The sun poked around the limb of the great blurry gasplanet, and the thick jungle mists clung close to the ground. The scattered and refracted light from high ice crystals in the air combined with polarized rays coming through the upper atmosphere of the gas-giant to create whirling, scintillating showers of rainbows. Even on the small images he captured with his personal datapad, we can see how the air sparkled and flared like a blaster battle in orbit.

Dr'uun Unnh chattered excitedly to his friends about this amazing event. From that point on, some of the Rebels made a practice of climbing the newly erected observation towers to watch the rainbows pour down on them for a few minutes until the white ball of the sun separated itself from the atmospheric fringe and shone full daylight upon Yavin 4.

THE JUNGLES

Dr'uun Unnh's greatest love was the lush jungle of Yavin 4, which he called "a dense tapestry of interconnected life-forms: plants, animals, insects, all species cooperating and competing with each other in a series of checks and balances that makes the ecology of the small moon. The jungle thrives with supercharged life, as if Yavin 4 somehow has left-over energy and diverts it to the biological systems covering the moon."

Dr'uun Unnh recognized that it would take a dedicated squadron of xenobiologists and botanists years to catalog even the most prominent species. In his researches he kept a databook of common flora and fauna, trying to establish a classification framework. In one marginal note he stated his hope that, in later times of peace, someone would complete the studies in his name.

any sections of the Yavin jungles are so dense that they proved impenetrable even for a small Sullustan. Vines interlocked, and trees grew together, walling off isolated clearings that Dr'uun Unnh discovered only by flying over at treetop level. The clearings were like microhabitats, terrariums shielded from the rest of the tangled jungle where the trapped plants and animals inbred so much that they eventually died out.

The most common large tree on Yavin 4, comprising much of the densest jungles and thickets around temple ruins, is the Massassi tree. Massassi trees have wide crowns and up-

separates easily into fibrous strands (probably used by the ancient Massassi natives for fabrics, ropes, and other materials). Much of the mulch on the jungle floor is composed of decaying bark shed from these trees.

common shrub is the blueleaf, which has thick, oily leaves and a sharp, pleasant fragrance that fills the air. Its leaves, clustered into groups of five or eight, are a bright cobalt blue. Though the blueleaf shrub grows only about a meter high, it spreads voraciously across the ground, forming dense thickets, particularly in the rich soil around fallen trees.

Other species in the rain forest include climbing ferns that sprawl across the high branches or ascend

the weathered stone faces of the ancient temples; brilliant nebula orchids that display maroon, magenta, and lavender colorations similar to photographs of the Cauldron Nebula and other stellar oceans of ionized gas; and the most common dangerous plant, the touch-not, which bears leaves coated with a contact toxin, making skin blister and burn at the slightest touch. (Dr'uun Unnh learned this firsthand, to his dismay.)

The thick branches of the Massassi trees and the tapestry of climbing ferns provide the framework for an arboreal ecosystem. Slothlike woolamanders, with naked skin on their bellies and thick blue and gold fur on their backs, live in family packs among the branches, feeding on flower petals, tender leaf

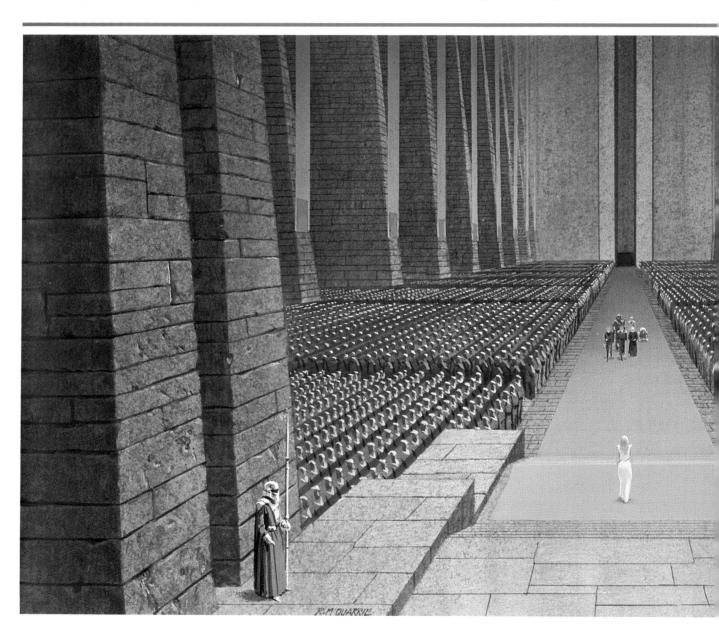

shoots, and the rhizome seed nodules of nebula orchids. Large groups of woolamanders make their way across the forest canopy with an incredible racket, chattering among themselves, pelting ground-dwelling creatures—including Sullustan naturalists!—with fruit and broken branches, generally making a nuisance of themselves.

The woolamanders' main nemesis is an omnivorous tree-dwelling rodent, the stintaril, which has protruding eyes and long jaws filled with sharp teeth. Packs of stintarils swarm across the arboreal highways, never slowing down, apparently never sleeping, eating anything that sits still long enough for them to take a bite, including woolamander

young or sleeping elders.

On the ground, a large and stubborn herbivore is the runyip, an ornery, shaggy beast that roots among the forest mulch in search of buried fungi, fallen nuts, and emerging shoots. Runyips emit loud squealing noises, grunts, and sighs, as if to entertain themselves as they dig among the underbrush with their flexible noses and clawed front toes. As it crashes through the forest, a startled runyip can make a symphony that sounds, according to Dr'uun Unnh, "like a diverse musical group in the middle of an ugly accident."

Sluggish rivers slice through the jungle, moving with languid currents and teeming with so much life that Dr'uun Unnh called it a "watered-down

primordial soup."

Dangling aerial roots of Massassi trees and nebula orchids trail in the surface of the river, absorbing water and precious nutrients. Clusters of algae gather around the tips, growing like hair in the current.

The angler, a spiderlike crustacean with small body and very long, very sharp knobbed legs, hangs among the

dangling roots in the water. Camouflaged and perfectly motionless, the angler waits for a fish to drift within reach, at which point the angler thrusts down with its limbs like sharp pointed spears. After stabbing its prey, the angler quickly hauls it out of the water into its waiting jaws.

Tiny swimming crabs erect labyrinthine nests in the mud of the riverbanks, building small towers and curving battlements to keep amphibious predators at bay. Submerged aquatic hunters crawl along the river channel with rows of eyes on top of their heads and in front of their snouts, stalking anything that moves and lunging out to snap

The grand audience chamber in the Great Temple is the largest room at the top of the ancient structure. This chamber was enormous enough to hold assemblies of the entire complement of the Rebel base.

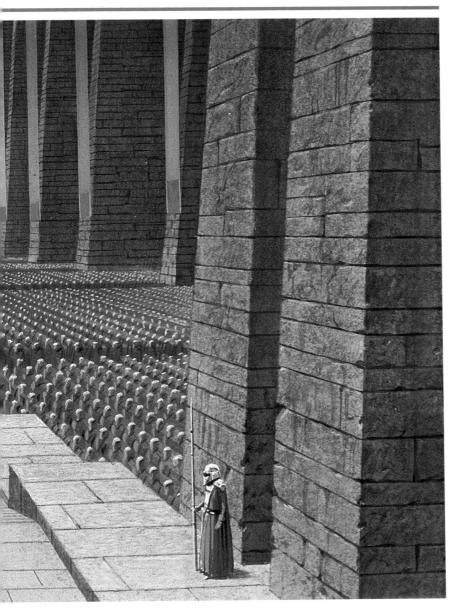

up a morsel of food with gundark-trap jaws.

Pinkish mucous salamanders swim formlessly in the water, diluted and without shape; but when they crawl out of the current and onto a riverbank they harden their outer membrane to a soft jellylike form with pseudopods and a mouth, allowing them to hunt among the insects in the weeds.

Iridescent blue piranha-beetles fly together with a high-pitched humming sound, spread out like innocuous insects while searching for prey. They subsonically contact the rest of their swarm upon finding an appropriate target. In moments a cloud of deadly sapphire beetles appears, whining a thin death cry and clicking their hard wing casings. When they set upon a poor runyip or doomed woolamander pack, the piranha-beetles cover the bodies of their victims in moments, tearing with thousands of piercing, razor-sharp mandibles, stripping every shred of meat from the carcass. Hidden in the bushes, Dr'uun Unnh witnessed the piranha-

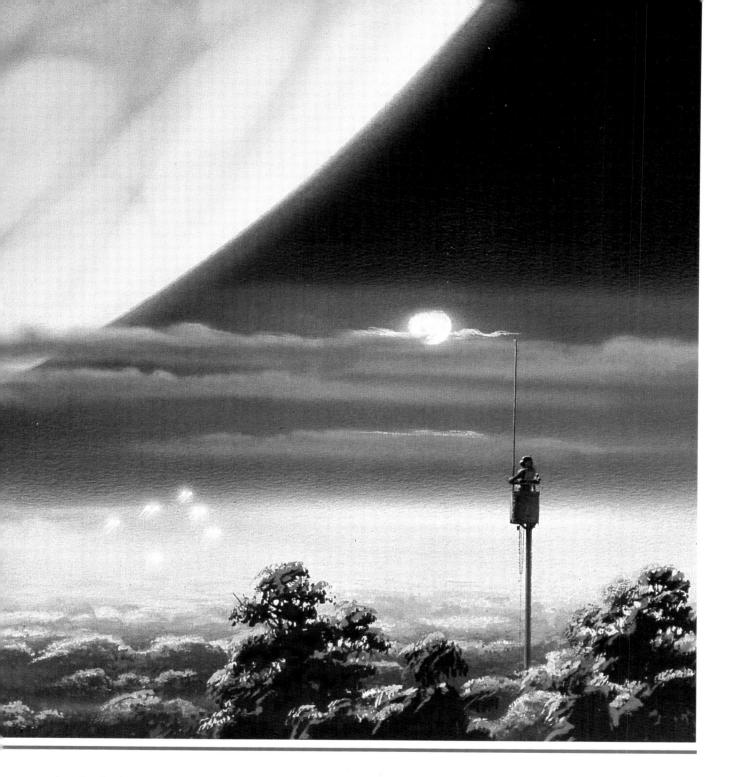

beetles feeding once, and he hoped never to see such a spectacle again.

THE MASSASSI TEMPLES

The most intriguing highlights of the fourth moon of Yavin are the scattered monumental temples left behind by the vanished Massassi race.

The largest construction, called the Great Temple, is an enormous ziggurat, a squared-off pyramid ris-

As the orange gas gaint Yavin hangs overhead, a Rebel scout keeps watch high in an observation tower. Tall Massassi trees rise up into the sky, and the thick, unexplored jungles below hide many old ruins and mysteries—but the Rebels had little time for such investigations.

ing four levels above the ground and extending into a labyrinth of passages and underground chambers.

The Rebels primarily occupied the lower two lev-

els of the pyramid, refurbishing large chambers and small quarters with the best materials available to them. They replaced weathered rock with sheets of seamed metal and erected temporary walls and barriers with poured paneling where ancient markings indicated that wood constructions had, under the planets conditions, long ago rotted away.

The Rebels complained that their dim quarters remained dank and unfriendly despite all the illumination sources and heaters they installed. Many

claimed to hear strange noises scratching through the night silence, though nothing threatening was ever found.

o Dr'uun Unnh, though, the dim and cramped quarters reminded him of the tunnel warrens on his home world of Sullust. He always slept comfortably and woke refreshed, eager to go out and investigate further.

At the apex of the Great Temple was a single vast

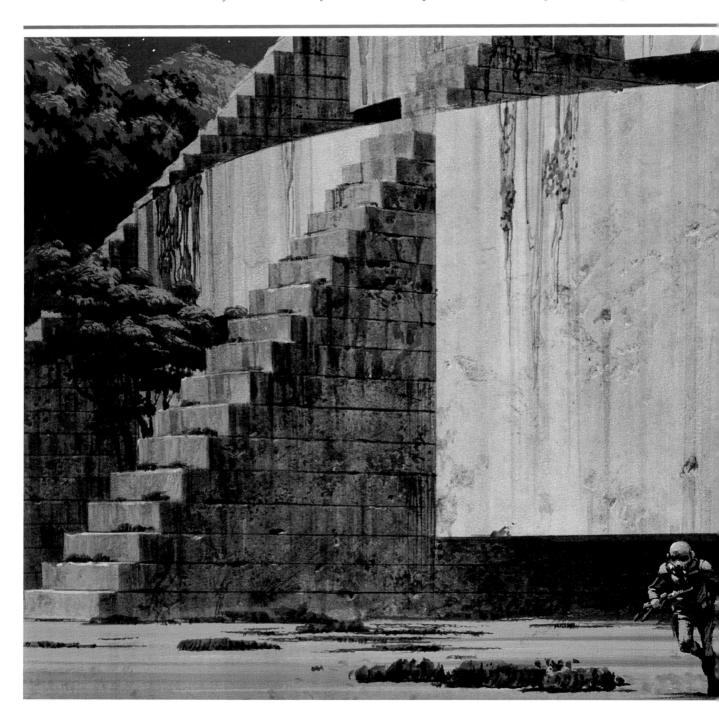

room, the grand audience chamber. The audience chamber was lit by tall, narrow skylights; sunshine streamed in and illuminated polished geometric shapes and tiles of translucent precious stones. The tiles were laid out in strange but hypnotic patterns that Dr'uun Unnh had never seen before. Most of the flat flagstones were a nonreflective smoky gray; other stone lozenges of dark green and vermilion and ochre ornamented the enormous chamber. Lush green vines climbed the stone walls, spread-

(below) The hangar bay door at the base of the temple grinds open to allow ships to emerge.

(pages 180-181) In the ruins known as the Temple of the Blueleaf Cluster, a strange crystalline centerpiece seems to throb with dark energy from some event in this world's past, as if trapped spirits reside in the crystal.

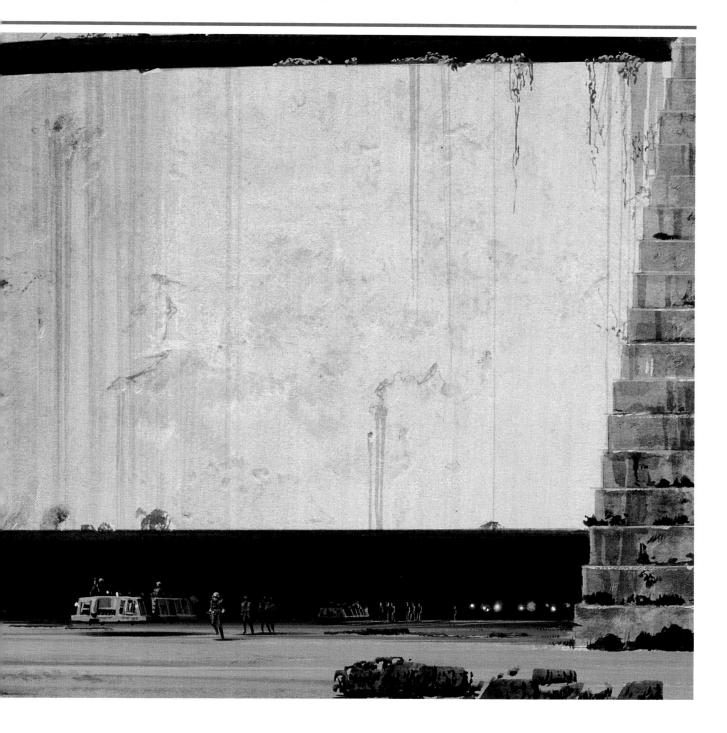

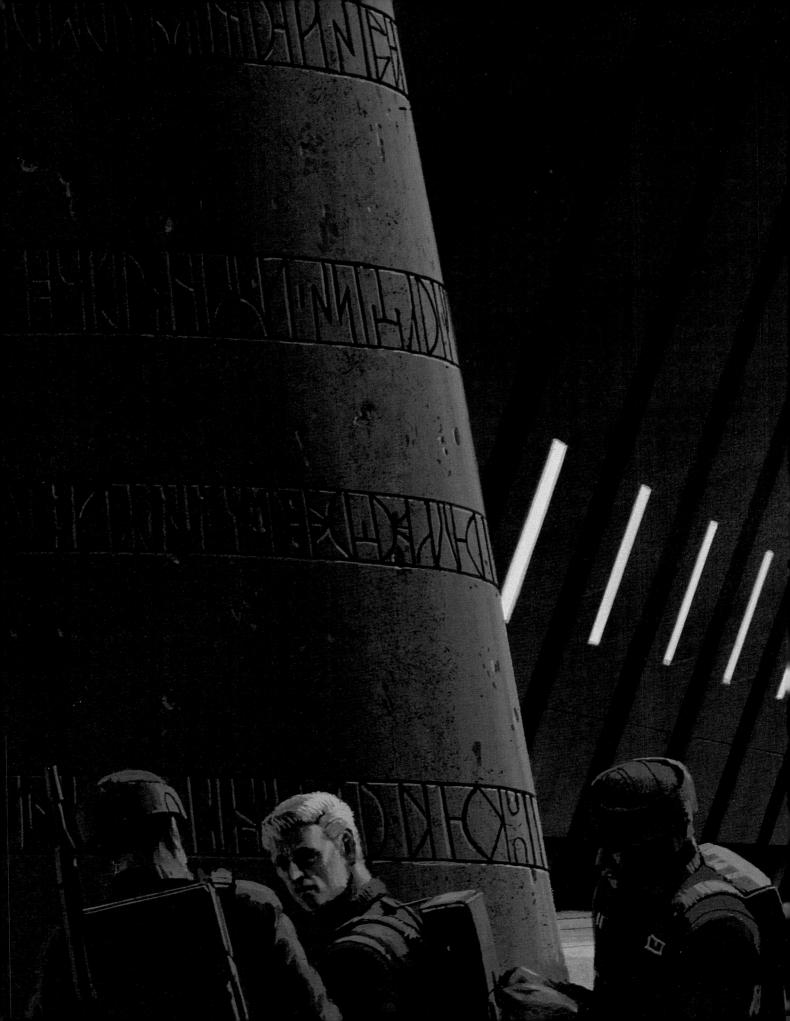

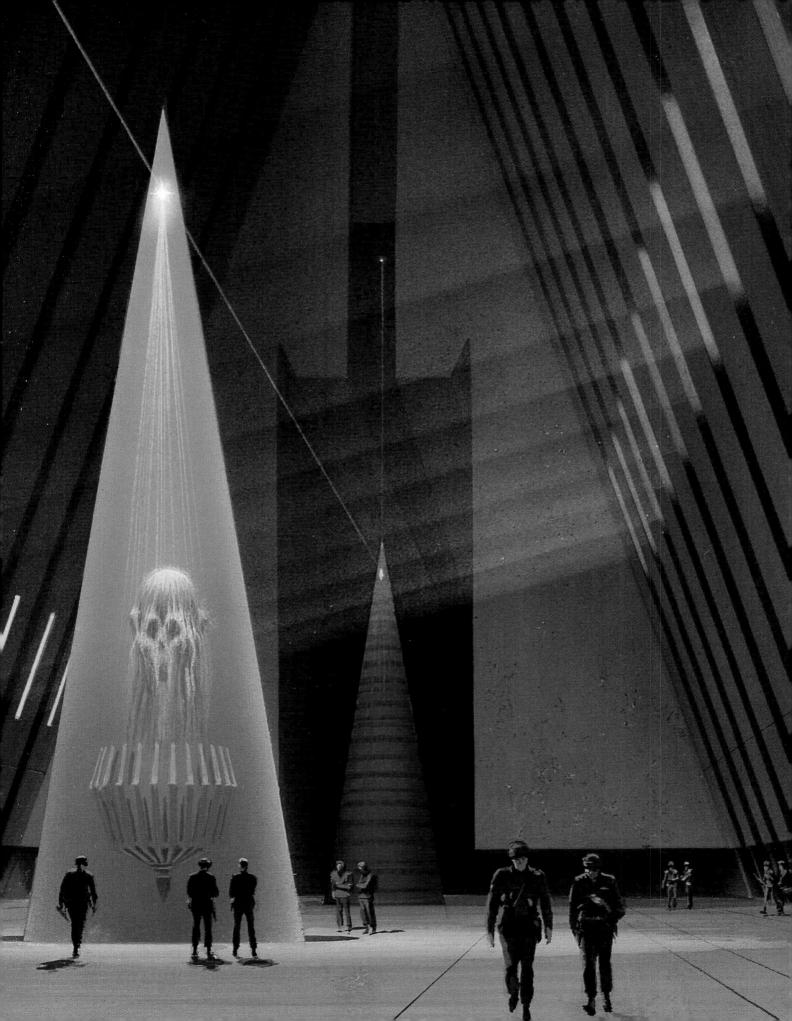

ing out in verdant webs in the corners.

The Rebels did little with this chamber, merely uprooting the overgrown weeds and cleaning weathered debris, polishing the ornate flagstones. The grand audience chamber served as their meeting hall and also as the site of the brief victory celebration after the defeat of the first Death Star, at which Princess Leia Organa presented the heroes of Yavin with special medals.

Dr'uun Unnh liked to come into this cavernous chamber by himself, listening to his own words as

datapad, collecting his thoughts in peaceful solitude. He heard his own whispers echo

he dictated into the

around the room like lost and forgotten Massassi voices spilling their secrets.

A small stairway behind the speaking platform at the end of the chamber rose to an observation platform at the roof of the Great Temple. A small group liked to stand on the platform and watch the huge gas-planet rise, when the mists rose from the jungle canopy and dissipated into the growing heat of day.

General Dodonna, however, took note of those who enjoyed standing atop the Temple and assigned them to high lookout towers erected in the jungle. These towers were made of durasteel rising tall above the canopy. It was lonely duty to be stationed with macrobinoculars, a day's worth of rations, and only a comlink for company. The towers swayed in the slightest breeze, but the hardest part by far was scaling the 812 rungs, hand over hand, just to reach the top.

The Rebels installed a modern turbolift through the center of the Great Temple. The shaft connected all the levels of the ziggurat down to the ground. The second and third levels were converted into computer processing centers, briefing rooms, and military offices, as well as recreation facilities and barracks. A large sector of the second level was outfitted as a sophisticated war room, while the corresponding sector on the third level served as the command center for the entire Rebel base.

At ground level the largest of the squarish rooms served as the launch bay and the hangar lift platform. An entire section of the floor could raise or lower shuttles and starfighters into the hangar cavity excavated beneath the main body of the temple. X-wings, Y-wings, and small supply vessels could shoot out of the long, dark hangar bay, streaking across the jungle and then up into orbit, vanishing into hyperspace.

n foot, Dr'uun Unnh explored other temple ruins in the vicinity. Directly across the forks of the river near the main base was a smaller high temple, which he named the Temple of the Blueleaf Cluster because of the unusual curved crenellations rimming the arches, as well as the ornate and deeply incised carvings around the keystone blocks.

The most frightening, yet intriguing, feature of the Temple of the Blueleaf Cluster is its main chamber, a vast echoing grotto extending to the top of the tower. In the middle of this chamber, filling the entire temple with a strange, cold, blue light, is an elongated crystal pyramid. The slick surface of the crystal felt cool and tingly, oily and charged with static electricity. To Dr'uun Unnh it seemed like a battery containing an enormous amount of power.

Looking closely at the translucent pulsating surface, Dr'uun Unnh was convinced he could see withered faces, strange alien visages like lost souls trapped within the crystal focus of power.

The frightening realization that no one knew what had caused the entire Massassi race to vanish suggested to Unnh that they should be cautious. He advised that they keep away, not understanding what awesome power might be contained within the throbbing crystal. General Dodonna agreed with him, and after the initial exploration and mapping expeditions, Dodonna sealed off the Temple of the Blueleaf Cluster, forbidding any of his troops to go there.

cross the other fork of the river stood a larger temple greatly damaged by time. Dr'uun Unnh named this crumbling ruin the Palace of the Woolamander, not because

of any motif he found but simply because of the huge pack of the hairy arboreal creatures he found nesting within the ruins. The woolamanders set up a loud, howling alarm

when he approached and began pelting him with rock shards and rotting fruit until he retreated. From his cursory inspection, Unnh determined that this palace held little of interest, and the structural damage and crumbling walls made the place unsafe.

After the Rebels had settled into their base and daily life gradually became a tense but well-ordered routine, Dr'uun Unnh's explorations ranged farther from the Great Temple. He knew from the tantalizing low-resolution maps taken from orbit that many other temple ruins poked through the jungle can-

opy, just waiting to be explored.

He took a small speeder bike, adjusted the controls so that his compact body could use it, and carried a blaster for protection (though his eyesight was poor and his aim was worse).

As a broad-based naturalist, Unnh viewed everything with far more fascination than caution, and only through sheer luck did he manage to get himself out of near-impossible situations when large animal specimens proved more interested in eating him for lunch than in providing important zoological data.

But the untamed wildness of Yavin 4 quickly taught Dr'uun Unnh a bit of common sense.

He kept a tracking device mounted on his speeder bike, and he was careful to let squadrons know approximately where he intended to go and when he would return.

On one of these wide-ranging expeditions, Dr'uun Unnh discovered what he considered his most important find, according to his logs. His entry in the records he left behind said that it gave him tremendous delight, though it proved to be the end of his career, his last discovery.

Unnh came upon another quiet, sheltered Massassi temple—but this one seemed impregnable to the ravages of time and weeds, even after approximately four thousand years. This structure stood black and glittering with sharp angles and razor edges, showing the distinctive markings of Massassi architecture. It had been built on a small island in the center of a circular pond that shone like a flat quicksilver mirror, completely free of ripples. Twin lights in the sky from the orange sphere of Yavin and the distant sun cast intersecting glitter paths across the still lake.

The water in the surrounding lake was as transparent as diamond and so deep that it reflected the bottom like a lens. Just below the surface, columns of rock rose from the bottom like submerged stepping-stones, stopping just barely beneath the water. Dr'uun Unnh imagined that penitents approaching the temple must have walked across the stepping-stones, causing ripples but not sinking. To an observer on the shore, it would have appeared that the visitors walked directly across the water's surface.

On the surface of the island, mounds of pitted volcanic rock were splotched with orange and green lichen that looked like droplets of alien blood. Silence blanketed the temple and the lake, as if none of the jungle creatures or insects dared to come near the isolated site.

Between the split apex of the tall pyramid stood a colossus, a polished black statue of a dark man, with long hair swept back behind him, and the padded garments of an ancient lord. Dr'uun Unnh was convinced he recognized the trappings of one of the fearsome Dark Lords of the Sith.

The walls of the temple were made of polished dark glass. Corusca jewels, cast out from the high-pressure core of the gas-giant Yavin, studded the steep obsidian walls. Hypnotic pictographs and hieroglyphics were etched into the volcanic glass, written in a long-forgotten language. On his initial inspection, Unnh could read none of the words.

He scanned the markings and fed them into his datapad, using language-translating routines to ferret out garbled details of the history of the temples.

He was astonished by the story that

unfolded, lending compelling evidence to a theory that had been growing in the back of his own mind. All these structures, according to his hypothesis, were relics left behind during an enormous conflict millennia ago that had pitted the old order of Jedi Knights against a dark offshoot that studied the even more ancient teachings of the Sith. Unnh speculated, too, that perhaps the legendary "Sith War" had been one of the reasons for the extinction of the Massassi race.

However, Unnh did not record all of his evidence, and translations of the ancient hieroglyphics found in his datapad are obscure at best, lending themselves to many different interpretations.

r'uun Unnh's last entries describe how excited he was by the discovery of this particular temple. Apparently he hopped aboard his speeder bike and headed back toward the main base. He made no note as he journeyed back to the Great Temple that he noticed another small metallic moon emerging from the limb of the gas-giant Yavin—the Death Star orbiting around the planet and coming into range. Nor did he note the launching of squadrons of X-wing and Y-wing fighters, streaking across the jungle canopy to do battle out in space.

The attack against the first Death Star had already begun. Rebel ships launched in parallel streaks from the lower hangar bay of the Great Temple. Swarms of TIE fighters fought the starfighters as they shot into space....

The body of Dr'uun Unnh was found several days later when the Rebels were preparing to depart

More of Dr'uun Unnh's sketches from his datapad.

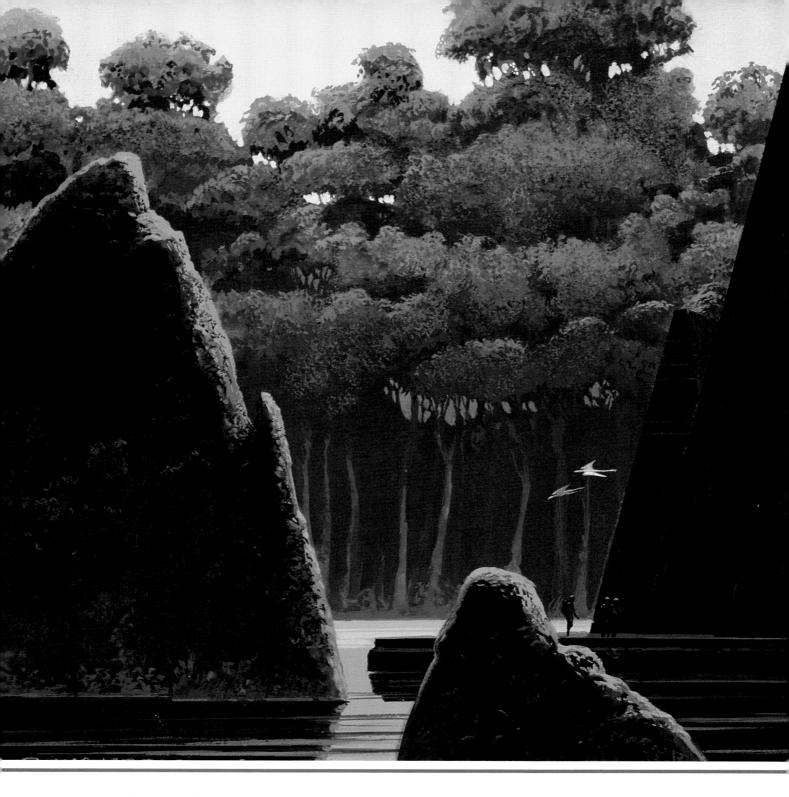

from their now discovered base and as they were taking a final tally of their losses. Preoccupied as they were with counting fallen pilots and destroyed ships, it took a long time for anyone to notice one missing member of the ground crew, a small naturalist who had been nowhere near the battle itself.

They finally located Dr'uun Unnh by the tracking mechanism he had strapped onto his speeder bike. His vehicle lay in a burned clearing out in the

jungle, beneath the exploded wreckage of a crashed TIE fighter. Apparently the Imperial fighter had been damaged in space, and the pilot had unsuccessfully attempted a crash-landing. The mousy naturalist had simply been in the wrong place at the wrong time—impossibly unlucky to make up for all those times he had miraculously survived the predicaments he had gotten himself into.

The Rebels buried Dr'uun Unnh next to the

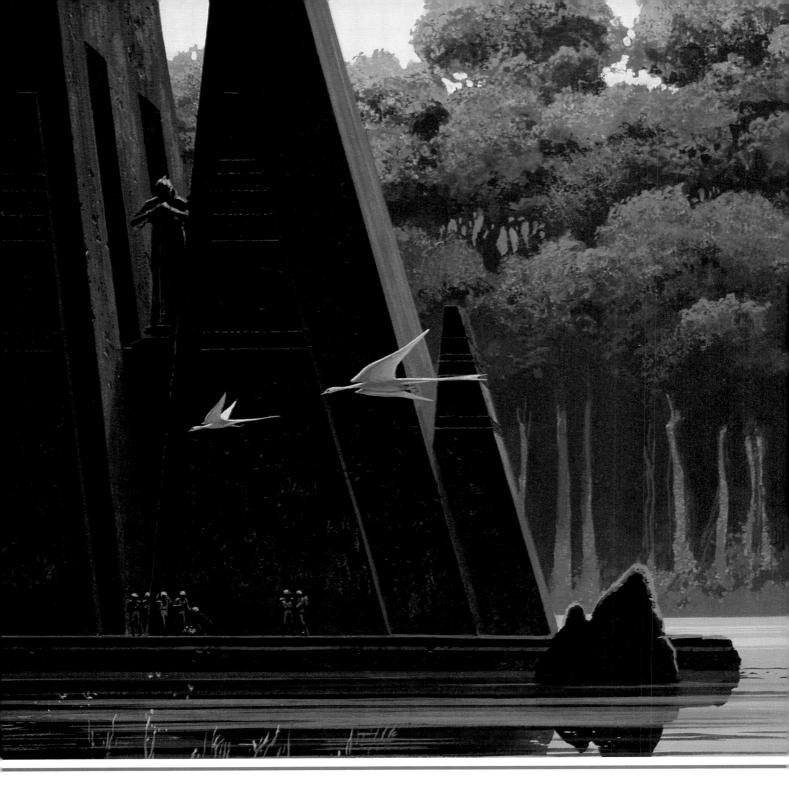

wreckage of the TIE fighter and left him to become one with the small moon he had spent so much of his time studying.

r'uun Unnh's personal datapad was mostly undamaged, and the other Rebel scientists carefully copied all the information that had been the Sullustan's life work. Then they packed up and abandoned the base, leaving much of their equipA brooding temple, surrounded by a shallow lake and crowned by the towering statue of an ancient dark lord.

ment behind. They departed the planet before Imperial forces could mount a massive counterstrike.

The implacable jungle began to retake what it had possessed before, and the fourth moon of Yavin once again became a mystery.

ALDERAAN-

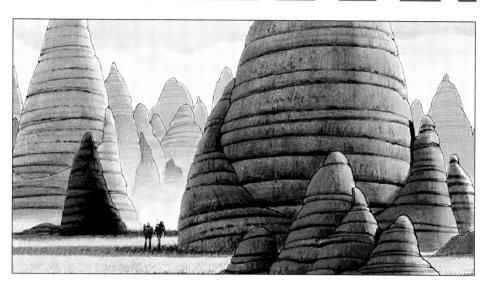

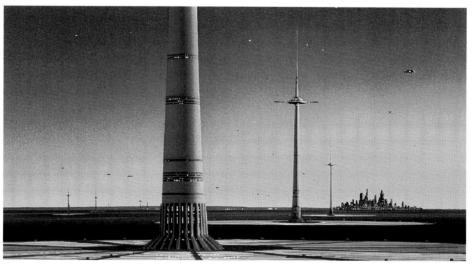

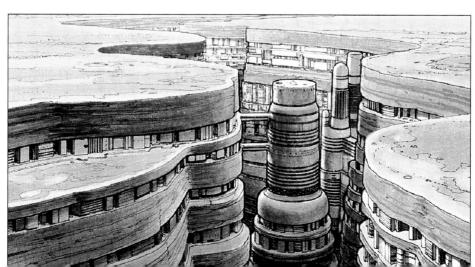

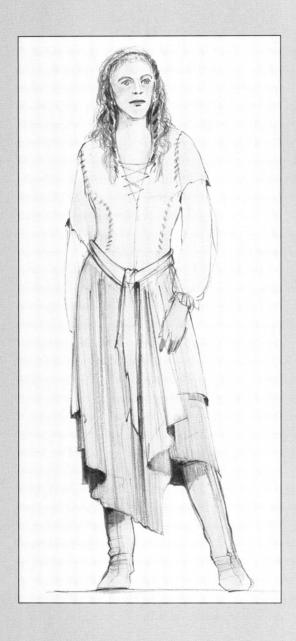

ABOUT THE AUTHOR:

Hari Seldona was a renowned poet of Alderaan who wrote many odes describing her great love for the peaceful, grassy world. Her popularity was such that she traveled from system to system, reading her poetry and describing her home planet, at the same time subtly criticizing the Empire. She was performing in the Corellian sector when the Death Star destroyed Alderaan—and thus Hari Seldona is one of the few natives of that world who survived.

She immediately dropped out of sight, fearing Imperial retribution. Her current practice, however, is to appear unannounced, read her poetry, and speak vehemently against the Emperor's New Order. She stirs up the crowd and then vanishes before stormtroopers can arrive. The following unsolicited article, "Requiem for Alderaan," is her chronicle of a murdered world.

ALDERAAN

hi so po ar w th

hile city-covered Coruscant may be the galaxy's political center, ancient and peaceful Alderaan was its *heart*. How I miss the calm, vast skies, the oceans of grass, the love-

ly flying thrantas.

A very old planet, calmed from the tempests of its geological youth, Alderaan had settled into a mellow climate, gentle landscapes, and a peaceful aura. A perfect place to live, to love, to ponder the universe. Perhaps the environment proved too peaceful, for otherwise the people of Alderaan might have been more prepared to see the huge sphere of death coming toward it. Perhaps they would not have been taken unaware and destroyed as they slept. Perhaps they would have fought—or perhaps not. Violence was not the Alderaan way.

As our planet fell into seismic slumber over the ages, the major mountain ranges weathered away,

leaving behind breathtaking steppes and the grasslands that rippled in the breezes. In my poetry I called the constant whisper of wind the Song of Alderaan.

Alderaan provided a comfortable home during the thousands of years of human habitation. The cities were carefully manicured and tended so as to interrupt the landscape as little as possible. The people of this

world tried to work with the landscape rather than against it.

Alderaan's open vistas proved inspirational to the galaxy's finest creative geniuses—as galactic culture has witnessed time and again. The famous Alderaan University was known throughout the galaxy for training and shaping the best minds in numerous disciplines. Many artists have claimed that the sprawling horizons opened doorways in their minds, allowing them to think vaster thoughts than they could otherwise have conceived in the confined quarters of a dirty metropolis-world such as Coruscant.

THE LANDSCAPE

Though this planet once seemed wild and empty, botanists have cataloged over eight thousand subspecies of grasses on the plains and an even greater number of native flowers.

fter the warm rains came each gentle spring, the grasslands exploded with a profusion of new life. Matted carpets of short-bladed grass, tall forests of cane and grains intermingled with a glittering spectrum of colorful flowers. And the fresh smell in the air seemed headier, more stimulating than the most potent drug.

In the late summer, when the air grew warmer and the vegetation turned golden as it dried, many flowers and grasses went to simultaneously. During these months, imposing "seedstorms" filled the breeze with dense masses of floating feathery seeds, like a blizzard of feathery dry snow. In years of heavy spring rains the vegetation grew thicker than usual, causing ex-

tremely heavy seedstorms. Airborne transportation on Alderaan ground to a halt, crippled by poor visibility. Clouds of windblown seeds choked domesticated flying beasts and clogged air intakes of mechanical craft. So the people remained inside with their families, watching the seed-strewn air through broad windows, enjoying this unexpected,

Alderaan was a peaceful world, with calm, open grasslands and quiet people.

The open plains of Alderaan let our thoughts travel unbridled, whether on a long walk across the grasses or flying overhead in a shuttlebeast.

naturally-wrought lull in their daily lives.

Wild creatures out in the grasses of Alderaan included furry, large-winged moths that nested among the bushy flowers and waving stalks. Their larvae, armored caterpillars more than a meter long, burrowed under the ground and fed upon swollen tubers in the grass roots. The armored caterpillar was known to live underground for a dozen years before it dug deep and sealed itself in a thick-walled cocoon, eventually to emerge as a furry moth. Perhaps somewhere, an alien entomologist kept a few specimens of the Alderaan furry moth; otherwise all are now lost.

These armored worms were the main food source for stilt-legged flightless birds that waded through the grasses in ranks like veteran soldiers in a well-trained infantry division. Spread out in a long, straight line, these reptilian birds moved in lockstep with their glittering eyes open, their heads tilted to listen for the subtlest of vibrations beneath the ground.

The birds swept across the prairie in a carefully regimented pattern, stopping to stab with their scissorlike bills into the packed dirt to spear caterpillars. With a honk for assistance, a stilt-legged bird could call for its companions to help wrestle the

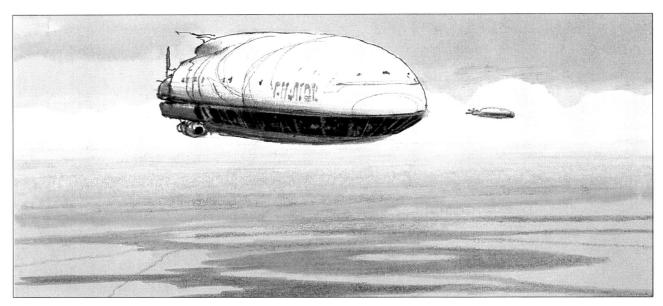

Huge flying hotels drifted aimlessly across the continents with no destination in mind, just a place to get away from personal pressures.

prey out of the ground; they used their sharp beaks to snip the victim into equal portions. The birds gulped down the morsels, leaving the heavy shells behind like the wreckage of a small crashed ship. Then the birds lined up again and continued their march across the grasslands.

All of these creatures were burned to a cinder with one blast from the Death Star.

The wide rangelands on Alderaan were also the primary roving grounds for two domesticated food sources—grazers and nerfs. Both animals were ungulates feeding on the inexhaustible grasses and thick vegetation and continue to be raised on many worlds, so their species is one of the few that has escaped extinction.

Grazers are sluggish and methodical, massive creatures bred for their meat. Genetically altered to optimize their muscle mass, they are docile, unintelligent, and slow-moving—little more than living machines to process grass into edible meat. They have large, stupid-looking eyes and react to almost nothing. They do not panic or stampede or protect their young. They simply wander across the prairies, heads down, nuzzling the grass until they are herded off to droid-run meat-processing centers.

Nerfs, on the other hand, are rangy, supple creatures with curving, dull horns and long, rank fur that covers their muscular bodies. Nerfs are temperamental and cantankerous. They are foul-smelling and apt to spit or kick at their handlers. In fact, if their meat were not so delicious and highly prized, no one would bother raising them at all.

Alas, of all the marvelous creatures to spring from Alderaan's nurturing environment, these two are among the lowliest. I weep for all those other magnificent animals that will never again grace the galaxy.

Nerf herders were a special breed of people frowned upon by the higher cultural elements of Alderaan because they chose to live out in the open and paid little attention to their own personal hygiene. Nerf herders are known somewhat disdainfully as odorous and scruffy-looking—but I remember that when they would bring their herds in once a year to sell the expensive, delicious meat, the nerf herders lived like kings.

A lderaan developed a justly famous cuisine based not only on these two delicate meats, but also on the wealth of exotic herbs available in their coddled botanical gardens, as well as fresh edible flowers and the variety of grains.

Alderaan chefs are famous throughout the galaxy. Popular dishes include grazer fillets in tart sauce, nerf medallions simmered in wine, and slivered spiced tubers cooked in a tender roulade of grazer flank steak. Because of the high demand for the services of these chefs at expensive casinos such as Cloud City on Bespin and high-level observation restaurants on Coruscant, many of them escaped the devastation of our world, much the same way I did.

GRASS PAINTINGS

One of my fondest memories of Alderaan is of flying in an observation boat over the huge and hyp-

notic grass paintings that covered dozens of square kilometers out on the plains. Brilliant botanical artists used the flat grasslands as a canvas for their marvelous work, skimming low to the surface in small craft to deposit the seeds of various flowers. The artists would pick out their designs, using the flowers themselves as paint, the winds as their paintbrush, to create a natural spectacle to prove how humans and nature can work together.

The styles of these grass paintings ranged from sweeping, energetic abstract designs to realistic representations that involved such precision that many of the seeds needed to be planted by hand to achieve the exacting detail required. The natural diversity and wonder of Alderaan supplied flowers rich with all the colors visible to the human eye, as well as others that only aliens could see.

In the normal days of Alderaan, grass artists applied for a five-year license to make their huge works. The first year's growth was recognized as the work of the artist, but in subsequent years the grass painting became a collaboration between the artist and the environment itself. As the carefully planted brushstrokes grew and then went to seed, the lines blurred into a chaotic lack of focus...but with a new kind of vibrant energy that drew from the natural forces of Alderaan. Viewing the paintings always made me feel the majesty of the natural forces that shaped the face of Alderaan long before we came to settle there.

Some of the best grass artists were also skilled in meteorology, but few succeeded in the vigorous task of predicting weather and growth patterns so exactly that they could re-create specific grass paintings from year to year as their initial creations went to seed and spread out.

ere I must tell the heroic story of one rebellious but extremely talented grass painter, Ob Khaddar, who was known to be a troublemaker and a radical at Alderaan University. Upon hearing that the Emperor intended to visit Alderaan on an errand of state, Ob Khaddar concealed his dislike and successfully campaigned for permission to create a large grass painting "to honor the Emperor."

He allowed no one to assist him in the planting of hundreds of thousands of seeds from various flowers, etching out a portrait of the Emperor himself. After the warm rains of spring the broad visage of Palpatine rose from the grasses, fresh and alive—cowled but powerful, his face radiating benevolent energy, his yellow eyes filled with strength. And so when the Emperor arrived for his state visit he took the opportunity to take his entourage out on a large

sail barge to view the great portrait made to commemorate him.

But Ob Khaddar had played a final trick. On the very day the Emperor rode out to observe, accompanied by his withered advisers and his red-cloaked Imperial Guards, another set of flowers bloomed in the midst of the grass portrait. Black lilies spread their dark petals across Palpatine's face, making it look as if his skin had begun to fester and decay from within. The bright flowers of his eyes withered, leaving hollow-looking sockets.

Seeing this, the Emperor was outraged and ordered the entire plain to be torched. Storm-troopers flew over the grasses, blasting with incandescent lasers, ripping up the soil, and setting the tall grasses ablaze.

Senator Bail Organa and other representatives of Alderaan apologized profusely, though none of the Imperials could determine whether they were sincere in their shock and horror...or were secretly pleased.

Ob Khaddar himself, intelligent as well as talented, wisely disappeared before the Emperor arrived on the planet. An Imperial death warrant has been placed on him, but numerous bounty hunters have never been able to get a clue as to his whereabouts.

WATERWAYS

Alderaan had an ice-rimmed polar sea and many large, shallow bodies of water, a few inland seas but no actual oceans. The land was dotted with thousands upon thousands of lakes, chains ranging from small ponds to large bodies of water. Many of these were connected by fast-flowing clear rivers or artificial canals for luxurious slow travel. Vacation barges drifted sluggishly across the ever-changing yet always-the-same grassy landscape, listening to the Song of Alderaan.

chain of islands in the largest inland sea held the tallest forests on Alderaan, the famed oro woods, where graceful, clean-limbed trees once climbed hundreds of meters into the air; the bark was covered with iridescent lichen colonies that glimmered in violet, cinnabar, and pale yellow. White cairoka birds fluttered from limb to limb, singing sweetly. Tiny, brilliant red deer with golden stripes rooted for shoots among the lower foliage. The oro woods were considered such a lovely oasis that the government of Alderaan decreed them a planetary treasure.

Now all this, too, is gone.

A few isolated lakes—chosen for the clarity, depth, and temperature of their water—were estab-

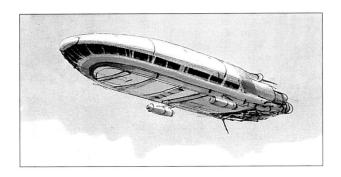

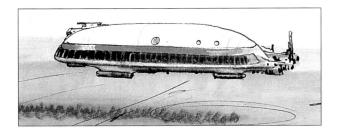

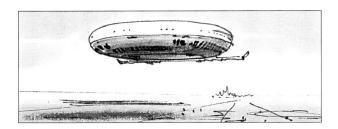

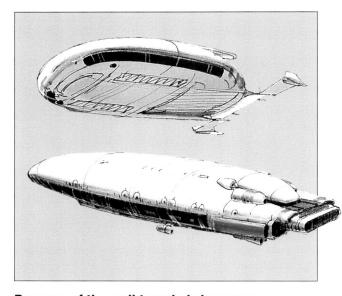

Because of the well-traveled skyways on Alderaan, a great many designs for flying crafts have been put into use, from large passenger buses to small skimmers that once cruised the skies in silence, unwilling to break the peace of this world.

lished as underwater preserves. Mon Calamari guides and fish keepers took tour groups and naturalists on diving expeditions to see the underwater habitats, to watch them feed on each other or on the numerous insect larvae that grow plentifully in the marshy weeds at the lakeshores.

mall crustacean workers built underwater mud castles where entire family units lived for generation after generation, strengthening the battlements, building protected egg chambers. Mon Calamari guides took students and tourists past these sprawling, fragile crustacean cities, but no one touched or damaged the delicate ecology.

All turned to steam with one blast from the Death Star's superlaser.

One of the natural wonders of Alderaan's waterways was a seemingly trivial phenomenon that centuries of tradition embellished into a gala celebration. The "Silver Flow" occurred like clockwork every spring.

Glimmerfish were small but incredibly fecund swimmers no longer than a finger, with highly reflective metallic scales. Females would lay hundreds of fertilized eggs up and down the shores of Alderaan's canals and rivers. When all these glimmerfish eggs hatched at once, the water became a seething, glittering mass of silvery reflections that sparkled from the sunlight penetrating the water's surface. Swarms of the tiny fish surged along with the current toward large bodies of water, where they would grow and live out their lives. Occasionally, with no cloud cover and at the height of day, the flickering light could be seen from orbit.

To the people of Alderaan the miraculous hatching of millions upon millions of tiny fish was a celebration of life and its persistence. Spectators would take boats and rafts along the canals as the glimmerfish swam by, watching the electric silver of the crowded creatures flowing beneath them. The people made the Silver Flow into one of their most popular holidays.

While the fish themselves were too small to be eaten, the celebration provided an excuse for confectioners to make small, silvery candies. Decorative laser shows dappled the night clouds with scintillating schools that looked like glimmerfish swimming across the sky.

Out in the broad lakes regatta ballets engaged colorful sailcraft and air skimmers trailing streamers in a well-choreographed dance. Musicians played on the bows of large barges as the smaller craft flitted in and out. The spectacle was popular enough that the Galactic News Service piped the

annual celebration across all its networks.

This will never happen again, but archival tapes still exist for others to watch, and see what the galaxy has lost, and mourn along with me.

SKYWAYS

Because the surface features of Alderaan were so gentle, the open skies of the world became well-traveled highways. Transportation specialists of Alderaan let their imaginations run wild, designing spectacular gossamer craft, too fragile to withstand rigorous storms yet perfectly feasible in the calm, predictable air currents of Alderaan. They enjoyed the freedom of the winds, drifting wherever whim took them.

uge sailing constructions with translucent sheets of flexible films and inflatable air bladders formed roving islands in the sky, nomadic resort hotels where tourists could relax above the serenity of the rippling grasses below. These lighter-than-air constructions moved at random over the surface, without a schedule and without a destination.

Other craft, from chartered hoverbarges to small personal skimmers, took people streaking across the sky—but the serene emptiness of Alderaan was so vast that I rarely remember seeing more than two vehicles in the same ocean of blue overhead.

For sport, some daredevils undertook the ancient hobby of constructing and piloting hot-air balloons, rising high over the unbroken terrain. Other people would tether themselves to huge kite constructions and go sailgliding, chained to the ground by a thin fiber and flying free. These daring athletes usually wore body armor and repulsorlift belts for safety.

People also rode the native flying creatures of Alderaan, particularly the thranta—an immense leathery creature whose body was primarily a giant wingspan with a central core made of lighter-thanair bladders. These creatures had long life spans and grew to unprecedented size in the unrestrained environment of Alderaan.

any species of native thrantas drifted across the skies, skimming low and feeding on windblown seeds and pollens. The thrantas were docile and easily domesticated. Bearing only a rudimentary intelligence, they adapted well to captivity and seemed not to resent their role as living aircraft.

Smaller thrantas were used as personal mounts with saddles and reins adjusted so that riders could take them out on recreational rides. The larger thrantas had standing platforms mounted to their backs, where groups of people could hold ropes as a

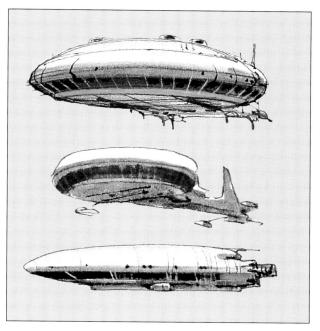

Windows were as important as propulsion systems in sight-seeing vessels, letting passengers stare out across the unbroken fields of grass and flowers, searching for herds of wild animals.

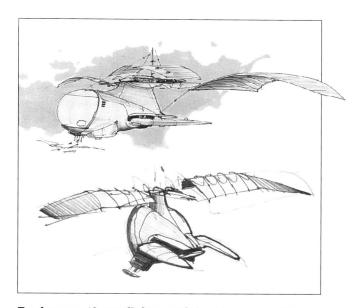

Engines on these flying craft had been modified for efficiency and cleanliness. Because Alderaan had little industry, the skies were always a clear, deep blue, free of pollution.

thranta pilot took the creature flapping up into the sky, riding high thermals. In this way tourists could look down across the plains and observe the grass paintings or the sparse natural features.

Luckily for their species, some young thrantas were transplanted to other planets with calm atmospheres and sufficient wilderness for the thrantas to roam. Most of these attempts proved unsuccessful,

except for a group of young, energetic flying creatures that have thrived on Bespin, where they still serve as an oddity, performing monthly sky rodeos. The rest of the thrantas, however, are dead in the space rubble of Alderaan.

An attempt to bring the thrantas to Coruscant ended in tragedy. Some Imperial fools hoped that the creatures could fly high above the city skyline, drifting over the glittering lights. At first the Emperor was amused by them—but the flying creatures wasted away no matter how much effort the wranglers

put into tending their beasts. The noisome city air seemed poisonous to them. The close confinement of monolithic skyscrapers and the sheer number of shuttlecraft and people and industry seemed to repel them. I must confess this is my own reaction to the metropolis world, and I will never again return there by choice.

On Coruscant the thrantas' grayish, leathery skin turned blotchy. Their air bladders sagged, and they drew no strength from the specially concentrated nutrient solutions the wranglers pumped into them.

One of the thrantas brought its rider to his death as the ailing creature swooped down in the canyons of the city, plunging hundreds of stories as if in a suicidal dive toward the incomprehensibly distant ground. The remains of the thranta carcass and its rider were never found deep in the murky underworld of Imperial City.

Now, if anyone wishes to see live thrantas, they must go to Bespin. I hope the creatures thrive there, without Imperial cruelty.

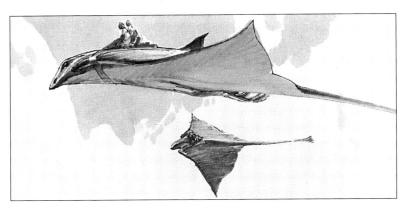

CASTLE LANDS

At the northern edge of Alderaan's great plains lay the mysterious Castle Lands: incredibly ancient ruins, towering cities made by extinct human-sized hive creatures known as the Killiks. These mysteries will never be solved, though—thanks to the Death Star.

The breathtaking Castle Lands were weathered turrets and structures densely packed into once bustling hives, built mound upon mound. The monolithic pinnacles were fundamentally similar, with only a few different designs copied thousands of times across the entire badlands. The structures were riddled with honeycombed passages, small dwelling chambers, larger communal eating areas, and egg-laying grottoes. The Killik Castles endured for millennia, barely changed—only to be destroyed in an eyeblink by a cruel superweapon.

At first glance these Castles seemed to be the work of a sophisticated species, but archaeological investigation only uncovered a deeper and deeper alienness. So much so that some question whether the long-extinct Killiks had any form of intelligence. Their iron-hard mounds are devoid of any technological improvements and appear to have been built entirely by insectile hand through a massive concentration of coordinated labor—however, the inner walls were decorated with brilliantly complex mosaics of colored pebbles.

Thrantas are magnificent flying creatures originally from Alderaan, though luckily they had been transplanted to other worlds before the destruction of this planet. Night riders (*left*) could see the plains under the silver wash of the moonlight.

No one has ever been able to determine whether these mosaics were some form of written communication or merely decorative art that makes sense only when viewed through multiply faceted eyes. The Killiks left no other artifacts: no tools, no machines, no vehicles, no possessions.

any of their chitinous carcasses have been found, their glossy, greenish exoskeletons so hard that they withstood thousands of years of erosion. The Killiks had four arms, each terminating in a powerful three-fingered claw, and two stout legs that appeared capable of leaping great distances.

Across the northern steppes of Alderaan, the Castle Lands appeared in eighteen well-defined groupings, each erected at a distinct age. Archaeological speculation has it that the Killiks built their

earthen cities in a certain area until either the food ran out or the population grew too large; then they abandoned their homes to swarm over the great plains until they found another site, where they erected a new city. The cycle was repeated over and over again until the Killik race finally and mysteriously died out.

Oddly, the oldest Castle structures showed the greatest technological sophistication, which dwindled with each successive generation. In progression the Killiks seemed to have lost their ability to function together as a hive organism, and their society degenerated into chaos.

Even during the centuries of human occupation, the abandoned Castles of the extinct Killiks remained in good condition—like empty, haunted spires out in the silent plains, a poignant example of how civilizations can fall...how even an abomination like the Empire is—thankfully—a mere blip on galactic history.

In the last days of Alderaan, the Killik Castles became popular retreats for those seeking places of solitude. Artists and musicians of a private, contemplative temperament often journeyed to the Castle Lands and selected any one of the similar empty towers to live in for however long they chose. They brought their own supplies and all the raw materials they needed for their craft. Traveling by silent aircraft or drifting thranta over the Castles, one could occasionally hear strains of practiced music or an unseen orator rehearsing a profound speech.

Some of the spires were revamped and modernized with plumbing, heating, power, and other amenities. Purist artists and philosophers, though, prefered to seek total primitive solitude and spend nights out under the open skies, watching the endless dizzying dance of stars and planets overhead....

So much of Alderaan's greatest cultural work was created in these isolated Killik castles that the ruins were revered with a sort of awe, as if they concentrated inspiration and deep thought. I spent many months during my own most productive period, creating sweeping verse that attempted to capture the feel of the boundless wilderness around me. Some critics have called these "Castle poems" my best work.

Alas, one artist with misguided intentions decided to paint an entire section of the spires in brilliant colors, swirling them with corkscrew designs and pastel splashes. Alderaan always did its best to foster the development and freedom of artwork and cultural enhancements of any form—and I, for one, would never dream of stifling artistic expression—but in this case the people were universally ap-

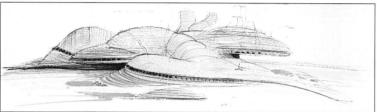

palled by the defacing of revered old structures. The Alderaan ruling council issued a decree banning such artistic pursuits from that point on.

Until the planet's destruction, the defaced spires could still be seen. The Alderaan council determined that more damage would be done by attempting to repair the unwanted painting than if they just left the eyesore as a scornful display of the excesses of certain artists.

he artist himself was not prevented from making further paintings, so long as he damaged no other ancient landmarks. Insisting that this spoiled the whole effect and crippled his artistic freedom, the artist left Alderaan and went to seek other commissions.

CITIES AND CULTURES

More than any other planet I have ever experienced, Alderaan had a worldwide conscience, an attitude among the vast majority of its population to be aware of ecological needs. They recognized that they must not ruin the environment, that their quality of life would be much greater if they found a way to cooperate with their delicate world. But all their careful plans were swept away in a single act of unspeakable brutality.

Because humans were not the original inhabitants

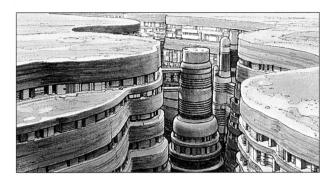

Crevasse City is a perfect example of how the people of Alderaan worked with their environment rather than against it, establishing even a large metropolis in such a way that the landscape was little affected.

of Alderaan, coming instead upon a world already littered with the debris of the Killik civilization, they developed an attitude that they were mere visitors no matter how long they remained there. Perhaps this attitude was one of the reasons why Alderaan was the birthplace of so many great artists and philosophers. It was a nurturing place, a cultural oasis that had forgotten the wealth of violence of which living creatures are capable.

The people of Alderaan were highly sensitive, paying close attention to their world and the universe they lived in. They bore within them a kernel of peace and acceptance not often found on colony planets where life is a constant struggle against the elements.

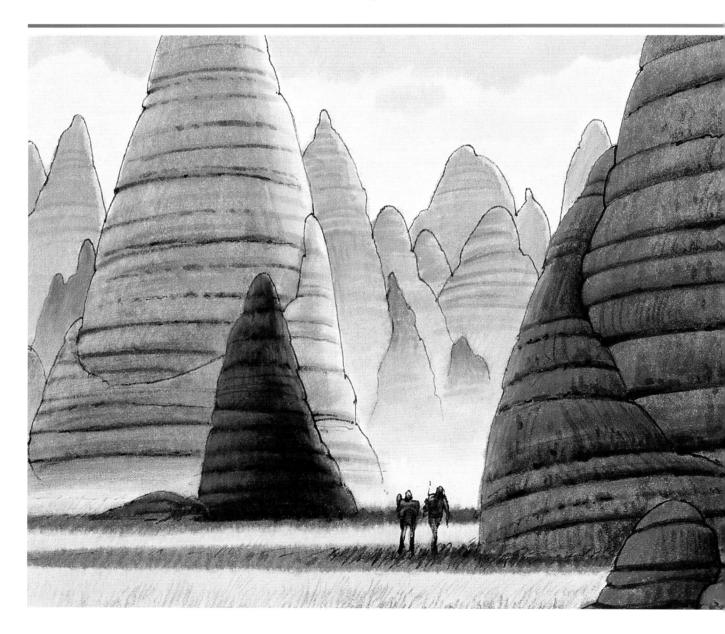

Though they passed no official laws or ordinances defining such things, the people of Alderaan long ago implicitly accepted the challenge of building their cities in such a way that it created a minimum impact on their world, finding various techniques to dig into the crust rather than erecting tall obstructions. Their cities were built on stilts out in the shallow inland seas, or wedged into crevices under Alderaan's polar ice.

Crevasse, one of the largest cities on Alderaan, was all but invisible from the air—built into the walls of a network of fissures. Once-mighty rivers flowed through these canyons, carving channels through strata laid down over thousands of years; but as the weather changed and the terrain altered, the main sources of the rivers were diverted, leav-

ing only small streams glittering, like quicksilver threads at the bottoms of the gorges.

During the first years of human habitation on Alderaan, a collection of miners lived in small natural caves while they quarried the colorful rocks as raw material for other building projects. But as the miners discovered freshwater springs within the cliff walls, and as word got around about the beautiful sunsets, more and more people came to Crevasse.

ost of those who made their homes on Alderaan were not desperate colonists, though, but retired dignitaries and well-established businesspeople, those whose fortunes had already been made offplanet. These people wanted a pristine place they could protect and treasure.

With the morning and evening breezes, flocks of what appeared to be birds swooped over the canyons—but on closer inspection it could be seen that these were people with kite wings soaring on the thermals, gliding about and looking down on the grandeur of Alderaan's natural landscape.

Crevasse city grew with dwellings carved out of the sheer rock walls. Passages connected, making

The abandoned, petrified mounds of the extinct insectoid Killiks were among the most intriguing natural objects on Alderaan, rising from the plains in smooth, organic-looking monoliths.

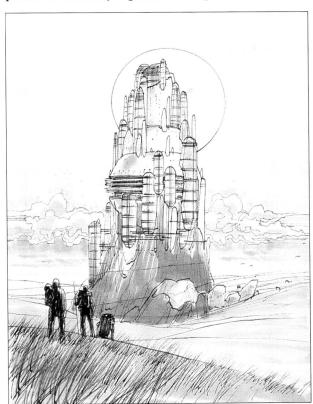

their city larger as it spread up and down the canyon and into side gorges. To a casual observer, Crevasse—though one of the most heavily populated areas on Alderaan—looked to be a wilderness unharmed.

nother of Alderaan's large population centers, Terrarium City, has been called the City Under Glass. Terrarium's founders chose a different way to build their metropolis and yet protect the landscape at the same time.

Teams of landscape engineers excavated a natural depression in the plains, a large bowl which they sealed with a liner so that nothing could leach into the soil. They fused the surface to an impenetrable glass and then began to lay down their city in a methodical, efficient way.

They filled the huge artificial basin with a liquid polymer. Tankers came from orbit, dropping enough

polymer to fill the excavated bowl until the liquid had reached a uniform height, at which the designers wished to place the city's bottom level.

Using a fleet of modified battleships, Terrarium's designers hovered over the bowl area and played their lasers over the liq-

uid polymer—not as destructive weapons, but as holography beams projecting a three-dimensional pattern into the transparent liquid, an image of all the preprogrammed rooms, buildings, and thoroughfares. The lasers hardened the resin in the appropriate places, crystallizing solid walls down to the tiny details of arches and windows.

The remaining polymer fluid was then drained out, pumped back into holding tanks. The first layer was allowed to dry before a capping sheet was laid on top as a roof of the bottom story, in preparation for the second layer of Terrarium City.

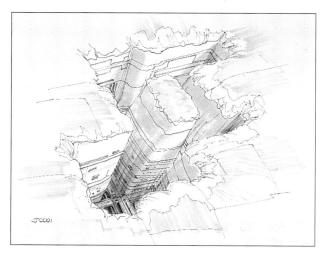

The polymer fluid was pumped in again, and this time a new blueprint was projected into the resin. Layers upon layers were patterned in an incredibly

short period, with no industry, no waste, no further disruption of the world. The polymer itself was completely inert,

giving off no harmful volatile chemicals to pollute the atmosphere.

When all eighteen layers of Terrarium City had been patterned and completed, the inhabitants were assigned quarters from the blueprint maps. Each family was allowed its full creativity, because for the first month or so the polymer walls were still soft enough to allow a certain amount of carving

> and patterning. Several types of sonic resonators and light baths were available to texture and color the walls to the inhabitants' preferences. Groups made great entertainment for themselves by chiseling bas-reliefs into the walls and arches, expressing themselves in their own

dwellings. It was a heady time, and their imaginations roamed free.

Finally the whole of Terrarium City was covered over with a transparent sheet that sealed it level with the rest of the plain. It looked like an incredibly still lake, a pool of glass from beneath which the lights of thousands and thousands of dwellings blinked, but the industry and the bustle of population remained silent from the outside, contained.

Tall pinnacle towers rose above the flat cap of Terrarium City. Slender monoliths stretched high into the sky like needles wavering in the gentle breezes. Thin cables extended from these towers out to anchor points, providing additional support to the broad rooftop layer of transparisteel.

Though their lives seemed idyllic beneath the ground in the perfectly planned Terrarium, occasionally the people needed to spend time above it—not just at grass level, but high enough to get a view from a height, to let their thoughts roam free. Turbolift shafts ran to the top of each turret. Office complexes and counseling facilities were housed in the needle towers. Lighter-than-air vehicles as well as repulsorlift craft were tethered to the towers.

The smooth lines of Alderaan architecture have been copied in many other cosmopolitan worlds, preserving yet another facet of our lost culture. he magnificent capital city of Alderaan, Aldera, was built on an island in the middle of a circular lake, a lake formed from a fresh meteor crater breaking through into subterranean aquifers.

Because Alderaan was such an old world, very few craters remain that have not been weathered completely away. This blemish was fresh in a geological sense, and the small pointed island at its center had a poignant loneliness that seemed to ask for some greater purpose.

Visitors reached the city of Aldera by air or by boat, crossing the deep lake. Beautiful white freeform buildings stood on the uneven slopes of the island—many of them dwellings, while other prominent structures served as the cultural and governmental facilities for which Alderaan was once so well known.

Aldera housed the embassies of off-planet dignitaries, and was also the home of Senator Bail Organa. Princess Leia Organa spent many years of her childhood there. Friends of the Rebel Alliance

will recognize those names, which have since been reviled by ignoble Imperial propaganda.

Despite its other picturesque land-

marks, though, Aldera was perhaps best known as the site of the famous galactic learning center, Alderaan University.

ALDERAAN UNIVERSITY

Before its tragic destruction Alderaan University was one of the oldest and most widely revered learning institutions in the galaxy. Other universities on other planets have adopted a similar model, but none was ever able to match the success of Alderaan. The university was founded long ago, one of the first structures erected on the island in the middle of the crater lake. It was originally established as a school of philosophy by the great Republic thinker Collus.

ollus originally brought with him a group of his brightest students to live in seclusion in the temperate climate of Alderaan, mulling over matters of great import (whether to the galaxy as a whole or just to the students themselves). With long stretches of uninterrupted time, the philosophers of the school of Collus pondered the inferences they drew from vast storehouses of data, statistics, and history compiled from a thousand worlds and as many civilizations.

It was here that the students of Collus understood that the Old Republic was crumbling—at least a century before the rest of the galaxy realized

it. Some of this informtion was documented but not widely released for fear of skepticism, disbelief, or outright antagonism. But the school of Collus continued to exist through the times of great upheaval, offering their

assistance and wisdom whenever they felt their help would prove more constructive than destructive. Many of the galaxy's greatest moral treatises and philosophical works were penned by the students of Collus during these difficult times.

grasp the importance of the school of Collus, other teachers came to Alderaan, building their own schools adjacent to the first learning center. They branched out in the disciplines of politics, mathematics, cultural pursuits, and the arts.

One of the conclusions that Collus himself came to before his death at an extremely old age was that knowledge without application was worthless knowledge, and that studying secondhand information without personal experience watered down any learning gained in such a manner. Philosophy studies were fine and good, because philosophy by its nature was a contemplative subject—but other disciplines required action and experience. How could a student of biology attain wisdom by looking at diagrams in books and not going into the field? How could a student of politics grasp the true mechanisms of government without setting foot on Coruscant?

Eventually it developed that while the main core of Alderaan University remained on the island

city of Aldera, various "pods" of the university dispersed to primary locations of study. Botanists and entomolo-

gists spent time in directed study on lush planets such as Ithor, the home of the Hammerheads, or other tropical worlds. Meteorologists would study the immense storm systems on gas-giant planets such as Bespin. Historians would visit the ruins of the ancient library on Ossus, or Deneba, where once a great council of Jedi was convened. Political science students found jobs as government functionaries in Imperial City.

With its large numbers of young and impressionable students recently awakened to political causes

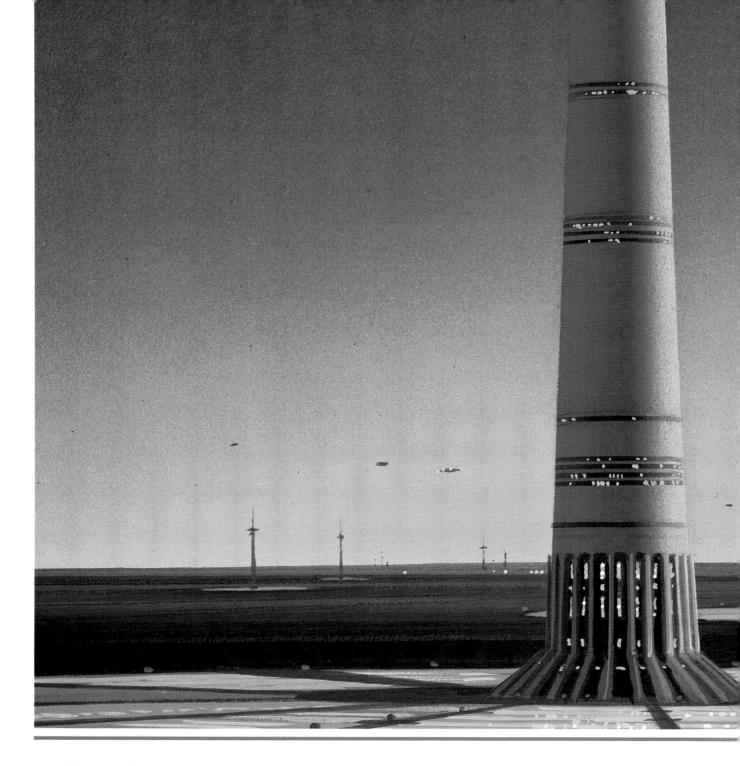

and idealistic dreams, it is not surprising that Alderaan University became a hotbed of carefully hidden dissent against the New Order. This is where many came to snoop and learn about the Rebellion against the Empire. This is where I myself was recruited as an outspoken proponent of the Alliance.

On the surface, Alderaan University retained a careful veneer of quiescence and deep study, with students focused upon their work and the lectures of their instructors. The philosophy students made no secret that they were fundamentally offended by

the Emperor's New Order and the limits it placed on thought and free expression, but they restricted their discussions to theoretical pursuits. No doubt this served as a useful red herring for Imperial spies seeking access to the real ringleaders of the Rebellion.

Imperial plants tried unsuccessfully over and over again to break into any Rebel cell and find connections to the larger Alliance. But even though the students might have been as naive as they were enthusiastic, they still managed to avoid capture. Until the end, when everything was on the verge of

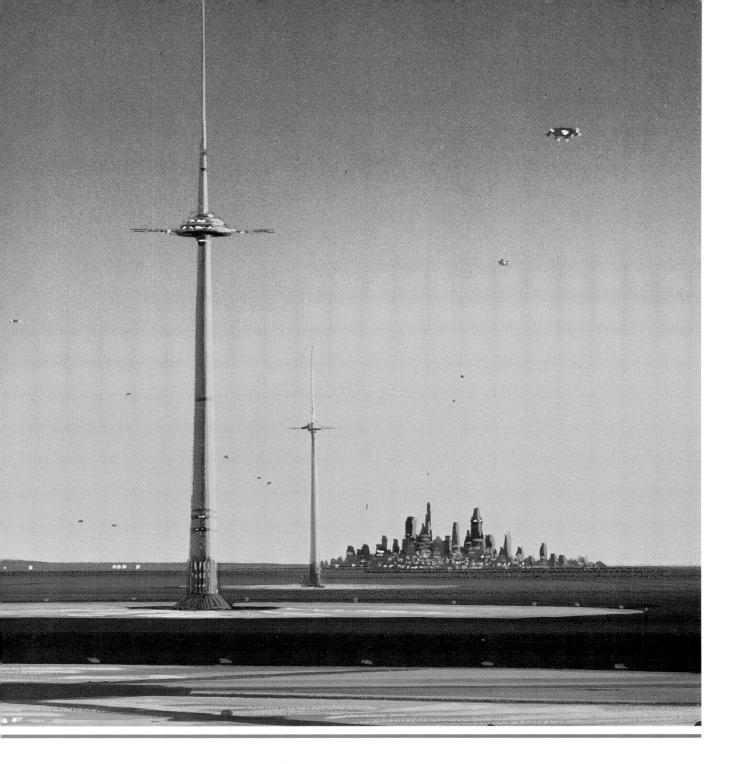

being cracked open—but ironically the Death Star itself ruined the crackdown on Alderaan.

ne secret dissident, a friend of mine, was the bright young student musician Thelaa. She was a quiet and creative woman who came to the University from one of the backwater agricultural planets. I remember with bittersweet bemusement how she had received a great shock upon being thrown among a more cosmospolitan group of people who were interested in the larger workings of

The tall pinnacle towers of Terrarium City stretch high like needles, giving the underground inhabitants a chance for a "view from a height."

the Empire and the very nature of freedom.

Originally Thelaa's talent produced remarkable musical compositions, but then she fell deeply into her own secret cause in the name of the Rebellion. With a head of close-cropped, straw-colored hair and overlarge eyes, Thelaa projected an expression of innocence and gullibility that served her well

during the several times she was routinely questioned by Imperial investigators. She took frequent sojourns alone out to the abandoned Killik monoliths, supposedly seeking hidden places where she could be inspired in her music. I know, though, what her real purpose there was.

Thelaa regularly delivered new works, much to the satisfaction of her instructors, until by a sheer fluke one of her teachers discovered that she merely copied the technically competent but generally uninspired work of a centuries-forgotten composer named Salyer!

hen Thelaa refused to explain why she had passed off plagiarized work as her own, she was expelled from Alderaan University. I tried to intercede on her behalf, using my own fame to intimidate the officials—but even my entreaties had no effect. (And, legitimately, how could they ignore such an ethical violation, even had they known her true work?)

In her trips out into the wilderness Thelaa was actually running black-market weapons, which were picked up by smugglers and taken off to arm the Rebel Alliance. This was her true calling in life, and I know it made her feel vibrant and alive.

After her expulsion Thelaa fled to the isolated fortress where she had stashed her latest shipment of weapons. She was desperate, needing to get off the planet. She contacted her Rebel partners in a hidden ship in orbit—but she did not realize that on this last trip a team of bloodthirsty Imperial trackers had followed her.

After Thelaa had gone to her cache of illicit weapons, the Imperial operatives closed in on her. Thelaa spotted them before they could break into the tall cement-hard mound where she made her encampment. She kept a coded comlink channel open with

her Rebel contacts as she withdrew several fully armed blaster rifles. She began shooting, but the Imperial forces were too great. They succeeded in stunning Thelaa—but only after she had managed to kill two of them.

With their new captive ready for full questioning from an IT-0 interrogation droid, the Imperial operatives were pleased to note an immense battle station arriving in orbit around Alderaan. Their smug calls to the Death Star are a matter of record. The trackers were convinced that the Empire had finally

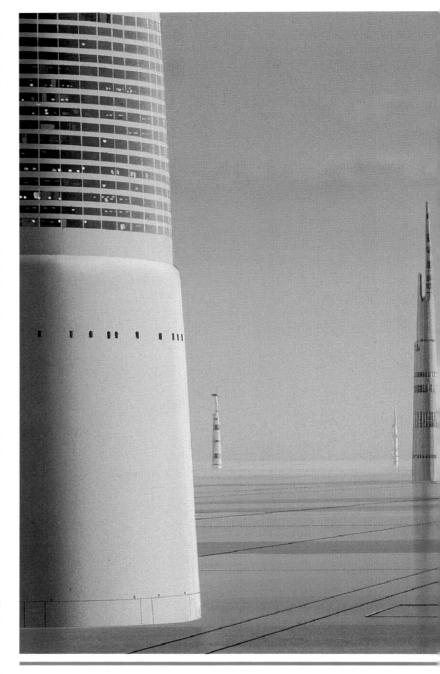

come to crack down on the freethinking and peaceful ways of Alderaan.

But the Death Star had far more extreme measures in mind, and Grand Moff Tarkin never responded to their transmissions.

The planet Alderaan was destroyed before Thelaa could be interrogated or her stolen weapons cache recovered. Despite my sadness, I can say only that it served them right.

The annihilation of Alderaan was intended to be

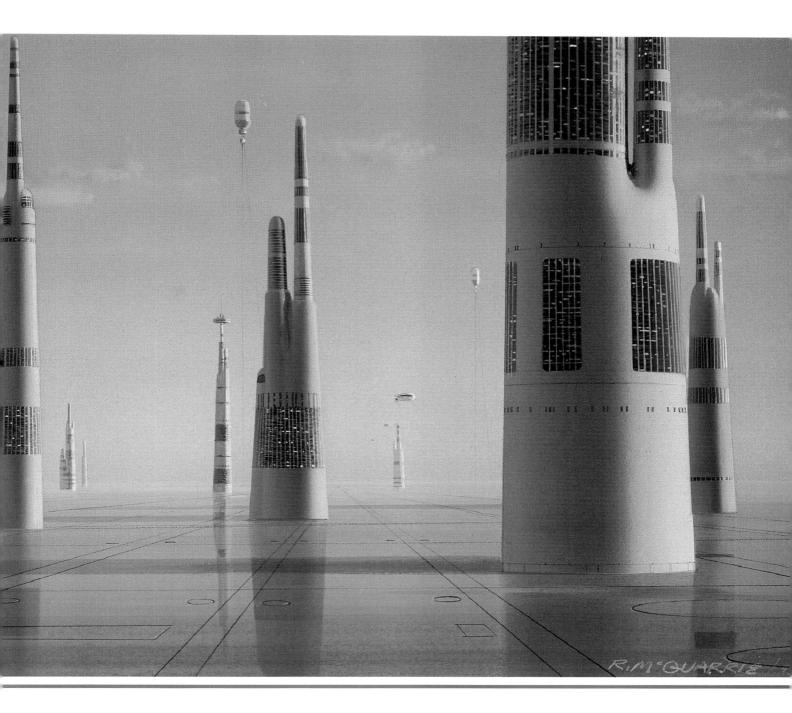

a demonstration of might by Grand Moff Tarkin, an exercise of Imperial power to increase terror of the Empire and to crush the Rebellion.

It is true that the wholesale destruction of Alderaan sent tremors across the galaxy—but the result was not what Tarkin had in mind. The Death Star's vicious attack was but another demonstration of the Empire's evil, and it drove many peaceful and docile citizens into open rebellion.

From the moment of Alderaan's death, the Rebel Alliance became less a secret underground battle

Again, to avoid harming the landscape of their world, the people of Alderaan covered one of their underground cities, Terrarium City, with sheets of transparisteel.

and more an overt civil war. There could be no hope for a peaceful resolution between the Alliance and the Empire.

Though Alderaan is gone now, it survives through the wealth of art and music dispersed from star system to star system. Alderaan has become a

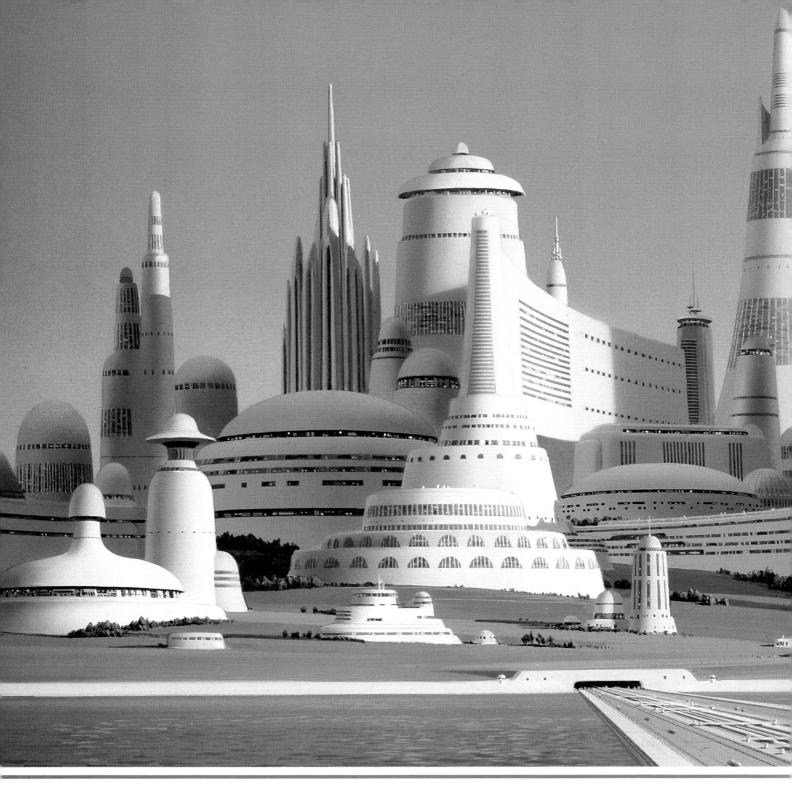

symbol of innocence against evil. My own memories are like precious jewels inside me, and I will devote the rest of my life to singing this requiem for Alderaan. Let no one else ever forget.

The pods of Alderaan University were dispersed like seeds on the wind, so that students taught at the ancient learning center of Collus have also carried their memories of Alderaan throughout the stars. Now, every time I hear the winds through the grasses on any world, I hear an echo of the Song of Alderaan.

The most powerful force of all, unquenchable by any Death Star's laser, is the spirit of freedom and resistance to oppression that continues to spread across the galaxy.

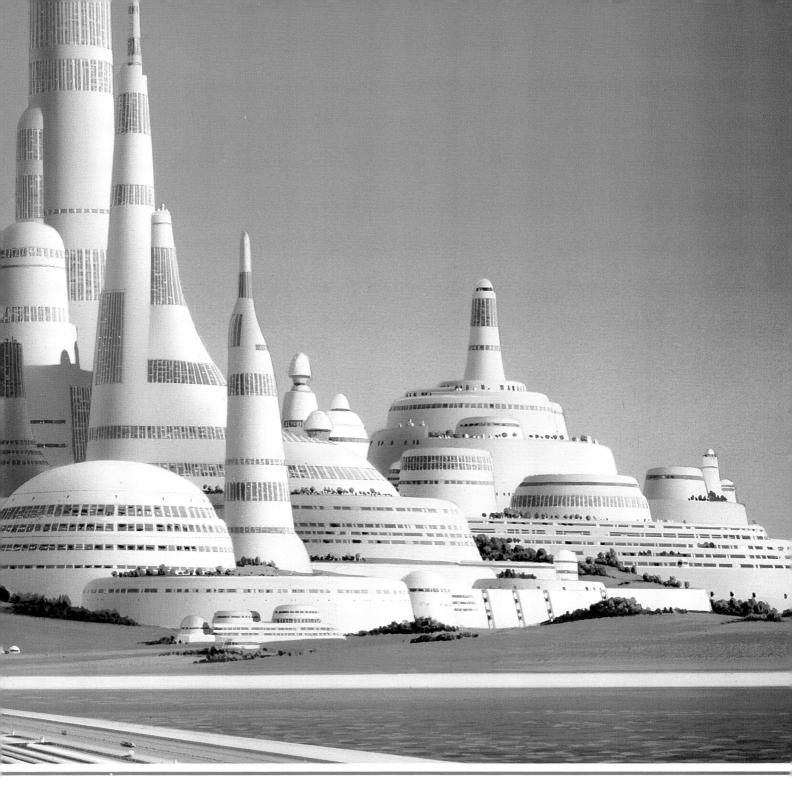

The glittering capital city of Aldera sat on an island in the center of a beautiful lake. Aldera was perhaps best known as the site of the renowned Alderaan University.

ART BY RALPH McQUARRIE TEXT BY KEVIN J. ANDERSON

ADDITIONAL ART BY:

Pg. 14: Nilo Rodis Jamero

Pg. 17, rt. Harrison Ellenshaw

Pg. 22/23 double pg spread:

Michael Pangrazio

Pg. 22: Joe Johnston

Pg. 23, lower: Norman Reynolds

Pg. 29, lower rt: Joe Johnston

Pg. 30, lower: Joe Johnston

Pg. 33, lower: Joe Johnston

Pg. 34, left: Joe Johnston

Pg. 48: Nilo Rodis Jamero

Pg. 50/51: Joe Johnston

Pg. 78: Nilo Rodis Jamero

Pg. 92: Nilo Rodis Jamero

Pg. 93: Joe Johnston

Pg. 94, lower: Joe Johnston

Pg. 95, lower: Joe Johnston

Pg. 103, both: Joe Johnston

Pg. 111, center: Joe Johnston

Pg. 114: Nilo Rodis Jamero

Pg. 117: Chris Evans

Pg. 118: Chris Evans

Pg. 119: Joe Johnston

Pg. 120, top: Joe Johnston

Pg. 120, bottom: Nilo Rodis Jamero

Pg. 121: Joe Johnston

Pg. 124: Joe Johnston

Pg. 125, top: Joe Johnston

Pg. 125, lower: Joe Johnston

Pg. 131: Joe Johnston

Pg. 132: Joe Johnston

Pg. 133, top: Joe Johnston

Pg. 133, lower: Joe Johnston

Pg. 134, top: Joe Johnston

Pg. 134, bottom: Joe Johnston

Pg.135, top: Joe Johnston

Pg. 135, bottom: Joe Johnston

Pg. 136, left: Joe Johnston

Pg. 136/137: Joe Johnston

Pg. 140: Nilo Rodis Jamero

Pg. 155, both lower: Joe Johnston

Pg. 165, lower: Joe Johnston

Pg. 168: Michael Butkus

Pg. 188: Nilo Rodis Jamero

Pg. 190/191: Concept by Nilo Rodis Jamero, art by Ralph McQuarrie

Pg. 195, lower: Joe Johnston

Pg. 196, lower: Joe Johnston

Pg. 197: Joe Johnston

Pg. 199, rt: Joe Johnston

Pg. 200, bottom: Joe Johnston

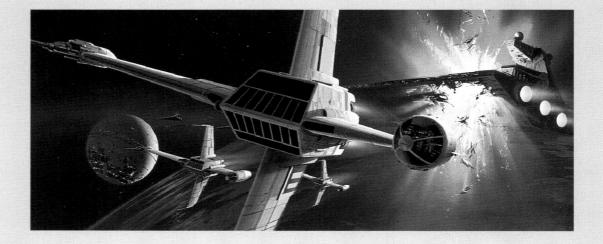

. • " .